First published in 1994
by G+B Arts International Limited
An *Art & Australia* Book

Distributed in Australia by
Craftsman House
20 Barcoo Street
East Roseville NSW 2069

Distributed internationally
through the following offices:

ASIA
International Publishers Distributor
25 Tannery Road
Singapore 1334
Republic of Singapore

AUSTRALIA
Craftsman House
20 Barcoo Street
East Roseville NSW 2069
Australia

EUROPE
International Publishers Distributor
St Johanns-Vorstadt 19
Postfach
4004 Basel
Switzerland

USA
International Publishers Distributor
820 Town Center Drive
Langhorne
PA 19047
USA

ISBN 976 8097 906

Designed by Harry Williamson
Printed by Eurasia Press, Singapore

Marea Gazzard FORM AND CLAY

Marea

An *Art & Australia* Book

CRAFTSMAN HOUSE

Gazzard

FORM AND CLAY

Christine France

For
Nicholas Gazzard
Clea Gazzard and
Harriet France

… many objects
tell me all.
They do not merely brush me by
or my hand them,
but are the accompaniment to my whole existence.

Pablo Neruda

Contents

Acknowledgments

When I began working on this book I was daunted by the task of amalgamating Marea Gazzard's considerable contribution as an artist who has produced an important body of work, with her achievement as an administrator who has done so much to change perceptions of craft both nationally and internationally.

This load was lightened, first of all, by the very real pleasure of working with Marea Gazzard, who gave generously of her time and information yet at all times allowed independent assessments and interpretations to stand; and, secondly, by the publication of Grace Cochrane's *The Crafts Movement in Australia: A History.* This important book is a thorough and analytical history which includes many of the ideas, events and committees that have shaped or been shaped by Gazzard's contribution as an administrator.

I would like to thank the staff of the National Gallery of Australia, the Art Gallery of New South Wales, the Art Gallery of South Australia, the Art Gallery of Western Australia, the National Gallery of Victoria and the Queensland Art Gallery, who have supplied information and allowed me to view works, as have the Brisbane City Hall Art Gallery and Museum, Lake Macquarie Art Gallery, Newcastle Region Art Gallery, Shepparton Art Gallery, Wagga Wagga Art Gallery and Wollongong Art Gallery, the Robert Holmes à Court Collection, Perth, and Macquarie University, Sydney. I should also like to thank Stephen Rainbird of the Queensland University of Technology; Grace Cochrane, curator of Australian Contemporary Decorative Arts and Design at the Powerhouse Museum; Peter Haynes, curator of the Parliament House collection, Canberra, who arranged access to the Executive Court in Parliament House; and Peter Morley of Meridian Sculpture Founders Pty Ltd.

Many private collectors have provided access to their collections and given most generously of their time in answering questions and providing information; to all of these people, most heartfelt thanks. I am also grateful to Ann Lewis, Chandler Coventry, Violet Dielieu, Mimi Falkiner and Anne von Bertouch, all of whom racked their brains, consulted records and helped in locating works. Special thanks are due to Felicity and Wally Abraham, Robert Bell, Giulia Crespi, Donald Gazzard, Kenneth Hood, Alexia Herbert, David Jackson, Elwyn and Lily Lynn, Valli Moffitt, Peter Rushforth and Margaret Tuckson, who all supplied information; and to Peter Travis and Alan Crawford who helped with the technical information.

I am very grateful to Elwyn Lynn, Tony Bradley and Grace Cochrane for reading the text and helping greatly with suggestions and corrections. Thanks are also due to Gayle McNeice, who has patiently and efficiently typed the text.

I would like to thank my husband, Stephen France, for his patience and encouragement, and my good friends who showed remarkable tolerance and pushed me on to 'get it finished'.

Most specially I would like to thank those involved in the production of the book. To the designer, Harry Williamson, who from the beginning has worked with enthusiasm and sensitivity; to the editor, Jill Wayment; the staff of Fine Arts Press – Hannah Fink, Hari Ho, Marian Kyte, Sook San Ang and Dinah Dysart.

Marea Gazzard's Windsor Street studio, 1972

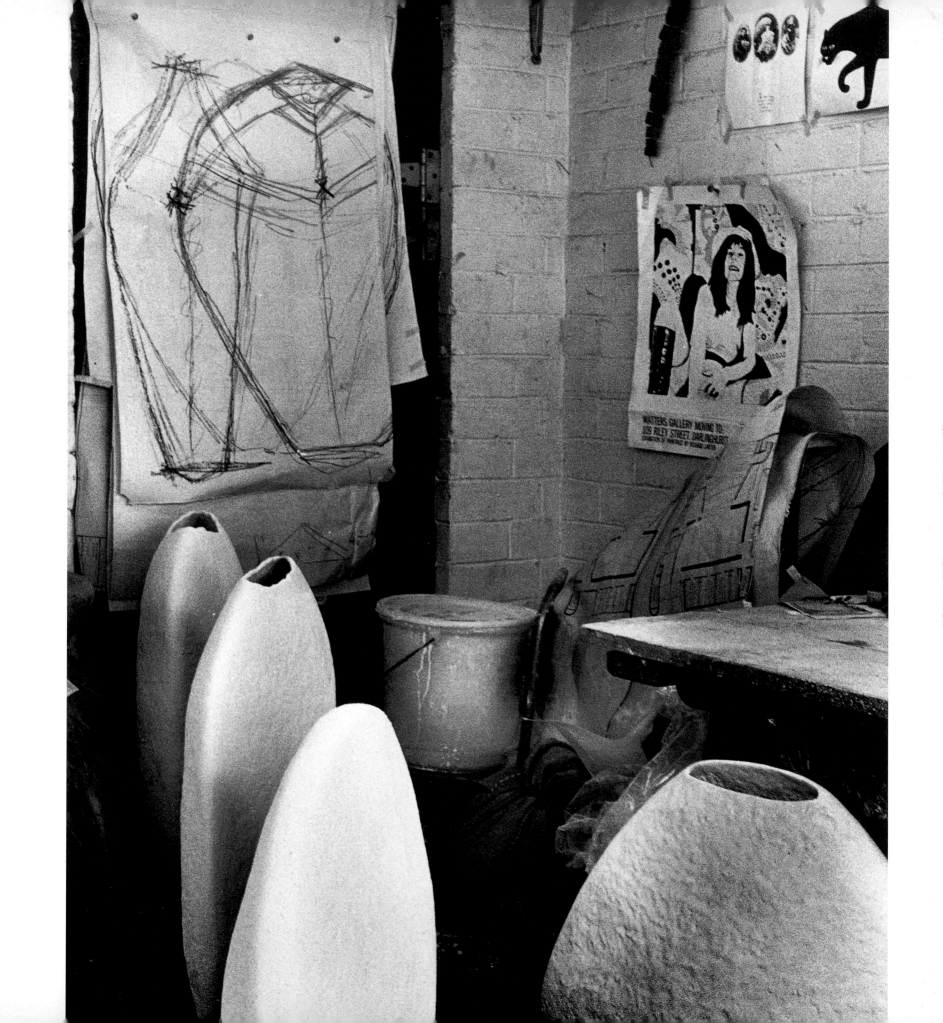

In the centre of the Executive Courtyard which adjoins the Prime Minister's suite in Parliament House, Canberra, are five quietly monumental, hill-shaped bronzes which cast changing shadows and evoke an atmosphere of serenity. Situated at a distance from the constant activity that characterises a centre of government, the forms appear perpetual, emerging from the ground and shaped by the spaces which flow between them. Entitled *Mingarri: The Little Olgas* 1984-88, they represent another centre – the physical centre of Australia, a centre of Aboriginal culture. At the same time their strong overlapping forms, almost painterly surface and changing shadow possess a universal quality, quite independent of national symbolism.

Their presence defines a place of calm, a place where decisions can be made and where visiting heads of state can meet. They are witness to both the past and the future, and symbolise the unique position which their maker Marea Gazzard has held in the shaping of Australia's recent art history.

In the past, it was unlikely that a woman would be chosen for such a commission. It was unlikely that a work which referred to Aboriginal culture instead of white achievement would be chosen for such a site. It was a remote possibility that someone trained as a potter and central to the revitalisation of the crafts movement would be commissioned to contribute more than a decorative trim or a functional object to a building of such national importance.

Worldwide there have been changes in attitudes to women, to cultural minorities, and to indigenous peoples. There has also been a broadening conception of the nature of art. Marea Gazzard has worked both in the context and as a protagonist of these changes.

Gazzard's art began with pottery and has concentrated on the presentation of form for over thirty years. In this time she has produced works of archetypal presence which have attracted both art and craft audiences, and eroded the status distinctions which existed in Australia prior to the seventies between the major arts of painting, sculpture and

architecture, and the so-called minor arts such as pottery, fibre, metal and woodwork.

Gazzard's role in establishing recognition of craft practices, many of which were the domain of women and lay outside the mainstream, extends beyond her own work back to the early sixties, when she started lobbying for the formation of the Craft Association to provide increased information, interaction and improved standards for those involved in the crafts.

In her later roles as inaugural president of the Crafts Council of Australia (1971), inaugural Chair of the Crafts Board (1973) and first elected President of the World Crafts Council (1980), Gazzard persisted in establishing systems of information and exchange which would assist in the pursuit of excellence and further encourage reciprocity of ideas on an international scale. This internationalism was based not on imperialist attitudes but on a belief in a common language of creativity which recognises differences within cultural systems and

traditions. In an attempt to create a regional relationship which was mindful of cultural differences, Gazzard had requested at the third World Crafts Council Conference, in 1968, that Australia cease to be regarded as a European outpost and be identified within the Asian region.[1]

Respect for different cultural systems was also reflected at this time in Australia's changing perception of Aboriginal culture. Previously subjected to policies of assimilation, Aboriginal art was by the early seventies being encouraged, with initial help from the Crafts Council of Australia, to a program of development which acknowledged cultural expression and fostered community industry.[2]

Mingarri: The Little Olgas stands as an expression of interaction and interdisciplinary collaboration. It conveys a sense of place yet establishes links with other cultures and refers to the unique heritage of Aboriginal culture. It signifies both constancy and change – a context in which it is appropriate to examine the work of Marea Gazzard.

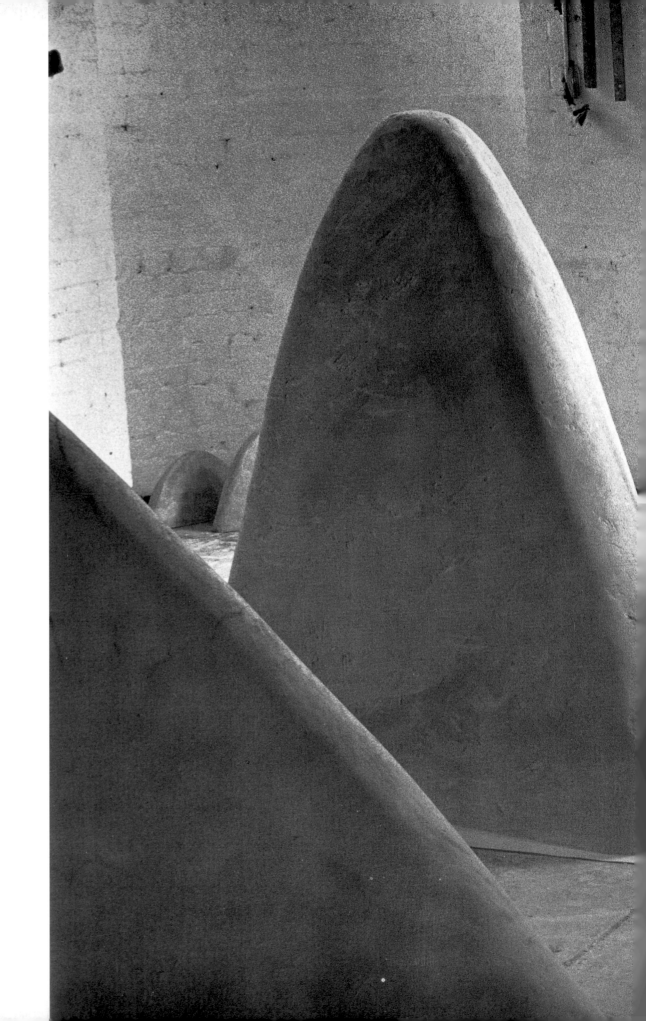

Marea Gazzard with clay models for Mingarri, 1985

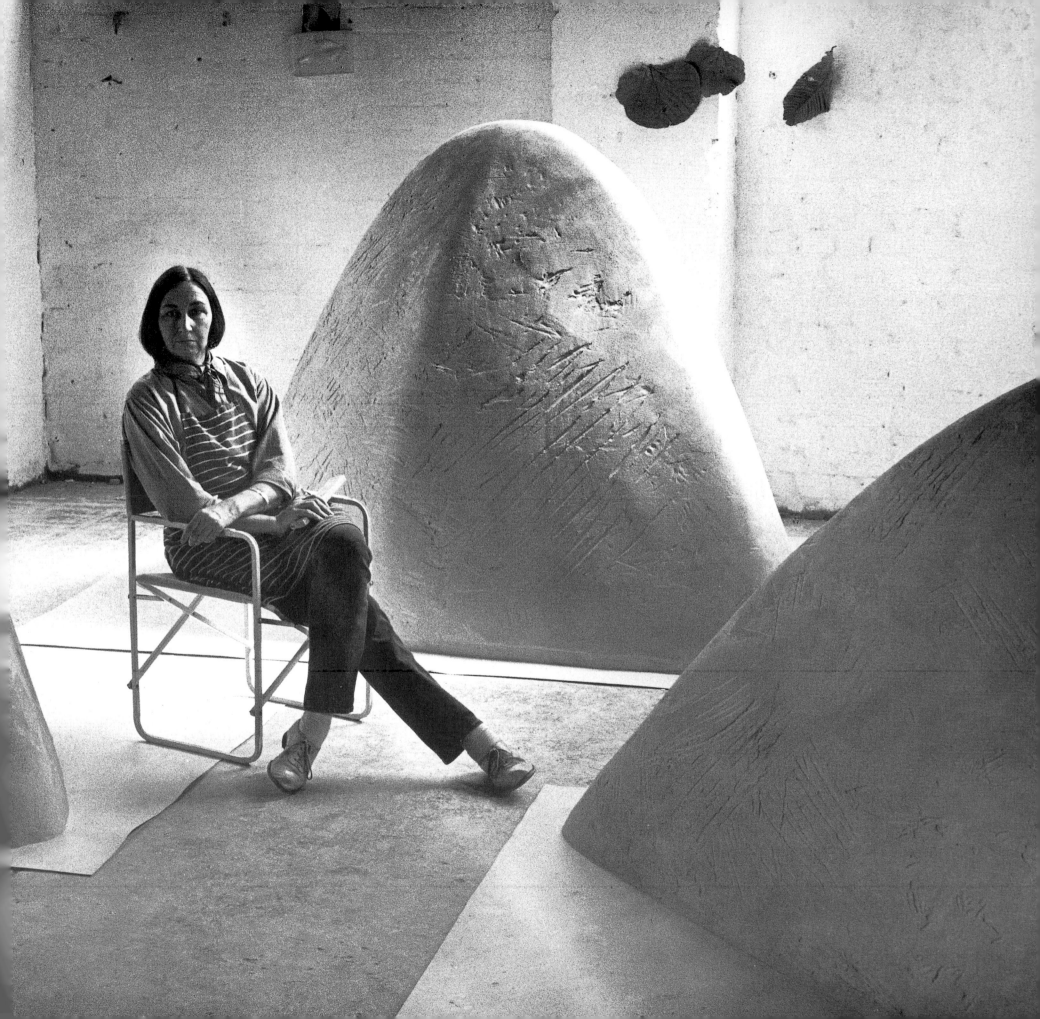

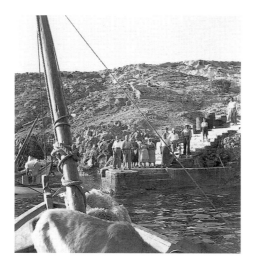

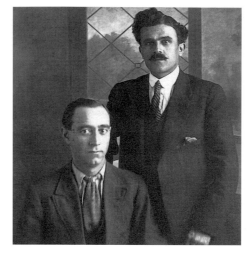

top left:
Relatives and friends on Andikythera
farewell the Gazzards, 1958

top right:
Harry Medis with friend in Australia, 1922

left:
Alexia, Harry and Marea in Brisbane, 1937

1. The Early Years

Marea Gazzard née Medis was born on 2 June 1928 at the Crown Street Hospital in Surry Hills, Sydney. Marea's father, Charalambus Ploumedis, had been born in 1894 on Andikythera, a small Greek island near Crete. His parents, Anna and George Ploumedis, had six children (George, Charalambus, Leo, Marea, Dimitri and Alexia), and the family had long been established on the island living a traditional life of grape- and olive-growing. As the island was not rich, it was customary for young men to leave and seek work elsewhere. When he was ten Charalambus went to work with an uncle in Athens and then at eighteen he was sent to fight in the 1912 war against Turkey. In 1920, sponsored by a Greek family, Freleagus, he emigrated to Brisbane, Australia. Here he worked to pay back his fare and then travelled to Tweed Heads, where he met Marea's mother, Christina Rudkin.

Like her future husband, Christina came from a hard-working rural background. One of ten children, she was born in 1898, the daughter of Mary Margaret[1] and John Henry Rudkin, who had a small farm at Berrico Creek via Barrington near Gloucester in New South Wales. The family was of English–Scottish descent and her father worked as a gold-miner. Christina's mother died giving birth to her tenth child, and the children were obliged to work hard on the farm as well as walking 10 kilometres to school each day. As soon as she was old enough, Christina left home to work in a domestic situation and then in 1921, when working at Tweed Heads, she met Charalambus Ploumedis.

After a three-year courtship the couple married in 1924. It was unusual at that time for a Greek to marry an Australian and in Greece it was regarded as shocking. Thirty years later when Gazzard visited the island of Andikythera her father's marriage to an Australian was still a talking point.

Both Charalambus and Christina were strong characters. Christina was a proud, independent woman who gave much of her time to community activities, and Gazzard recalls that her father always maintained distinctly Greek characteristics. Although her mother insisted he change his name from Charalambus Ploumedis to the more Anglicised Harry Medis, contact with the Greek side of the family was maintained by the sending of parcels, photographs and contributions to the dowries of the sisters-in-law. Greek was not spoken in the Medis household, but Marea and her sister Alexia were encouraged to learn the language at after-school classes. Occasionally they attended festivals in the Greek Orthodox church, and were enchanted by the singing and incense, which offered a rich contrast to the plainer service of the local Presbyterian church.

Before Marea's birth in 1928, Harry and Christina had moved to Surry Hills, Sydney, and two years after Marea, a second daughter, Alexia, was born. The family lived first in Crown Street, then in nearby Cooper Street. Christina and Harry were proud of their daughters and brought them up in a simple but structured way. They attended the Presbyterian church in Crown Street and in 1932 Gazzard began her schooling at the Riley Street Public School. After school she attended the Creative Leisure Movement for children in Devonshire Street. Surry Hills was fortunate in offering a cultural mix not very common in the thirties in a predominantly Anglo-Saxon country which had a White Australia Policy and showed little respect for its indigenous

21

people. During these early years Gazzard remembers a number of Chinese people, a Russian who rented the Medis' front room, and next door an Aboriginal family, the Humphries (the father, Dick Humphries, was an amateur boxer of some note). These early associations were probably important in nurturing Gazzard's keen awareness of other cultures and her ability to forge friendships across nationalistic boundaries.

The Depression years were difficult for both jobs and money but Gazzard states, 'Although we were poor I never felt poor'. Harry Medis was a fine cook and managed to produce nutritious, flavoursome Greek food. Food, says Gazzard, was the family's art form.

When her mother fell sick, and again when she herself contracted rheumatic fever, the young Marea was sent to a children's home. The family must have been emotionally secure for, apart from experiencing a normal feeling of loneliness, the young child was in no way upset; she knew it was for only a few weeks and took both events in her stride. Gazzard was not a particularly strong child and was prone to frequent bouts of bronchitis. In 1935 her parents decided that her health might improve in a warmer climate and moved to Brisbane, where they eventually found a flat in Cordelia Street, South Brisbane, and Harry Medis obtained work as a chef for the railways.

Both Marea and Alexia attended South Brisbane Public School. On Sundays they went to the Presbyterian church, and several days after school to Greek School, where they learned classical Greek. The writer Barbara Blackman, who was at school with the sisters, recalls that the other children found this exotic and would wait outside for their friends to finish classes.[2] About fifteen children attended this school but as few spoke Greek outside the class the teaching was not reinforced and the two girls learned little.

As the family prospered it moved to an old Queenslander house at 16 Spring Street, Westend, and the girls attended Westend Public School. Marea was not a particularly scholastic or athletic child. Like dozens of other Australian children, she slid down hills on cardboard, had a swing under the house, started a secret club, went to movie matinées, climbed a frangipanni tree in the garden and went on special 'dressed-up' outings to town.

In 1938 Harry Medis obtained work in the Railway Refreshments Rooms at Coffs Harbour. This was to be a turning-point in Gazzard's life. Here the family found a big house with a verandah overlooking the ocean. There was swimming before and after school, freedom and an intense relationship with nature. Between the ages of eleven and fifteen she became aware of the spiritual solace to be found in wilderness, alone with the waves, watching light on the rocks, exploring the secrets of a rockpool, the fine textures of driftwood. It was this, more than any encounter with art, which was to develop her finely honed aesthetic.

The war in Europe was a distant reality, but one event which did have a direct influence on Gazzard was the arrival in Coffs Harbour of twelve-year-old Rina Landau. Rina's mother had died in Italy, her father was in Israel and so the child, under the guardianship of her aunt and uncle, was a refugee, one of many to flee to Australia during this period. Marea responded to the difference of this family: their interest in books, the Landaus' collection of paintings and their Europeanness provided the different perspective of another culture. Rina and Marea became life-long friends.

At school, art had no relevance for the young adolescent. When her homework needed any illustration or map-drawing, Marea would generally persuade her mother to do it, as she had no confidence in her own ability.

Living at Coffs Harbour was to change Marea's response to the Australian landscape. Previously she had looked through train windows and perceived as bleak and alienating the expanses of ring-barked trees and wire fences. Now as a result of her more direct contact she found inspiration in the giant trees, rocks and landscape of the area. Years later Rina Landau was to remark to Gazzard that the forms of her sculpture in Parliament House, Canberra, had an affinity with Mutton Bird Island off the coast of Coffs Harbour.[3]

Although Marea thrived on the gentle life at Coffs Harbour, her mother had always loved Sydney and longed to return there. In 1942 the family moved back to the inner-city suburb of Camperdown. Alexia, who was the more academic of the two girls, attended Fort Street Girls' High School and Marea attended the Burwood Central Domestic Science School. Here, art was taught in a way that Marea found difficult and uninteresting. More significant were the school excursions to the ballet or to concerts at the Sydney Town Hall or the Conservatorium. These aroused an interest in serious music which was sustained by radio music programs on the ABC.

The following year, aged fifteen-and-a-half, Gazzard took her first job: at the Department of Motor Transport, where she spent most of her time filing applications for liquid fuel, which was severely rationed during the war years. The Presbyterian church in Crown Street, which they had attended before moving to Brisbane, again became a focal point in the family's life. Marea taught in the Sunday School, helped organise social dances for servicemen in the local hall, and after work did voluntary service in an Army mess temporarily established in Hyde Park to feed hungry soldiers. Many of her friends had American soldier boyfriends but Marea was allowed out only on group outings.

After the war she worked as an office assistant at Luton Millinery. Her employers, the Kohanes, were Viennese; kind, sophisticated people who took an interest in the young girl and in her desire to further her education. With their encouragement she began night classes first at the Metropolitan Business College, then at the Ultimo Technical College. Here she met many interesting people, including the journalist Margaret Lindsay-Thompson. About the same time she was introduced to the lawyer Maurice Buckley who offered her a job in the legal firm T. W. Garrett, Christie and Buckley, which she took. Like the Kohanes, Buckley was impressed by the young girl's determination and suggested she join the Penguin Club of Australia, a women's public-speaking organisation which encouraged women to formulate and deliver ideas with clarity. This training later stood Gazzard in great stead as she addressed vast audiences at World Crafts Council conferences.

In 1949 at a Sydney University Film Festival, Margaret Lindsay-Thompson and her future husband, Peter Makeig, introduced Marea to a young engineering student, Donald Gazzard. In September the following year Marea and Donald were married at the Methodist church in William Street, Darlinghurst. The minister who officiated at the service, Bill Hobbin, also ran the Methodist Church Social Service Department, and he was so impressed by Marea Gazzard he offered her

employment. This work was more challenging than that of a legal secretary and for the next three years she assisted Hobbin in the Children's Court, finding jobs for men who had been in jail and organising the 1953 UNICEF (United Nations International Children's Emergency Fund) appeal. Hobbin's ideas were enlightened and attracted much attention in both Australia and overseas. Through this work Gazzard got to know the social worker Richard Hauser and the pianist Hephzibah Menuhin, both of whom showed great interest in the achievements of the department. Hobbin wrote in a reference for Marea, '[she] was employed at a time when social work required a great deal of original planning and organisation and in both these aspects she played an active part and revealed outstanding ability'.[4]

Sydney in the early fifties was in the grip of Menzies' conservatism. Family life, a steady job (for men) and eventual home ownership were the values promoted. A strong emphasis was placed on conformity, and migrants were expected to assimilate into the 'Australian way of life', which was centred on the suburban house, family car and weekend outings. Cold War propaganda determined that this 'way of life' should be protected from the threat of communism.[5] In 1949 when the future Prime Minister Robert Menzies stood for office, a part of his platform had been the introduction of an Anti-Communist Bill. In 1950, within a few months of being elected, he duly introduced a bill into the House of Representatives outlawing the Communist Party. This naturally was opposed by those interested in civil and intellectual freedom, particularly in the universities.[6]

During the first year of their marriage, the Gazzards became actively involved in student action to overthrow the bill. Living at 98 Cathedral Street,

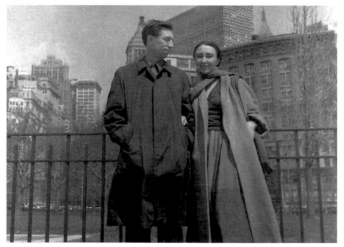

top:
Marea at Mycenae, 1958

above:
Donald and Marea in New York, April 1959

Woolloomooloo, they kept pamphlets under the bed and would work through distribution tactics with Jim Staples, Lillian Roxon, George Clarke and other student activists. This was a risky business; in Melbourne students were arrested for similar activities.[7] There was a great deal of general hysteria against communism, and Marea's sister, Alexia, recalls that the Gazzards' landlord even objected to their red front door.[8]

Amidst the oppression and conservatism of Sydney were many who expressed a great desire for change. The war had resulted in disillusionment with old values, and for some the teaching of John Anderson, Professor of Philosophy at Sydney University, became increasingly influential. 'Andersonism', which emphasised individuality and encouraged the questioning of social values, gained currency among groups both in and outside the university. The Gazzards were amongst those who sat on the steps of the Mitchell Library, drank endless coffee at the Lincoln Café, frequented Colonel Sheppard's bookshop, went to Push parties and drank Fiorelli wine. These were idealistic times when much of the conversation was philosophical, and discussions often lasted until the early hours of the morning.

There was a strong belief in progress and for some a growing conviction that the concepts of modernism could offer a new way of life. In 1939 the catalogue foreword for the abstract exhibition 'Exhibition I' had stated that 'modern painters were abandoning the representation of objects in order to establish a new realm of existence'.[9] Since the war a more intimate romanticism had dominated Sydney art, and although non-objective artists continued to exhibit, it was in architecture and design that modernist principles received most recognition. The Gazzards occasionally attended openings at the Macquarie Galleries but found little of interest.

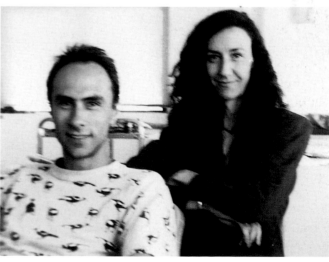

top:
Christina Medis with grandson Nicholas Gazzard at Berrico Creek, 1961

above:
Nicholas and Clea Gazzard at the Redfern studio, 1991

More pertinent was the arrival of a young architect, Harry Seidler. Seidler had been born in Vienna, graduated in Canada and spent a year at Harvard University as a post-graduate student under Walter Gropius, former head of the Bauhaus. He had also attended Josef Albers Summer School at Black Mountain and worked as chief assistant to Marcel Breuer in his New York office.[10] Seidler, who became friends with the Makeigs and the Gazzards, had come to Australia in 1948 to design a house for his parents. Rose Seidler House incorporated principles of Breuer and Le Corbusier, linking architecture, art and interior design. The sculptural form of the building, imported contemporary furniture and the drawing by Albers were exciting and controversial to Sydney audiences.[11]

Before his marriage Donald Gazzard had shared a house with architecture students Wally Abraham and Peter Makeig. In this company, he found he was much more attracted to the idea of studying architecture than engineering. He was intrigued by Seidler's holistic design theory so in 1951, when Seidler offered him a job, he abandoned his engineering studies, joined the Seidler office and sat the Board of Architecture examinations. Gazzard remembers many gatherings at the Seidler house when they, the Makeigs and others discussed modern architecture and design in utopian terms. These were exhilarating years characterised by a belief in social, creative and intellectual unity.

A feeling of internationalism was growing as an increasing number of European émigrés introduced different cultures to Australia. The Savoy Theatre showed European films, expanding the previous diet of Hollywood and British film. Robin Boyd gave slide shows of contemporary American architecture in the old Adyar Hall in Bligh Street, and Peter Makeig reproduced contemporary European

furniture such as the DCM plywood chair.[12] In 1954 Gropius visited Australia, lecturing at Sydney University, and the Gazzards were among those invited to a party in his honour at Rose Seidler House.

Marea Gazzard was particularly receptive to the spatial concepts of modern design and architecture. Influenced by her parents and her own response to nature, she also placed a strong emphasis on both the individual and the elemental.

Her aesthetic response was perhaps best expressed by the Italian journal *Domus*. As no art journals were being produced in Australia during the fifties, overseas publications, although scarce, were highly influential. *Domus*, edited by the Italian designer Gio Ponti, presented 'form' in architecture, sculpture and artefacts by means of high-quality photographs. Ponti's publication crossed national and time boundaries so it was possible to find Henry Moore presented alongside a T'ang terracotta from the British Museum. Ponti was also an advocate of organic modernism as practised by Alvar Aalto, which later influenced Gazzard. And through these early *Domus* journals she became interested in the work of artists such as Moore, Lucio Fontana, Reg Butler and Kenneth Armitage.[13]

The energy which Gazzard put into her social welfare job was indicative of her continuing concern for the outsider, but as she grew older she realised that to be effective she must also take responsibility for her own development. Donald was studying so in 1953 she decided to attend night classes in dress design at the National Art School at East Sydney Technical College. This decision was probably influenced by two facts. Dress design in the early fifties was relentlessly innovative and exciting, and close to Marea Gazzard's workplace in William

Street, Sydney, were the showrooms of designer Hani Wilson. Hani's vibrant personality and designs attracted many creative people. At this time the writer Faith Bandler was working with Hani, and Gazzard would often call in, intrigued by the atmosphere and the clothes, which had great verve and flew in the face of Sydney conservatism.

When she arrived at the National Art School the head of department, Phyllis Shillito, informed Gazzard that the dress design course was fully booked and suggested she enrol in pottery. With little interest in the subject, Gazzard began attending classes. Within six months she was fascinated and had begun to read about pots and pottery; at the end of the year she left her job to study full-time.

Peter Rushforth, who ran the department, had trained at the Royal Melbourne Institute of Technology under Jack Knight and Jeff Wilkinson. His appointment in 1951 was the first full-time appointment in ceramics in New South Wales.[14] As Rushforth says, 'the department was in a very embryonic state with very little equipment and no high temperature kilns'.[15] For some this was disappointing, as during the early fifties the work that most interested both students and teachers at the East Sydney Technical College was the stoneware of the English potter Bernard Leach.

Leach had trained in Japan and identified with the artistic life of that country, sharing a belief in the value of crafts not only as a means of artistic expression but as a way of life and spiritual antidote to the materialism of mass production. On his return to England he and his assistant, Shoji Hamada, established a pottery making raku and stoneware, before becoming interested in English traditions involving combed and trailed slipwares.

Hamada later returned to Japan, taking these techniques with him and establishing Leach as one of the few potters to contribute to oriental ceramic knowledge.[16] In 1940 Leach's *A Potter's Book* was published. This book discussed both his technical and philosophical approach and gave his ideas wide currency. Gazzard acquired Leach's book and was impressed not only by his philosophy but by the directness of his work which was in marked contrast to some of the more decorative earthenware potters of the period.[17]

What the department lacked in equipment it made up for in enthusiasm. Both Peter Rushforth and Mollie Douglas were dedicated teachers. Rushforth, whose own work followed the Leach tradition, encouraged his students to adopt a straightforward approach rather than any technical cleverness. He liked them to concentrate on making functional pots as a means of acquiring technique, discipline and control. He encouraged them to use natural materials and, in throwing, to work towards unity, spontaneity and simplicity of form.[18] This was to prove a good beginning not only for Gazzard but for fellow students Col Levy, Peter Travis, Les Blakebrough and Bernard Sahm.

Recollections of this period differ; Gazzard says that she was an average student who showed no signs of being exceptional, while Rushforth remembers her as 'one of a number of bright students'. He comments that even at this early stage her work often exhibited a sculptural quality.[19] In retrospect, it would seem that these years were important to Gazzard in that she acquired a philosophical understanding of pottery and developed a serious and dedicated approach to her work. She received a good grounding in technique and, most importantly, developed a strong feeling for the substance of clay.

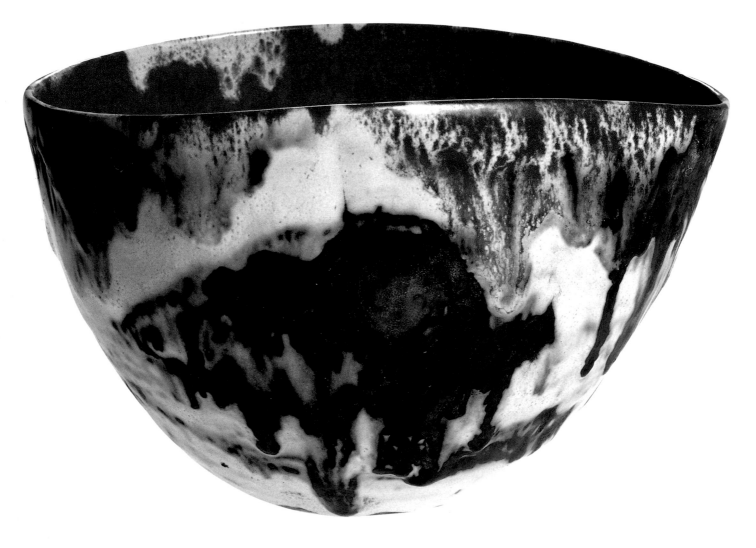

1. BOWL 1958
earthenware, oxide glazes,
wheelthrown
13.5 x 21.5 x 17.5
photograph Paul Green

2. Discovering Form

Feelings of isolation from the rest of the world have long plagued Australians and, like many others, the Gazzards had a strong desire to become acquainted with different cultures and to see the great art and architecture which they had experienced only in reproduction. So in February 1955 they sailed for Europe on the Italian ship *Toscana*. It was a six-week trip, during which they formed a friendship with the ship's doctor, Manlio Crescentine. Crescentine was interested in art and architecture and was able to give the Gazzards much advice on important collections and buildings in Italy. The collection which made the most impact on Marea Gazzard and that began a life-long interest in museums was that of Etruscan art at the Villa Giulia, Rome.

With a Lambretta motor scooter and a pup tent, the couple worked their way through Italy, visiting Venice, Verona, Perugia, Milan and Genoa. They then proceeded to Yugoslavia, but in Mostar their bike broke down, so instead of continuing to Greece as planned they returned to Italy and France. They soaked up the joys of Renaissance palaces, baroque fountains and hill-top towns, and as well made special pilgrimages to visit the Olivetti building in Milan, the Rome Railway Station and Le Corbusier's Unité d'Habitation in Marseilles. To students of modernism all of these buildings were enormously exciting, but in the fifties it was the Unité d'Habitation which symbolised the social idealism of contemporary architecture. Housing 1,600 people in self-contained duplex units with their own shops, library, roof-top kindergarten and parkland setting it was (if somewhat misguidedly) regarded as utopian.

As soon as their money ran out the Gazzards headed for London and jobs. After months of camping, Lambrettas and wet weather, it was a pleasure to experience the comfort of staying with friends. Marea applied for a job advertised in the *New Statesman* and within a week was working in the Edgeware Road with a legal firm, Wegg-Prosser & Co. Wegg-Prosser was standing as a Labour Member of Parliament, which made Gazzard's job more demanding but also meant she met a cross-section of English people. By the second week the Gazzards had a basement flat in 18a Parliament Hill, Hampstead.

Hampstead is an area with long-standing literary and artistic associations.[1] Gazzard enjoyed the bohemian atmosphere of the village, its bookshops, cafés, street markets and, in particular, the walk across Hampstead Heath to Kenwood House. Kenwood House, remodelled by Robert Adam in the late seventeenth century, has a library of outstanding spatial design, and it is also home to the Iveagh Bequest – arguably the finest small collection of art in Britain. The house affords an intimate relationship with its art works, and Gazzard would return frequently to study the works of Gainsborough, Vermeer and Rembrandt.

The Gazzards painted the flat on Parliament Hill in bright primary colours, and it was often filled with architects or visiting Australians. Donald had begun work with the London County Council in their public housing scheme and in 1956, when Harry Seidler and the Sydney engineer Peter Miller visited, Marea was to write to her mother, 'I had ten architects to dinner one night and fifteen the next'.[2] There would be slides and excited comparisons of the things they had seen; Gropius, Breuer, Le Corbusier and Niemeyer were the heroes.

Her appreciation of modernist principles soon led

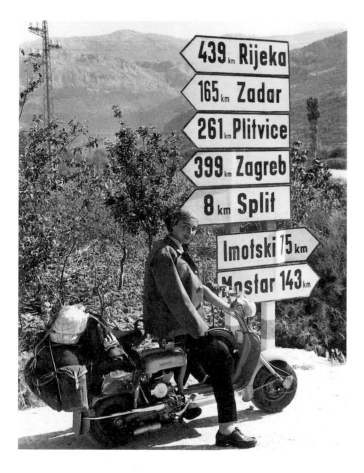

Gazzard to make contact with the potter Lucie Rie, a move that was to be the start of an important friendship. Gazzard had first noticed Rie's work in an architectural magazine when she was a student in Sydney. She remembers an immediate recognition of form and spatial purity; 'It was work', she says, 'which took my breath away'.[3] Shortly after arriving in London, her determination to see more of this work prompted her to phone Rie and ask if she might visit her and her associate, Hans Coper. Years later she recalled:

My first visit to their studio remains indelibly in my memory. I felt I was in the presence of very special artists. We talked little that first time. I mostly looked. I was invited back and this was the beginning of a long friendship.[4]

Rie had been born in Vienna, where she trained under the potter Michael Powolny. In 1938 she fled the Nazis and arrived in London where she

survived the war years as an air raid warden and button-maker, before setting up a studio to concentrate on her own work.[5] Since the seventies her lightly and finely thrown vessels have been acknowledged as having founded an alternative tradition in English contemporary ceramics, although in the fifties Bernard Leach was the dominant influence on most potters.

Rie, like Gazzard, was conscious of modern architecture. In Vienna, her father, a medical doctor, had used the design of Eduard Wimmer in the interior of his surgery and reception rooms. Wimmer was included in the circle of architect Josef Hoffmann, and his designs had a mood of purity as well as ethical and aesthetic value. Rie also studied at the School of Arts and Crafts in Vienna, where Hoffmann was a professor. Later, her close friendship with architect Ernst Plischke, who had worked with Peter Behrens, increased her understanding of modernist principles.[6]

This common background did not result in stylistic similarities in the work of Rie and Gazzard. Neither artist works from a theoretical basis; their response to their work is intuitive and individual. What they do share, however, is an almost ethical belief in modernism's search for form and simplicity as a means of expressing mood and meaning. It was this shared attitude, the quest for excellence and mutual respect for individual goals, which formed the foundation of their sustained friendship.

Rie's studio house at Albion Mews was not far from Gazzard's workplace at Wegg-Prosser. In her lunch-hour Gazzard could walk to the small mews house and observe the activity in the downstairs pottery workshop fitted with its electric kiln and display shelves. Later she would enter through the high narrow door of Rie's tree-top sitting room,

furnished simply in light-coloured wood designed by Ernst Plischke in 1930.[7] Here she would have coffee and talk with Rie and the charismatic Hans Coper.

Coper, like Rie, had fled to England to escape the Nazis. Coper's pots are functional but present a strong sculptural presence. As his biographer, Tony Birks, has stated, 'If he influences others it is in directing the modern potter towards a concept in pottery which is ancient in origin, but new in our time: fusing the functional with the cultural and symbolic'.[8] Coper identified with the anonymous potters of the past who saw no separation between form and decoration and with certain twentieth-century artists such as Brancusi and Giacometti, whose work he perceived as the result of a compulsion to get closer to a basic truth.[9]

Gazzard's great affection for Rie and Coper was important, as their work confirmed much of her own thinking. Their attitudes and dedication helped direct her ideas in these early years.

Gazzard was anxious to study at the London Central School of Arts and Crafts, where there were limited places for experienced students. Australian qualifications were not widely known and she literally had to talk her way into the part-time course before commencing the two year full-time course in 1956.

The Central School was a lively place in the late fifties. The pottery department under Gilbert Harding-Green and Dora Billington provided a thorough, traditional grounding with a high standard of craftsmanship, but its great strength lay in the courses taught by visiting artists. Ceramics were represented by Nicholas Vergette and Kenneth Clark, drawing was taught by

William Turnbull, sculpture by Eduardo Paolozzi and history of architecture by Reyner Banham.

These were interesting teachers at an interesting time. Both Paolozzi and Banham were involved in the Independent Group and its investigation of urban popular culture, while 1956 was the year of the Whitechapel Art Gallery exhibition, 'This is Tomorrow', where Richard Hamilton's painting *Just What Is It That Makes Today's Homes So Different, So Appealing?* 1956 was to announce the arrival of pop art in Britain.[10] Although pop art and Banham's theories of brutalist architecture appear to have had little influence on the pottery department, the interaction of ideas brought about a realisation of shared values and approaches between different disciplines.

Paolozzi sought unity in his assemblages, and Turnbull, Gazzard recalls, taught her to see 'the whole', not the parts.[11] A problem with colour could be sorted out with Nicholas Vergette, or one with moulds with Kenneth Clark (the potter). It was a system which encouraged the development of individual sensibility, the students gaining confidence in their own perceptions yet free to seek appropriate guidance in their realisation.

As in most schools, the students learned as much from each other as from their teachers. Since the school took only experienced students, the majority were in their mid-twenties and highly motivated to learn as much as possible. The students represented over fourteen nationalities from countries as diverse as Israel, Sudan, India and Jamaica, and there was a variety of approach and experience. Through fellow student Ruth Duckworth,[12] who had originally trained as a sculptor, Gazzard first became interested in handbuilding. Handbuilding was a liberating experience which gave direct

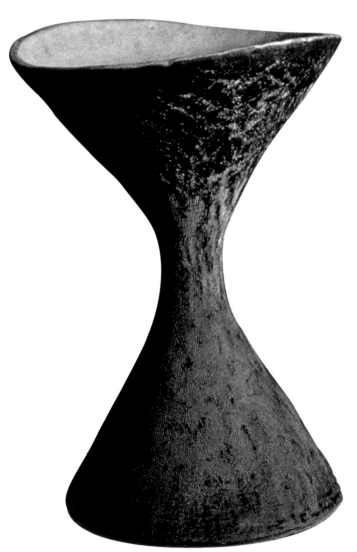

contact with the object and allowed far greater expression of her ideas on form than had wheel-throwing. It is interesting that from this generation of students, Gazzard, Duckworth, Gillian Lowndes and Gordon Baldwin have all emerged as 'form potters'.[13]

During her time at the Central School Gazzard began to feel positive about her work. She comments:

I can remember one morning I had a marvellous feeling about work and started to throw lots of shapes which I knew were good. A few people made comments at the time, but I felt this was just the beginning.[14]

Unfortunately little remains of Gazzard's work at the Central School. It would appear that there was the customary student involvement of working through various techniques and influences. One richly glazed bowl, *Bowl* 1958 (ill.1) shows the influence of Rie in its fine elliptical form. There are other more organic shapes, and a photograph of a large handbuilt waisted *Planter* 1958 (ill.2), which reveals something of her future work in its slight asymmetry, unglazed textured exterior and sculptural form. Gazzard's work was well received at the Central School. In 1957 her teacher, Nicholas Vergette, invited her to share a commission to make a number of ashtrays for a large hotel in Bermuda. Gazzard was to make the forms and Vergette would do the glazes and decoration. Vergette had trained as a painter at the Chelsea Art School and is often attributed with bringing a new look to British pottery. Inspired by Picasso's post-war approach to ceramics, Vergette believed that ceramics should not be anchored to a particular ideology but should embrace the contemporary scene within the context of a broader shift in aesthetics.[15]

left:
2. PLANTER 1958
stoneware, applied oxides, handbuilt
76.0 x 50.0 x 48.5
photograph Donald Gazzard

opposite:
3. CONTAINERS 1959
earthenware, applied oxides, handbuilt
left: 54.0 x 28.2 x 6.3
right: 59.0 x 18.5 x 12.0
photograph Donald Gazzard

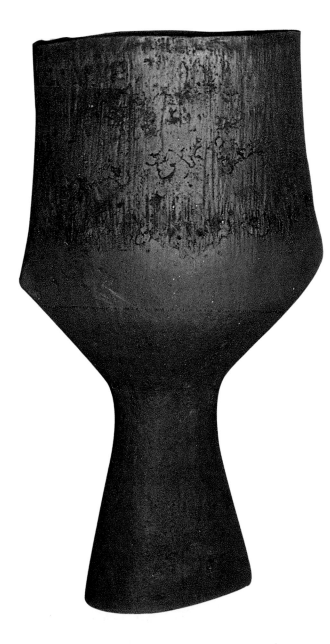
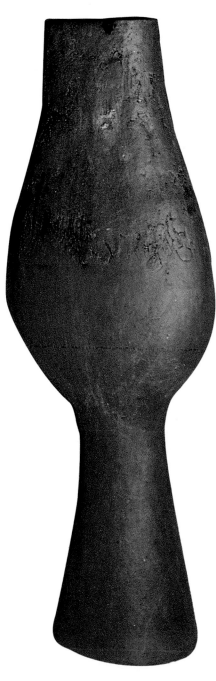

The opportunity to work on a professional basis with Vergette was valuable in terms of experience and gaining confidence, but as in most student– teacher collaborations the student anticipates the teacher input, and Vergette's decoration tends to dominate the forms. Vergette was one of the important influences on Gazzard's work but, like Rie, it was his thinking rather than his work which was important to her.

Close to the Central School was the British Museum. The collections there proved to be a source of constant enjoyment and inspiration for Gazzard. She still vividly recalls the great Egyptian pots, works from the Greek geometric period and, in particular, the Cycladic collection which became and has continued to be one of her most powerful aesthetic influences.

In 1913 Clive Bell, the English art critic, had introduced the notion of 'significant form' to English art audiences. It was this which resulted in many of his readers looking again at the non-English section of museums and seeing them as works of art rather than relics. Gazzard had never heard of Bell, and had little interest in art theory. Her sense of form came from a childhood which had no pretensions about art. At Coffs Harbour she had responded to the form of rockpools, headlands and driftwood. When the family moved to Sydney the same intuition resulted in her seeing the Annandale stormwater channel as an exotic creek, at times flat and linear, at other times bubbling with volumetric mass.[16] Later her association with design and architecture and journals such as *Domus* alerted her to the fact that form could be found in a building, chair, basket or pre-Columbian figure.

The British Museum was not the only collection that attracted Gazzard. At the Victoria and Albert

Museum her attention was often focused on costume – the shoulders of a cope, a headdress, all were important. Her selection of forms depends on an intuitive response rather than any systemised approach to her work. Gazzard fills countless sketchbooks with the forms that interest her. In a sense these are exercises in form, as it is rare to see a Gazzard work which mimics a museum object. The sketchbooks provide a commentary on Gazzard's thinking. They are storehouses of forms, some of which are never used, others developed and repeatedly reworked, while some may act as a stimulus to a new series of work perhaps even years after they first enter her consciousness. Whatever the outcome, this initial experience of studying the rich collections in London's museums, whether a work by Piero della Francesca at the National Gallery or a Cycladic figure at the British Museum, was formative to Gazzard's later approach and development.

In art school holidays she would take temporary jobs in various parts of London to increase her knowledge of the city. When there were sufficient funds the Gazzards would visit Europe: Barcelona for an exhibition of Gaudi furniture; Amsterdam for museums and early modern architecture; Paris for the UNESCO building and the famous artists' ball. These trips gave them an understanding and appreciation of the past but were also oriented towards the most contemporaneous.

In 1958 the Gazzards decided they would like to see something of North America. The easiest way of doing this was to emigrate to Canada, where work was available. Before leaving they planned to spend about nine months in Europe, particularly in Italy and Greece.

Having learnt the pitfalls of motor scooters and bad weather, they set off in a small van, motoring through France and visiting Le Corbusier's Chapel of Notre Dame du Haut at Ronchamp. In Italy they visited the studios of designer Ettore Sottsass and of ceramists Fausto Melloti and Guido Gambone. The design-conscious modernism emerging from these studios contrasted greatly with the work from the studios of Bernard Leach and Harry Davis, which Gazzard had visited in Britain.[17] The Italian ceramists did much to confirm her belief that pottery should move into the broader shift of modernism. Running parallel to this thinking was her great fascination with the Etruscan sculpture at the Villa Giulia, in Rome. A letter to her mother records:

The sculpture fascinates me – small bronze figures from 3"–3' high. I think I will be doing sculpture soon as my pottery becomes more and more sculpture-like.[18]

This interest was further intensified when the Gazzards arrived in Athens. Visiting Greece had been one of Marea's keenest wishes but because she was well acquainted with the Greek art in the British Museum she had not anticipated she would react so strongly to the pots, sculpture and archaeology of the country. In particular, the experience of seeing a rich and extensive collection of Cycladic art in its original context was to have a potent effect on her thinking and her work. On a return visit in the seventies she wrote:

I think the attendant thought I would like to steal the Cycladic sculpture. He was quite right! I have not felt so emotionally involved in sculpture for a long time, it makes everything else (in art) meaningless.[19]

In Athens the couple stayed with Marea's aunt Alexia and there was a feeling of 'coming home' both in terms of family and the culture. In London

Marea had attended night classes in an attempt to learn Greek but her command of the language was limited. In spite of this, there was a bond and great warmth between her and other members of the family. From Athens they went by boat to the small, thinly soiled and rocky island of Andikythera where her family had originated. Her relatives gave an unrestrained welcome to the Gazzards. Farming methods and customs on the island, which supported about four major families, had changed little since biblical times, but photography linked the family members who had remained on the island with those who had left. Gazzard recalls that it was extraordinary to find photographs of her and her sister on the mantelpieces of people she had not met, on this tiny Greek island where so little else had been touched by technology.[20]

One aspect of island life that particularly impressed Gazzard was the long tradition of craft. The girls wove the cloth for their own clothes, while sheets, pillowslips, rugs, and bedspreads intended for dowries were handspun and handwoven. This experience in Greece was to increase Gazzard's consciousness of craft, not only in terms of self-sufficiency but as an example of the value of tradition and common purpose within society.

The family was enormously proud of its visitors and a genuine warmth overcame language barriers. Gazzard felt a sense of identity and pride as she wrote to her father commenting on the beauty of the place, the people and their craft.[21] It was an important experience and one which led to an understanding of the vitality and integrity which exists within small regional cultures.

On their return to London, Gazzard sold nearly all the work she had undertaken in England to Heals, the first post-war shop in London to specialise in 'good design' and art objects.[22] Although she kept only one or two pieces of her own work from this period she collected a number of works from other good potters, including Harry Davis and Lucie Rie, which she was to take with her to Canada.

The Gazzards had anticipated that Canada would seem isolated and provincial after London. Arriving in Montreal they were surprised to find a stimulating environment. Donald Gazzard had work designing a shopping centre near McGill University; there were film groups, a potters' club and a number of interesting people. One of these was the potter Virginia McClure, who had a large studio space which she offered to share with Gazzard and the jeweller Alexandra Solowij-Watkins. Gazzard also managed to obtain part-time employment teaching at the potters' club as well as working for the Jewish Welfare Society and the Salvation Army.

This period in Canada was important as it was the first time Gazzard had worked alone without the security of teachers. It forced her to be accountable for her own ideas and their execution. This was demanding but essential, and in this period she began seriously to develop her own ideas and work.

Working in Canada had some practical inconveniences. The kiln she was using would heat only to earthenware temperature, and as the earth was frozen for eight months of the year it was difficult to obtain clay. There was not a sufficient number of potters in Canada to make a commercial supply viable and all deliveries of clay had to be organised through the United States.

Surprisingly, the Gazzards found they were still in contact with a number of old friends. The Vergettes

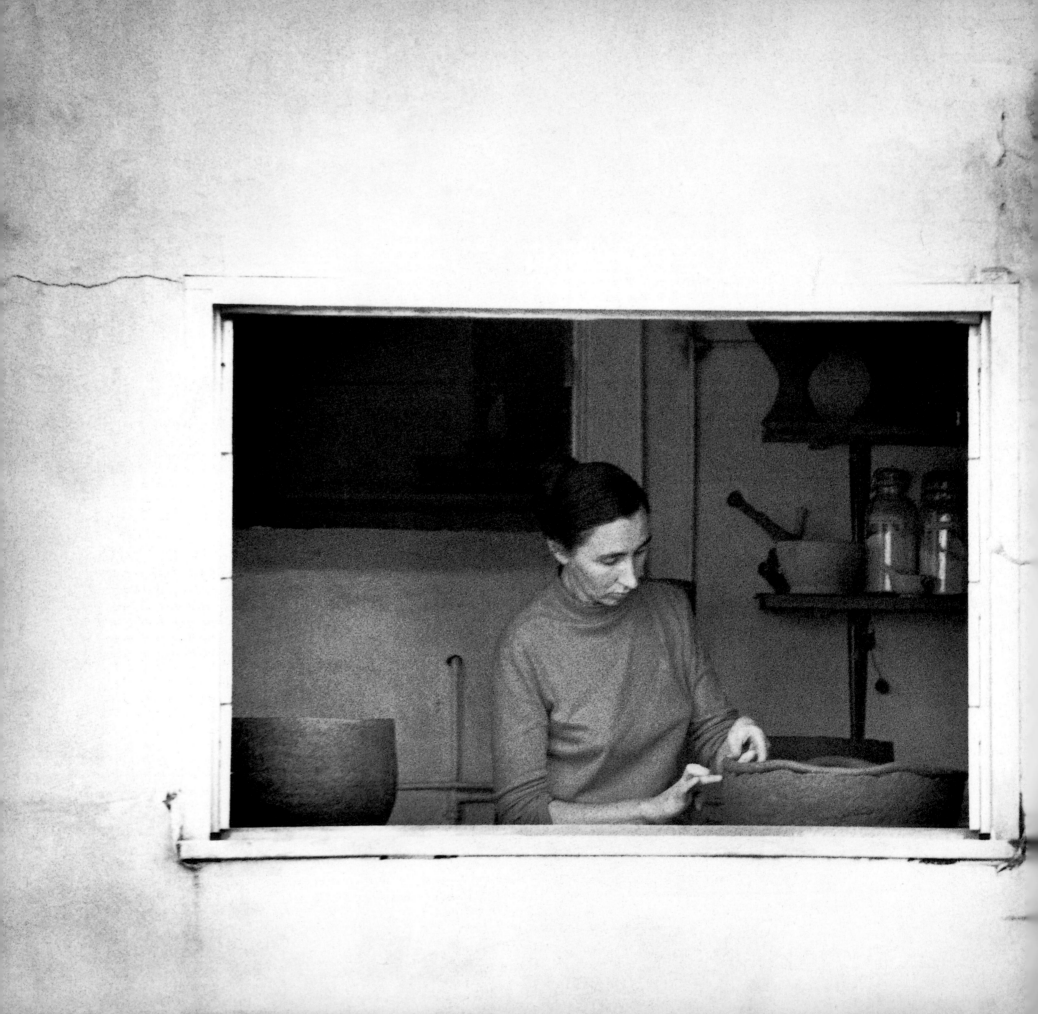

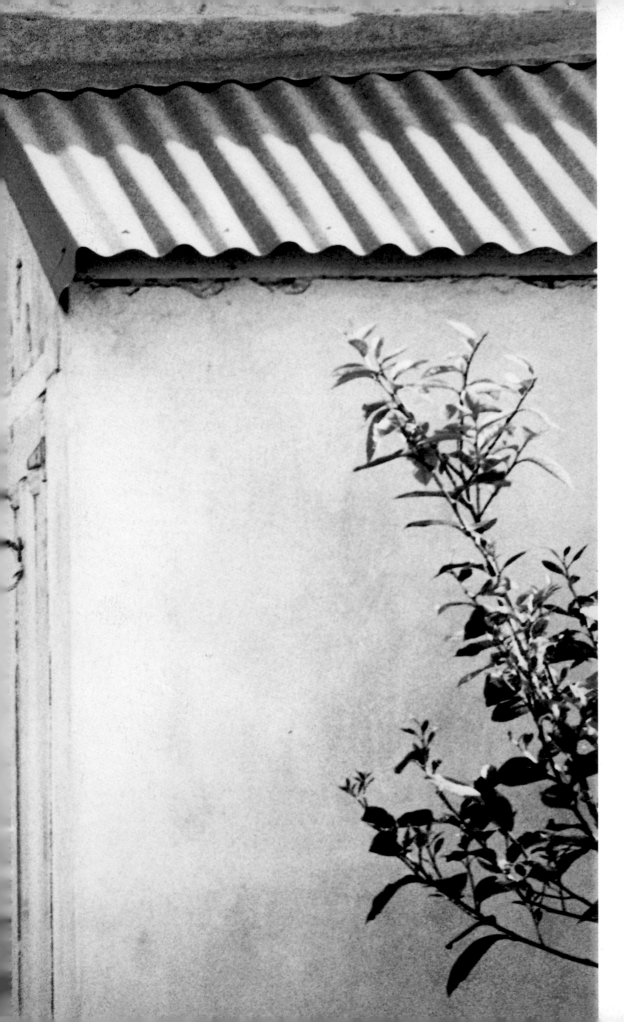

were at Rochester University where Nicholas
Vergette was teaching at the School for American
Craftsmen, and several students from the Central
School visited Canada. There were also trips to
New York to see art and architecture: the Museum
of Modern Art; the Whitney Museum of American
Art; the newly opened Seagram building by Mies
van der Rohe, and in 1959 Frank Lloyd Wright's
Guggenheim Museum. Gazzard's first commission
in Canada was to come from an architect who
required chimney pots for a house in Knowlton.
This was an excellent opportunity to handcoil
large pieces and produce work which was not an
itemised domestic object but part of an architec-
tural whole. In a newspaper interview given at this
time, Gazzard stated her preference for large-scale
work and suggested there could be much more
architectural application of imaginative form.[23]
The size of these works necessitated firing in a
brick kiln and Gazzard recalls that they were so
big by the time she had finished coiling the top,
grass seeds were growing out of the bottom.[24]

In 1960 her first solo exhibition, at the Westmount
Gallery, Montreal, displayed work on a more
domestic scale. Here, for the first and last time,
she exhibited cups and saucers in the form of an
elegant white coffee service in the Leach tradition.
A small white vase has a simple elegance and clarity
of outline, reflecting the influence of the Italian
moderns, but the larger handbuilt vases, *Containers*
1959 (ill.3), were more indicative of her future
direction. These were functional and have a strong
sculptural presence. Rising from cylindrical bases,
their pillowed and flattened forms make reference to
Cycladic and Minoan pottery, while their unglazed
and rubbed surfaces display the elemental quality
that was to characterise her later work. With these
works Gazzard made her first statement of artistic
independence.

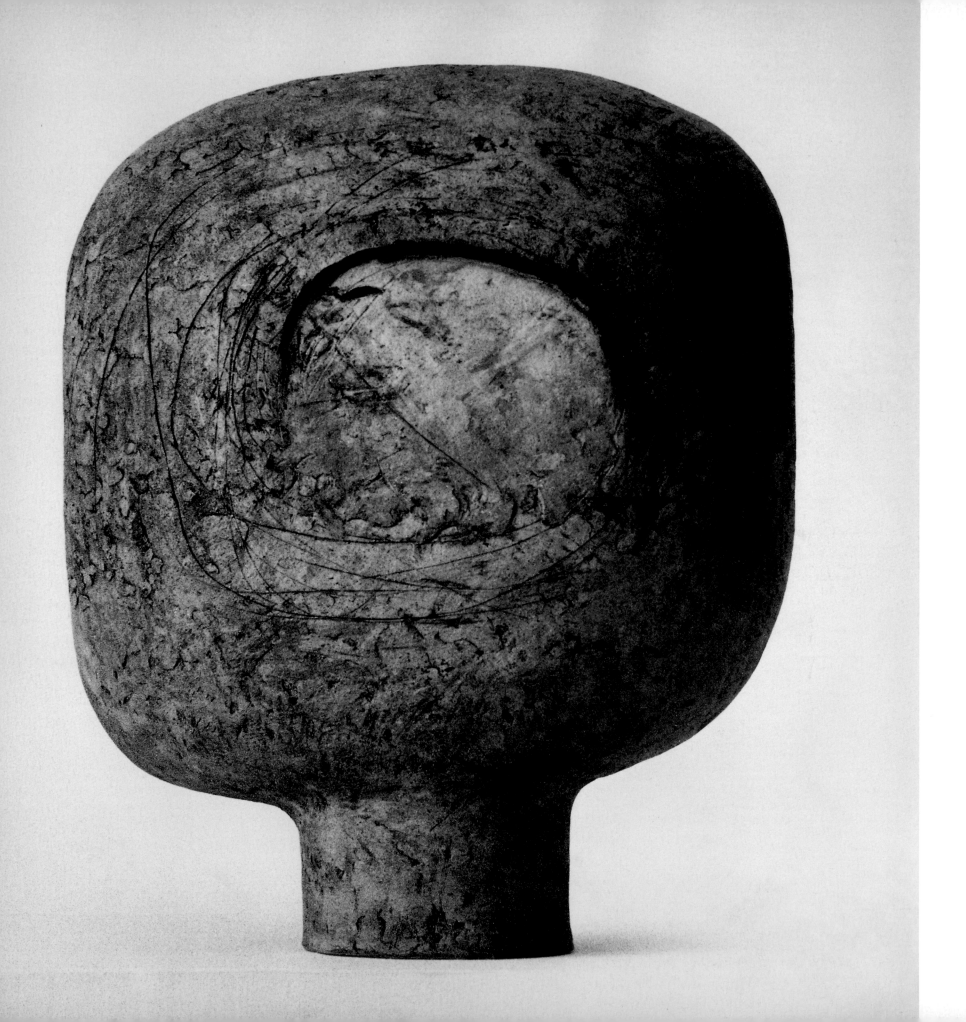

3. Form and the Substance of Clay

In 1960 the Gazzards decided to return to Australia for the birth of their first child. Travelling via New York and San Francisco, they arrived in Sydney in April and stayed with Donald's parents, Perc and May Gazzard, who had a large house in Elizabeth Street, Ashfield. This was a happy arrangement, although after years of living in big cities there was a feeling of isolation in suburban Sydney. Not long after their arrival Donald became a partner in the architectural firm Clarke, Gazzard and Yeomans, and on 4 July 1960 their son, Nicholas, was born.

Prior to his birth Marea had worried that a long break from her work might result in a lack of confidence which would make it difficult for her to start again. With the last of their savings the Gazzards bought a second-hand kiln which they installed in the garage at Elizabeth Street to enable her to keep working while tied to the house with a young baby.

Since their departure in 1955 cultural attitudes in Sydney had become more internationalist as a result of increased travel and communication. Joern Utzon's design for the Sydney Opera House was seen as a symbol of cultural awakening and there was a greater awareness of overseas art. In the absence of any local art journal, this awareness was fuelled by the return of travelling artists and by the *Contemporary Art Society Broadsheet*, which, under its editor Elwyn Lynn, made a conscious effort to keep readers informed and up-to-date on overseas art issues. This resulted in a more vibrant art scene, with an increased interest in abstraction and keen desire to keep up with world standards.

Some viewed this growing internationalism with distrust, and the move to abstraction was hotly contested, particularly by Melbourne-based figurative artists who felt this growing trend would result in a loss of regional identity.[1]

In pottery the situation was less polemical. From the fifties on most Sydney potters were interested in the Leach–Hamada stoneware aesthetic and philosophy. Those wishing to increase knowledge turned to the great ceramic traditions of Japan, where the writings of Soetsu Yanagi, as well as those of Leach, had done much to create an interest in Japanese folk art and the 'unknown craftsmen'.

Over the years, potters sought to use Australian materials in the Asian traditions to express a personal and yet Australian identity. At this stage comparatively little was known of European or American developments.

Sydney potters did, however, enjoy a more cohesive structure than those in other States. In 1956 the Potters' Society of New South Wales had been formed by four potters: Mollie Douglas, Peter Rushforth, Ivan McMeekin and Ivan Englund. This small group aimed to improve the quality of pots by encouraging the exchange of information and by encouraging galleries to establish quality collections of local and overseas work. They also organised biennial exhibitions of members' work at the Macquarie Galleries, Sydney.[2]

Gazzard became a member of the Society, exhibited in the 1961 exhibition at Macquarie Galleries and was sometimes able to attend workshops at the Sturt Craft Centre in Mittagong.[3] These events were, however, well spaced, and living in Ashfield she felt isolated from a creative community. In 1961 she decided to study sculpture one day a week with Lyndon Dadswell at the National Art School.

4. DIAL 1966
earthenware, applied oxides, handbuilt
51.5 x 49.5 x 29.4
photograph David Moore

Dadswell had recently returned from America and a study of developments in art education. As a consequence he had set up a course which was based very much on the ideas of Walter Gropius. Students were given time-controlled exercises which did not aim to produce 'artworks' but were to encourage individual aesthetic awareness, desire for experimentation and eventually any form of personal expression and problem-solving.[4] For Gazzard the long-term benefits of this course were the imposing of discipline and being trained to work within the context of external criteria – a great advantage in later public sculpture.

Anticipating the arrival of a second child, the Gazzards were anxious to have a house of their own close to the city. Before leaving for Europe they had lived in a rooming house in Goodhope Street, Paddington, where they established a great affection for the Paddington area, at a time when treeless streets and dark brown terrace houses were regarded as a social blight by those from more affluent suburbs.

In the interim period several artists, writers and an art gallery had moved into the area. Looking across from the National Art School, Gazzard was again attracted by the play of light on the rows of terrace houses against the Paddington hills. In her lunch-hour she began searching the area for a house to buy.

After a few months she and Donald purchased a terrace house at 54 Windsor Street, Paddington. Whilst retaining the façade, the Gazzards gutted the house to let light and air flow through the previously dark interior. On 18 June 1962 their daughter Clea was born and, although busy with two young children, Marea set up a tiny studio in the laundry of the house, where she could snatch any quiet moments for work.

The move to Paddington was a good one not only for the Gazzards but for Paddington. One day Marea bumped into the poet and broadcaster John Thompson in the suburb's only delicatessen and suggested forming a group to fight off the insensitive development and proposed road-widening that threatened to devastate the architecture and social fabric of the area.[5] Following the involvement of others, much discussion and considerable planning, the Paddington Society was eventually founded. This society became one of the earliest examples of successful resident action groups in Sydney. The Gazzards played an active role in its formation. Donald later became President and also initiated the establishment of the Paddington Plan, which set guidelines for future development.

Paddington's central position gave Marea greater access to the emerging art world. She was able to attend Contemporary Art Society meetings at the Adyar Hall in Bligh Street, go to gallery openings and become more involved in the activities of the Potters' Society. In 1962, with Ivan McMeekin, Ivan Englund and Peter Rushforth, she was a member of the steering committee which brought out the first issue of *Pottery in Australia*, edited by Wanda Garnsey.[6]

In the next few years there was a groundswell of interest in pottery. Classes at the National Art School and at the Sturt Craft Centre Workshops were booked out and a crowd of 400 flocked to hear a lecture by Peter Rushforth, following a study trip to Japan in 1963. Visiting potters Fred Olsen, John Chappell, Takeichi Kawai and, in 1964, Shoji Hamada further stimulated the interest in Japan.[7] Although Gazzard was involved in this activity the direction of her own work and thinking lay outside the prevailing oriental aesthetic.

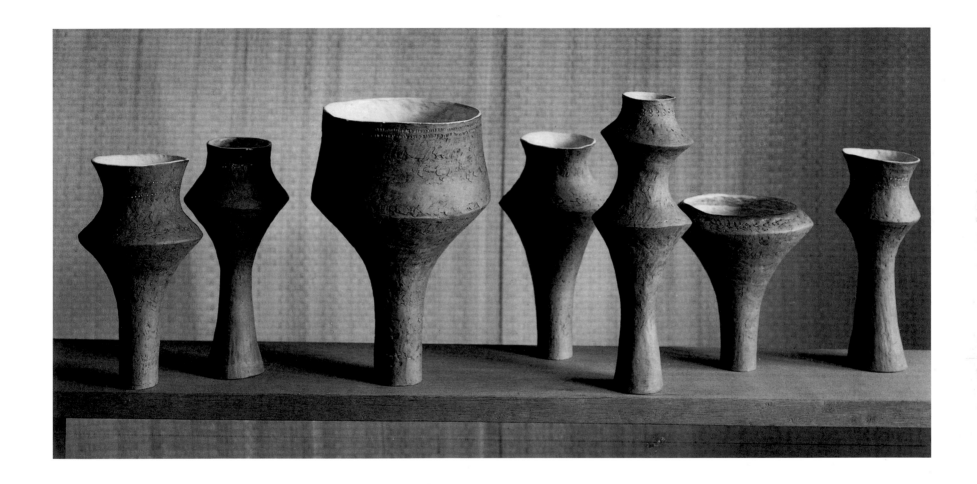

5. WORKS FOR HILTON HOTEL,
HONG KONG 1962
earthenware, interior tin glaze,
handbuilt
height 40.0 – 50.0 x
circumference 20.0 – 70.0
photograph David Moore

following pages:
6. POTS FOR SOLO
EXHIBITION 1963
earthenware, dark leadless glaze
on interior, handbuilt
height from 32.2 – 83.0
photograph David Moore

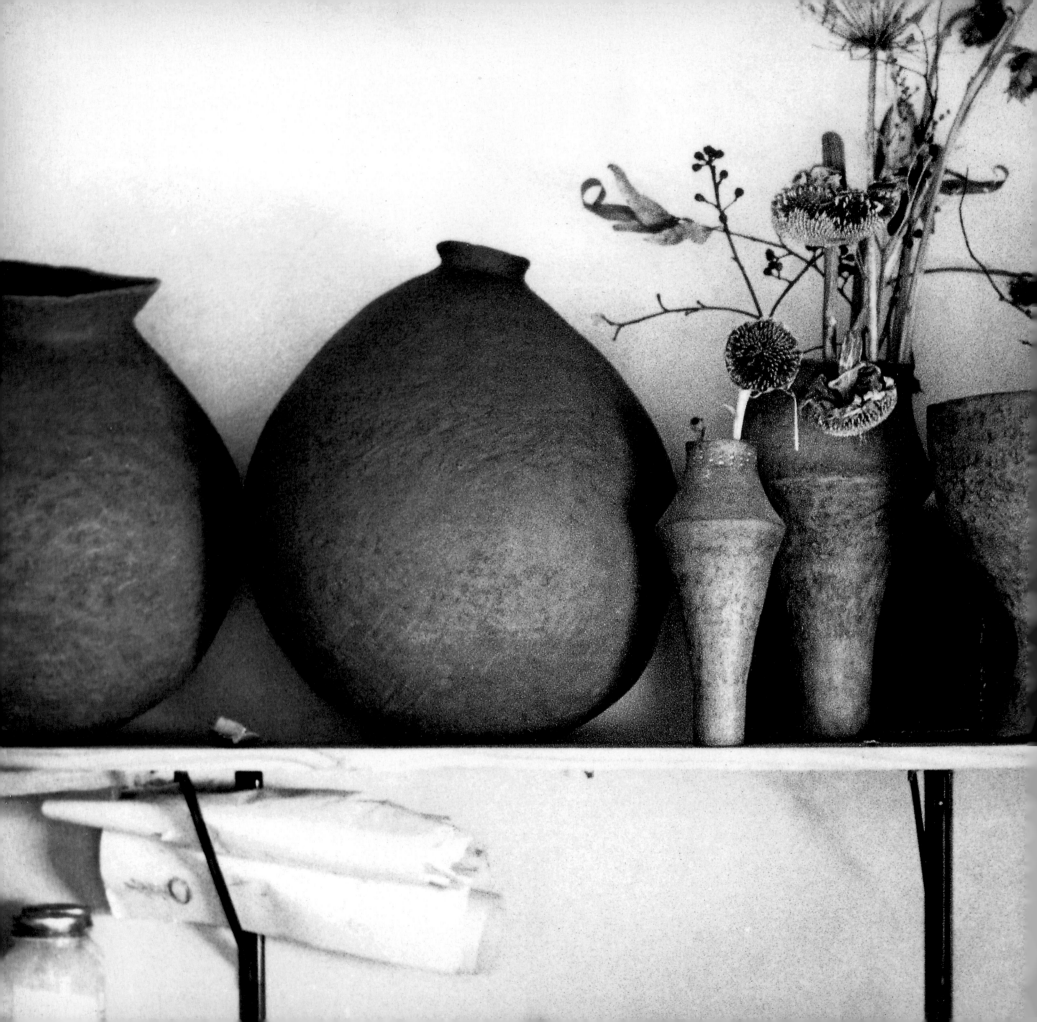

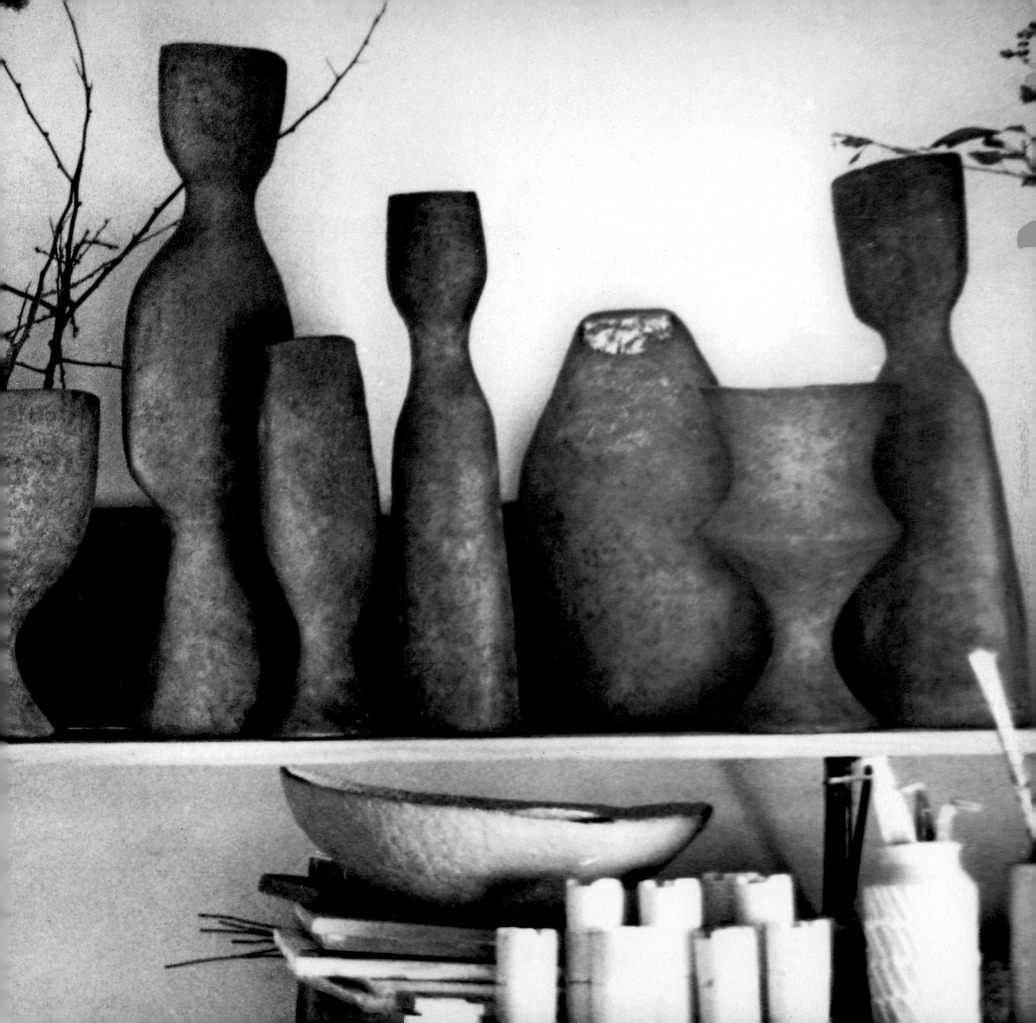

Her desire to work in an architectural context was briefly fulfilled with two commissions. The first came from architect David Jackson, then working with the firm McConnel, Smith & Johnson. Jackson had only recently arrived from England and was engaged in designing the Returned Services League's Club in Wellington, New South Wales. He was interested in incorporating the work of artists and designers within architecture and, impressed with the work Gazzard was doing in Ashfield, asked her to design ceramic tiles for the bar of the club.[8] The resulting dark blue glazed tiles were a rare excursion into the two-dimensional for Gazzard, who enjoyed the interaction and the opportunity to work within the wider concept of architecture and total design.

The second commission came from the interior designer Marion Hall Best, who had been asked to design an 'Australia Room' for the Hilton Hotel in Hong Kong. Best's interior design was the most innovative in Sydney during the sixties. She had a background interest in Bauhaus design theory, imported good design furniture and fabric, and used exceptional local talent such as the designers Gordon Andrews and Clement Meadmore.[9]

Gazzard's brief, to design ceramic ashtrays, resulted in a series of vibrant forms. Acknowledging the Cycladic, these pieces, like many of the idol figures, sprang upwards and outwards from small elongated bases (ill.5). Intended to be hung in brackets on the wall, the works have a buoyant vitality, as variation in height and their white tin-glazed interiors create a lively rhythmic effect, which was to become characteristic of her later work.

In 1963 Gazzard had her second solo exhibition, at Betty O'Neill's Hungry Horse Gallery in Paddington. This gallery, situated only a hundred metres from the Gazzards' house, had opened in 1962 and quickly established a reputation for good avant-garde art.[10]

The exhibition of fifty-six handbuilt pots, most with glazed interiors and an unglazed textured surface, produced a wide variety of forms that were indicative of her interest in the ancient and primitive while displaying a modernist clarity of line and volume. There was a continued development of the forms present in the small-based Hilton Hotel works and in the flattened Cycladic vase forms she had shown in Canada. Coiled, pinched and paddled, the works have a gentle asymmetry and earthy, time-ravaged surface which makes reference to both the archaeological and the primitive.

Gazzard's interest in the archaeological had been stimulated by her visit to Greece and by the book *Prehistoric Art*, which she had purchased in London in 1957.[11] The weathered exterior and incised dot decoration as seen in *Krater* 1963 (ill.7) acknowledges the Neolithic, while the thin-walled clarity of outline and the freshness of white, translucent tin glazes connect the works to the present.

Gazzard's ability to create form is best seen in *Pot* 1963 (ill.6). Here the textured octagonal surface frontally appears flattened, revealing a lead-glazed interior, yet laterally it mysteriously slides into a softly moulded Brancusi-like shape with pillowed base and pencil-thin top.

In a series of small bowls there was a suggestion of fragility as paper-thin edges and pale translucent glazes connect to the hand-pinched rawness of the exterior. It was the larger works, however, that were the most confident. Like *Pot* 1963 (ill.9) they show an assured use of asymmetry and a vitality of form.

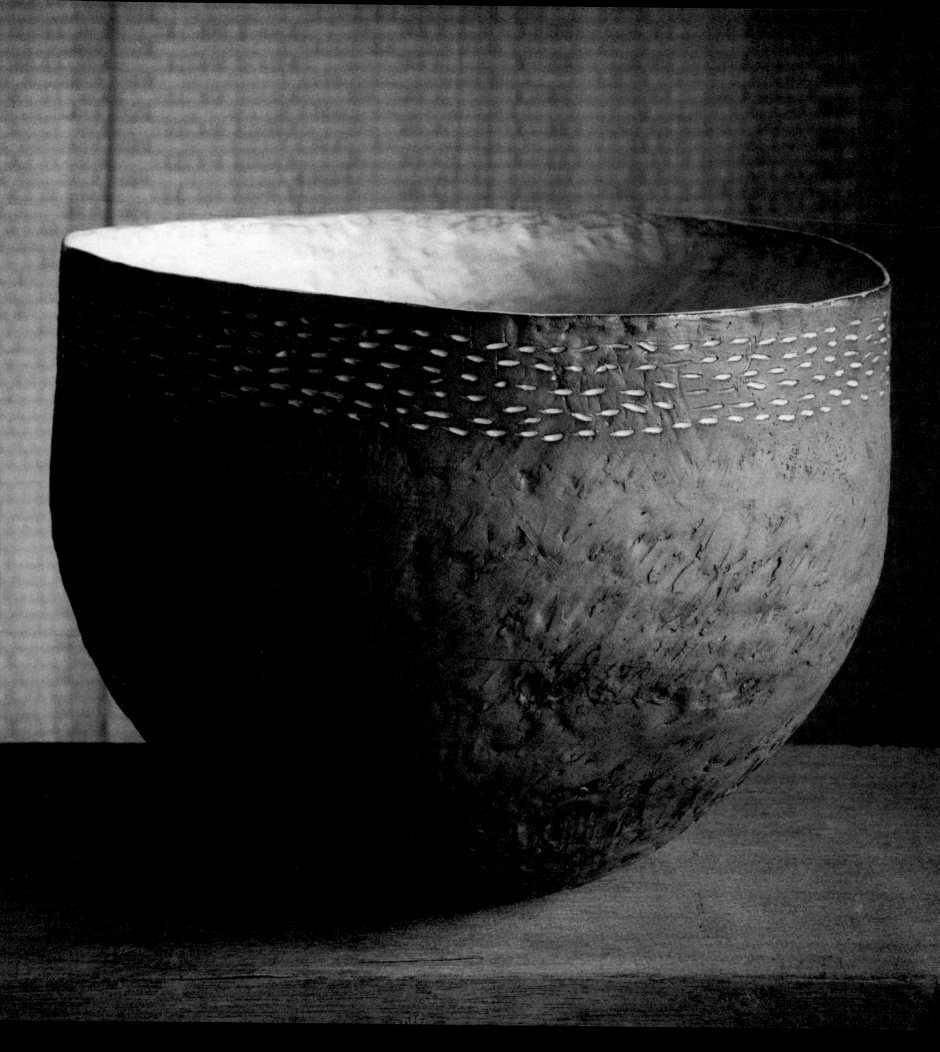

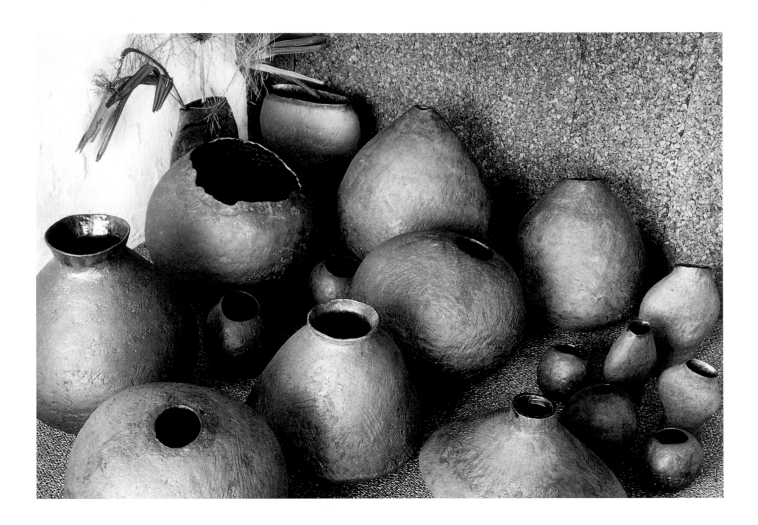

The Hungry Horse exhibition was well received: the Art Gallery of New South Wales purchased *Pot* 1963 (ill.9), and favourable comments came from four critics who were quick to recognise the timeless quality of the work.[12] There was acknowledgment of Gazzard's serious and evolving sensibility, her independence from current trends, and comment on the direct connection between object and maker which was established by her method of handbuilding as opposed to wheel-throwing. For Daniel Thomas this connection was as direct as that between painter and picture surface, while Elwyn Lynn perceptively noted, 'Many potters are designers. Marea Gazzard wants her ceramics to be still memorials of primal inspiration'. In making these distinctions, it would appear that some Sydney critics were aware of the narrow boundaries which existed between art and craft.

Following her return to Australia, Gazzard had been concerned with the divisions between different media which existed within the art world. In Europe and America the boundaries were more flexible, particularly since the advent of abstraction, which had resulted in an unprecedented intimacy between the fine and applied arts.[13]

At the Contemporary Art Society in a lecture entitled 'Clay', Gazzard made a plea for the breakdown of the barriers which existed between potters, painters and sculptors. Clay, she argued, could be sculpted as it had in the past. It could be thrown as it is by potters, decorated by painters or even dripped, poured and pinched. It was time, she argued, to get over the stoneware snobbery, break down the boundaries and create a more stimulating environment of practitioners moving from one field to another.[14]

This was similar to the argument she had earlier put forward in her efforts to establish a craft organisation. In Europe and the United States her travels,

8. SPHERICAL POTS 1963
earthenware, dark leadless glaze
interiors, handbuilt
height from 15.0 – 55.0,
width from 15.0 – 65.0
photograph David Moore

opposite:
9. POT 1963
earthenware, dark glazed interior,
handbuilt
46.0 x 38.0 x 38.0
photograph Max Dupain

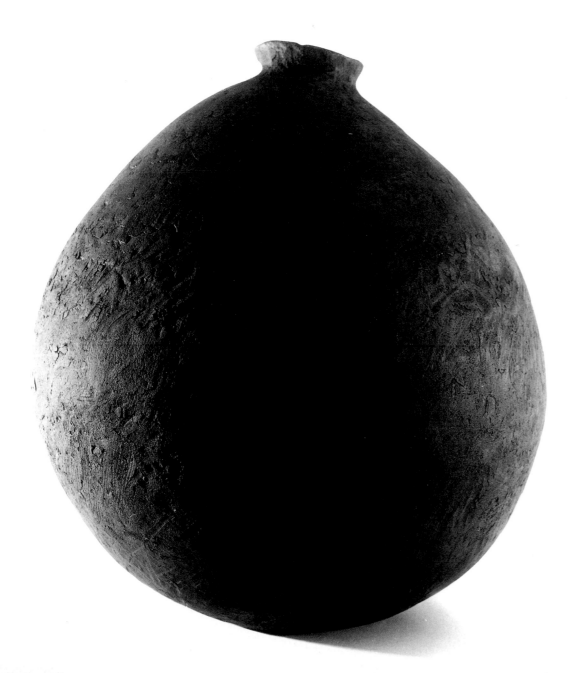

studies and subscription to publications such as the American journal *Craft Horizons*[15] had made her aware of the great revitalisation which had occurred in the crafts as a result of cross-fertilisation and holistic design theory. In Australia, apart from the interest in stoneware pottery, there was almost no public recognition of craft. There were excellent craftspeople but their work was compartmentalised and in many cases fading into oblivion. On her visits to the United States and in her reading of *Craft Horizons*, Gazzard had observed the success of the American Craftsmen's Council, which had been founded by Mrs Vanderbilt Webb in the Depression years.[16] There was, she felt, a great need to establish a similar multi-craft organisation in Australia, where interaction of ideas could stimulate, improve standards and help establish a contemporary relevance for the crafts. Looking back in 1975, she said:

Really what we were concerned about was changing the environment from mediocrity to one of excellence. We wanted to get good people in different fields together so that there would be a cross-fertilisation of stimulation and interest, and more excellent craft would result.[17]

Gazzard discussed these ideas with the potter Les Blakebrough and the importer Axel von Rappe and in 1963 called a meeting which resulted in the foundation of the New South Wales branch of the Craft Association of Australia.[18] Shortly afterwards, Gazzard received a letter from the President of the World Crafts Council, Mrs Vanderbilt Webb, requesting that an Australian representative attend the first World Crafts Council Conference, to be held in the United States in 1964.

The humanist ideals of creativity and international co-operation which shaped the foundation of the World Crafts Council were strongly upheld by the

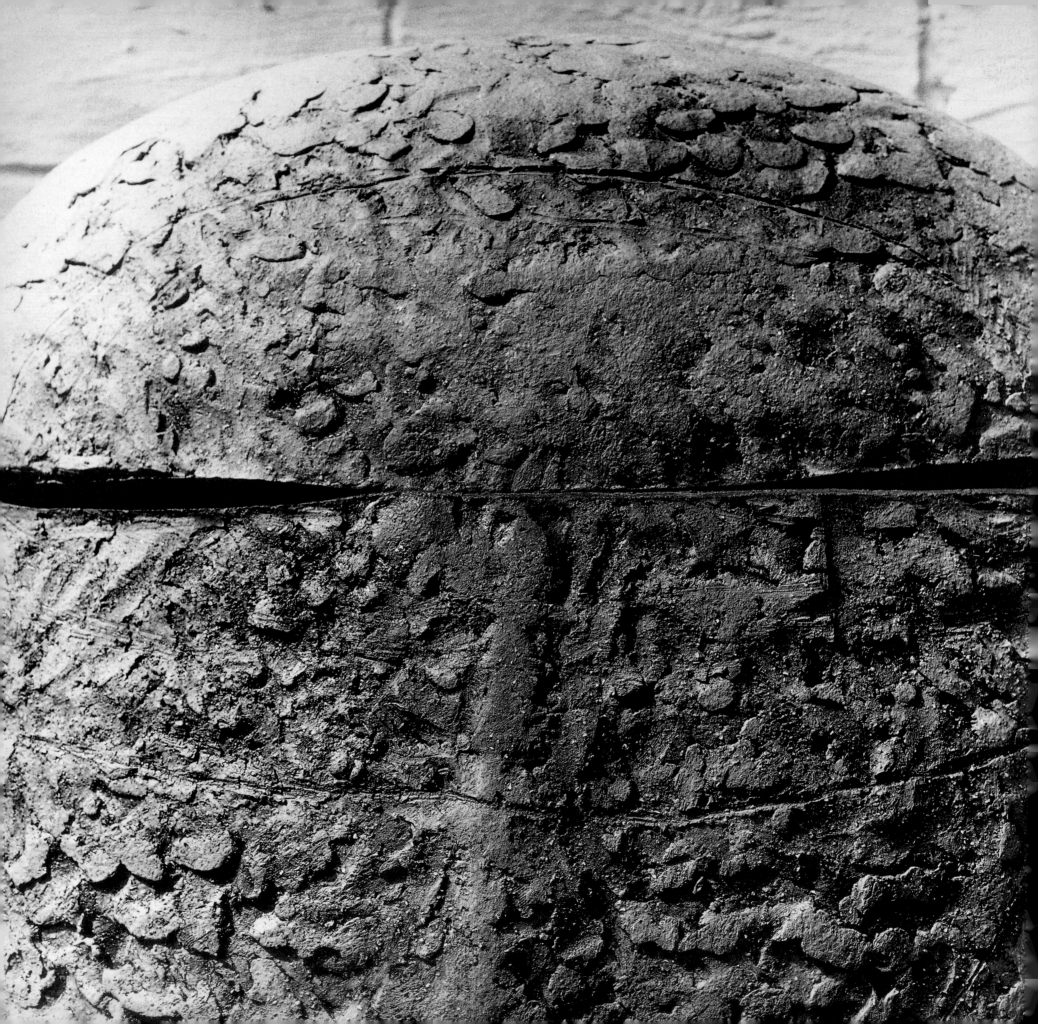

Craft Association.[19] Australia would gain much from the opportunity to interact with craftspeople from both industrial and non-industrial countries. It would facilitate the exchange of ideas and improvement of standards. Mrs Vanderbilt Webb's donation of an airline ticket enabled the potter Mollie Douglas to represent Australia at the first World Crafts Council Conference, at Columbia University, USA.

The opportunity to be part of the World Crafts Council greatly increased the need to establish the Craft Association as a national body. It was a time of hard work and commitment as members lobbied and discussed plans to encourage other States to join. There was a growing sense of camaraderie amongst those who worked long hours establishing the Association. Meetings were held in members' houses and often ran late into the night, and there was a real feeling of achievement as obstacles were overcome and goals attained.[20]

Some awareness of the benefits of cross-fertilisation in various branches of the arts was evident at both Sydney University and the University of New South Wales where artists were employed within the architecture departments, and in the running of Mary White's School of Art. White, an interior designer and member of the Craft Association,[21] ran a private school in Sydney which was concerned with the teaching of art as well as design theory and practice. In 1964 Gazzard was teaching pottery at this school, while other artists such as John Olsen taught painting and Robert Klippel sculpture.

Around this time Gazzard's approach to her own work began to change. Since her 1963 exhibition she had become increasingly aware of connections between many of the forms with which she was working. To enable her to work through her ideas

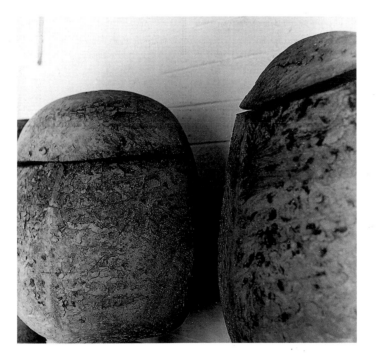

Dials 1966
details
photographs Harry Sowden

more rigorously, she decided to concentrate on a smaller number of forms and produce work in a series which would facilitate a strenuous exploration of each form.

This change was first evidenced in those of her works exhibited in a group exhibition at the Hungry Horse Gallery in 1964 [22] and in a solo exhibition at the Johnstone Gallery, Brisbane, in 1965. Among the exhibits was a group of handbuilt earthenware *Spherical Pots* 1963 (ill.8). Here, the irregular size, shape and placement of the openings set up a rhythm within the series and provide a sophisticated exploration of form and void. These pots, although still containers, are no longer viewed as functional. Like hatched eggs, empty exoskeletons or spent seed-pods, they exist as form alone.

It is from this time that forms found in nature began to exert a greater presence in Gazzard's work. Following her Brisbane exhibition, the family holidayed at Heron Island in Queensland where Gazzard became fascinated by the shape and thin edge of the stingrays in the area. As she later remarked:

Form can be found anywhere. Sitting in the park one day, my children brought me a squashed fig. Instantly I recognised that this object and stem was exactly the form I had been searching for. [23]

On her return to Sydney she began to study at the Australian Museum of Natural History, and became interested in both skeletal shapes and fossils.

Working in series provided Gazzard with a structure to explore her ideas. In 1966 she had an exhibition at Gallery A, Sydney, presenting an exploration of four forms which she called *Boulder*, *Dial*, *Torso* and *Shield*. All of these works were handcoiled earthen-

ware with unglazed exteriors and dark-glazed interiors fired to 1160°C in an electric kiln (see Appendix). *Boulder* 1966 and *Torso* 1966 show a reworking of the earlier spherical pots and the flattened Cycladic vase forms with an increased development of textural surface. In *Torso* 1966 (ill.14) Gazzard shortened the neck, narrowed the openings and extended the shoulders of the flattened Cycladic forms. This introduces for the first time a level of ambiguity into her work, as frontally the works are suggestive of a human bust or torso. In this exhibition Gazzard moved away from the idea of container towards the notion of containment.

In the *Shield* series the works are containers but this function is dominated by the archaic presence of the object. Their great diamond-shaped forms refer to the stingray shapes she had seen in Queensland but appear as trilobite fossils weathered into rock rich with the striations of age. In *Shield* 1965 (ill.12) an elemental spine is at times pressed smooth or given depth with the application of dark oxides which also draws attention to the hidden crevices of the surface. Against this weathered surface the precision of a diamond-shaped lip defines the dark-glazed interior and pulls the eye from surface to void, suggestive of that which is within.

In most of the works in this exhibition colour appears to emerge from the object. In *Shield* 1965 Gazzard has achieved this effect by adding some coils of contrasting clay, paddling them into the surface. Compared to her 1963 work the internal glazes have darkened, while the application of oxides to the unglazed exterior heightens the effect of colour being secreted through the surface.

In her *Dial* series 1966 Gazzard abandoned all suggestion of container and presented forms which

are completely contained apart from a slash or narrow opening. These large bulbous ovoid forms were handbuilt on small neck-like bases and exude an enigmatic power. In *Dial* (ill.10) the surface is encrusted with flattened pellets of clay which, like impressionistic brushstrokes, set up surface rhythms, modulating light against the earthy texture and giving the appearance of ancient rock. Inside the slit which slashes across the front of the object a shiny boracic glaze hints at life within the embryonic lips.

Dial 1966 (ill.4) asserts a quiet power of solidity. A central visor glows warm against the dark, rubbed oxides of the outer body, a small crack-like space suggests a cave-like retreat and protection, while sweeping sgraffito across the surface conveys a wind-swept weathering and a primordial presence.

Increasingly Gazzard's non-functional work was gaining support from the art world. Both Robert Hughes and Elwyn Lynn welcomed her independence from prevailing trends,[24] while Donald Brook remarked that 'her work made everything else look like Sunday School'.[25] Reviews of her 1966 exhibition commented on the off-balance and asymmetry of the works, which displayed 'her ability to turn awkwardness into a virtue'[26] and, as in nearly all reviews of Gazzard's exhibitions, noted the sculptural feeling of the work.[27]

In 1967 and again in 1970 Gazzard was invited to enter the Mildura Triennial Prize for Sculpture and on both occasions received favourable critical comment.[28] It would seem that in some areas the boundaries between sculpture and pottery were dissolving. In a 1967 solo exhibition at the Johnstone Gallery, Brisbane, she tentatively exhibited three small works entitled *Solid Sculpture I, II* and *III* 1967.

During the sixties Gazzard was to undertake several trips which greatly increased her understanding of the global role that crafts could play in terms of both culture and economy. In 1966 she and Donald embarked on a long-awaited holiday which included a visit to India and Finland, two countries rich in creative effort but operating from entirely different perspectives. In post-war years the small country of Finland had thrived on world recognition of its contemporary architecture and industrial design, but in India industrialisation was proving life-threatening to the large population involved in handcrafts. The trip provided not only a visual feast but some insights into the complexities involved in the advancement of craft. In India they stayed with Patwant Singh, publisher–editor of *Design* magazine which dealt with issues relating to architecture, visual, performing, graphic and industrial arts. Singh lived in New Delhi, overlooking the Lodhi Gardens. He was an informed, lively and extremely hospitable host, who introduced the Gazzards to a number of architects and designers, including the influential architect I. M. Pei, who was visiting India at this time.

Gazzard was fascinated by the Gandhara sculpture, the museums and the architecture, but it was the streets of tie-dyeing, the traditional block-printers, rug-weavers and cottage industry centres that revealed to her the bond between creativity and everyday life in India. It was on this trip that she first forged her interest in the Asian region. In Finland the Gazzards' long-felt enthusiasm for Finnish design and architecture was increased as they witnessed the ways in which the great innovative designers such as Alvar Aalto had succeeded while holding tradition and craft in high regard. Here they met the ceramist Rut Bryk, Kyllikki Salmenhaara, who had been one of the ten artist potters with studios in the well-known Arabia

factory, and Armi Ratia, founder of the Marimekko fabric design empire. Ratia took a great liking to the young Australians and asked them to spend Christmas at her country house, Bökers. This was an early timber farmhouse in which everything inside had been designed by Marimekko. Guests were given Marimekko clothes to wear. It was a traditional celebration, a family occasion vitalised by the best of contemporary design. Gazzard still remembers the Marimekko fabric in the light of dozens of tan, white and dark blue candles, the snow, the music, the colour, the silence and a toast of 'peace and health'.[29] This experience of a total environment was to remain vividly in her consciousness.

In 1968 the Craft Association of Australia elected Gazzard as Australia's representative to the World Crafts Council Conference in Peru, and fares were raised by a lottery of members' work. It was an attendance which was to have great significance for Australia. At this meeting Gazzard proposed and was successful in identifying Australia with the Asian region, a move that considerably fore-shadowed the country's current, more general reorientation.[30]

In 1969 she attended the first Asian Region Conference of the World Crafts Council in New Delhi, and in 1970 the World Crafts Council Conference in Dublin, where she was elected a Director of the World Crafts Council.[31]

These commitments were making inroads into Gazzard's time but while abroad, if there were any moments between meetings, she would visit museums, filling her sketchbooks with forms. These sketches are exercises which have kept her mind open to the enormous vocabulary of form, but sometimes they have a direct effect on her

10. DIALS 1966
earthenware, applied oxides, glazed interior, handbuilt
45.0 – 63.5 x 41.5 – 58.4 x 16.0 – 20.0
photograph David Moore

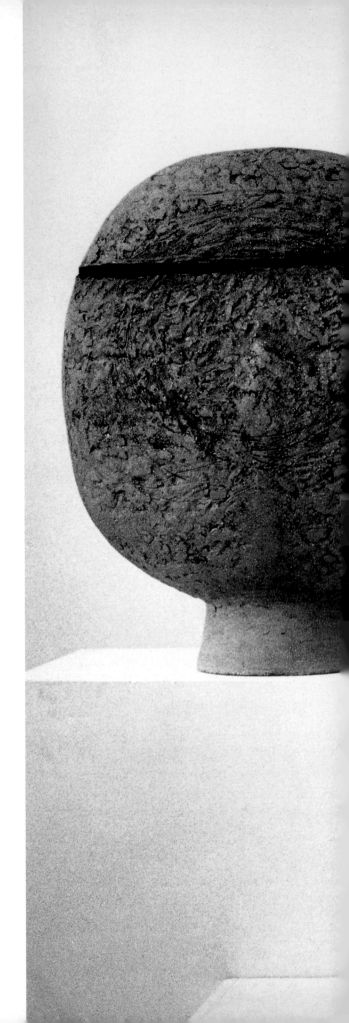

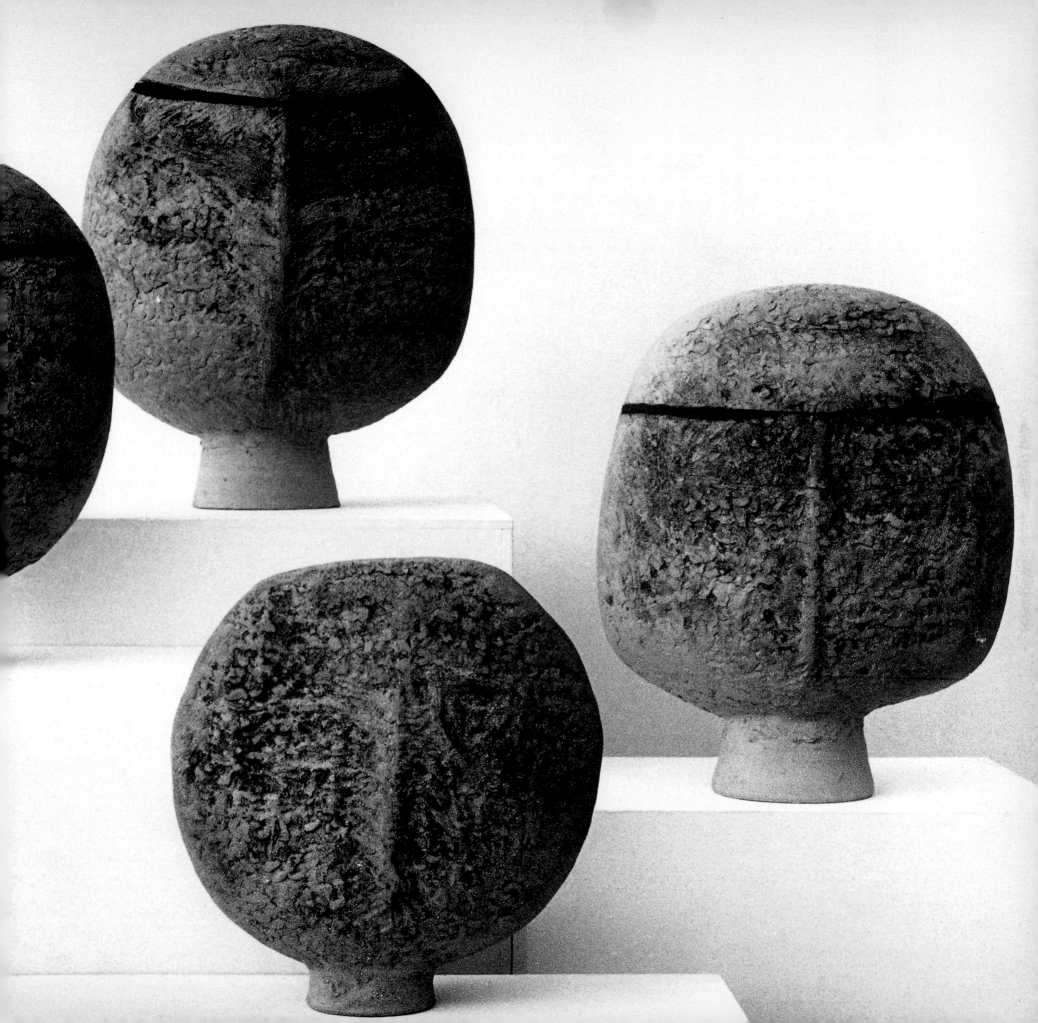

11. SHIELDS 1966
earthenware, applied oxide, glazed
interiors, handbuilt
left: 46.0 x 35.0 x 13.0
right: 56.0 x 46.0 x 23.0
photograph David Moore

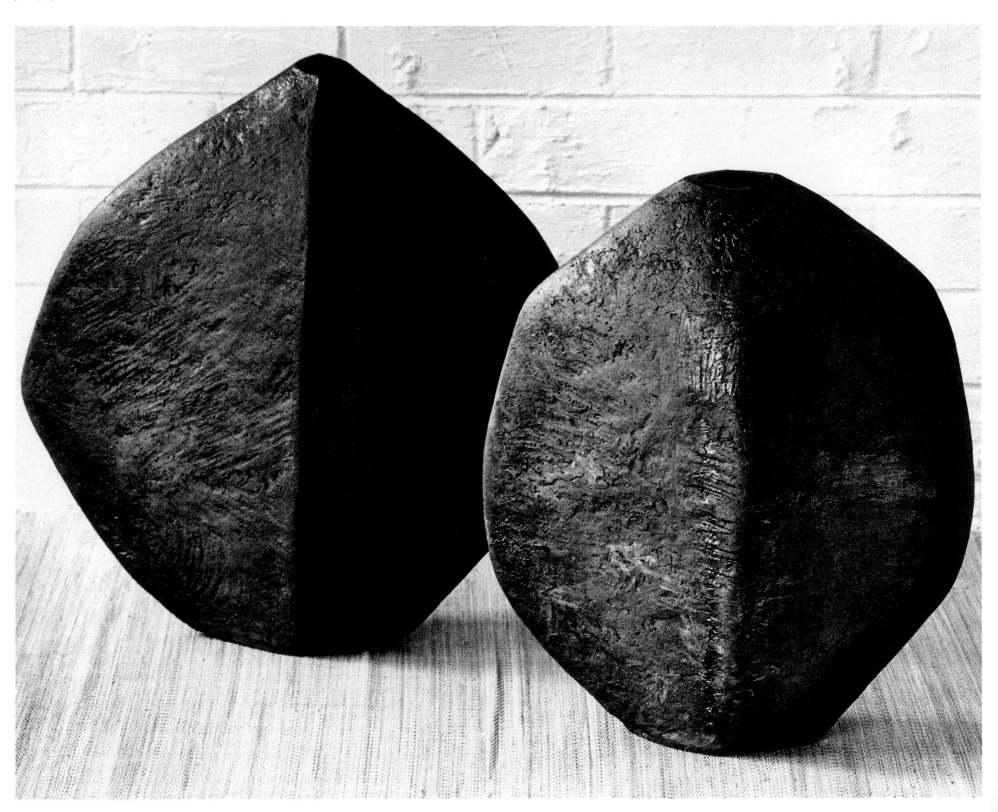

work. When visiting Peru and Mexico in 1968 she was greatly impressed by the monumental Inca stone walls of Peru and the Diego Rivera Museum Anahuacalli. The influence of these and the many pre-Columbian clay sculptures she saw was clearly evident in the works which she exhibited in 1969.

By 1968 the Gazzards had built Marea a studio. Situated across the courtyard at the rear of the house, it was small but had large glass doors which could be thrown open to the leafy white-walled garden. Her colleague Robert Bell, who first met Gazzard at this time, remembers visiting the house and being impressed by the way in which she could maintain big work in a small space. 'She was focused and would concentrate on a small number of forms. Unlike other potters who had built up huge ceramic studios, she was not concerned with techniques, other than her own. She worked simply, in a clear organised way.'[32]

In the new studio Gazzard installed an improved kiln which had a high temperature range and enabled her to fire works from earthenware to porcelain. At the same time a meeting with the sculptor Stephen Walker, who suggested she should try casting in bronze, led her to begin handcoiling some works in wax.

In a solo exhibition at Gallery A, Sydney, in 1969, six of the thirty pieces she showed were bronze; the other twenty-four were stoneware forms. Her work responded well to the transition into bronze. Reminiscent of the tension in Fontana's large terracotta boulder pieces, *Slit I, II* and *III* 1969 (ill.18) had an increased feeling of vitality. Light reflected from the bronze patina of the beaten surfaces and played against the irregular openings of the splitting spheres as if capturing the moment of bursting from whole to void. By contrast, in

Permian I and *II* 1969 (ill.19) the surfaces with their indentation of fossil-like form convey the feeling of perpetuity in the still permanence of the rock-like forms.

It was, however, the stoneware works which displayed increased monumentality. Made of a light buff clay, the elongated forms of *Totem I, II, III* and *IV* 1969 (ill.15) have the towering presence of Easter Island idols and the beaten weathered surfaces of Inca stones. The seemingly simple shapes reveal anthropomorphic metaphors and exhibit a complexity of form when viewed in the round.

In *Dial* 1969 (ill.17) the ovoid shape of the 1966 *Dial* series has been pushed into a pillow-like form with a backward thrust to its flattened top. This form is reminiscent of the Cycladic and also the small clay figures (with headdress) which Gazzard had seen in 1968 in Peru and Mexico. The worked, beaten surface has the appearance of wind-eroded stone worn smooth at the shoulder. Across the flattened top a small row of perforated holes acknowledge the pre-Columbian figures.[33]

In this exhibition Gazzard achieved the rare quality of monumentality without heaviness. Some of her *Shield* forms are widened but lose none of their upward thrust. In the *Boulder* series 1969 (ill.20), surfaces show increased texture, some of which are offset with splash-glazed interiors, while in others the use of a dark glaze accentuates the thin shell between solid and void, restating the issues of contained and container.

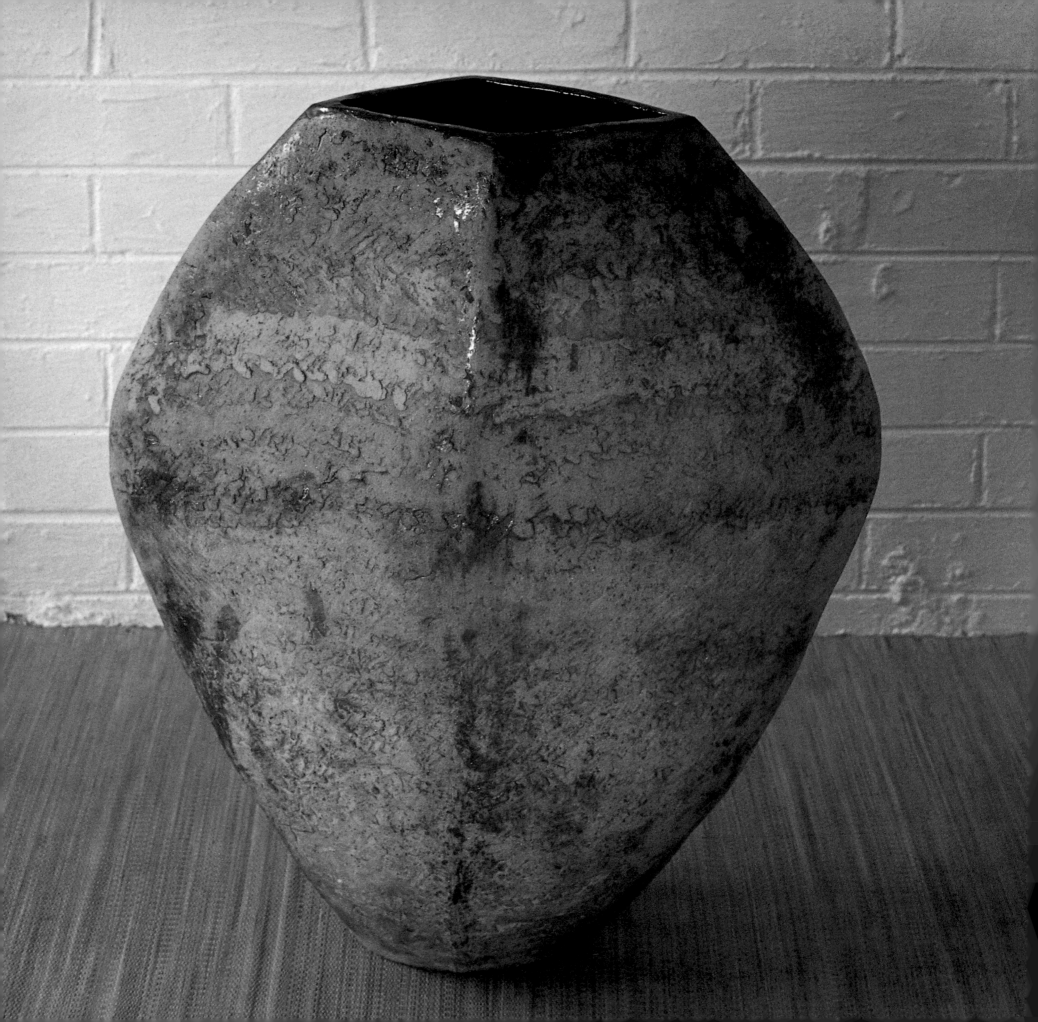

opposite:
12. SHIELD 1965
earthenware, applied oxides, glazed
interior, handbuilt
70.0 x 60.0 x 27.2
photograph David Moore

13. SHIELDS 1966 and 1965
earthenware, applied oxides, glazed
interior, handbuilt
left: 65.3 x 55.0 x 26.2
right: 70.0 x 60.0 x 27.2
photograph David Moore

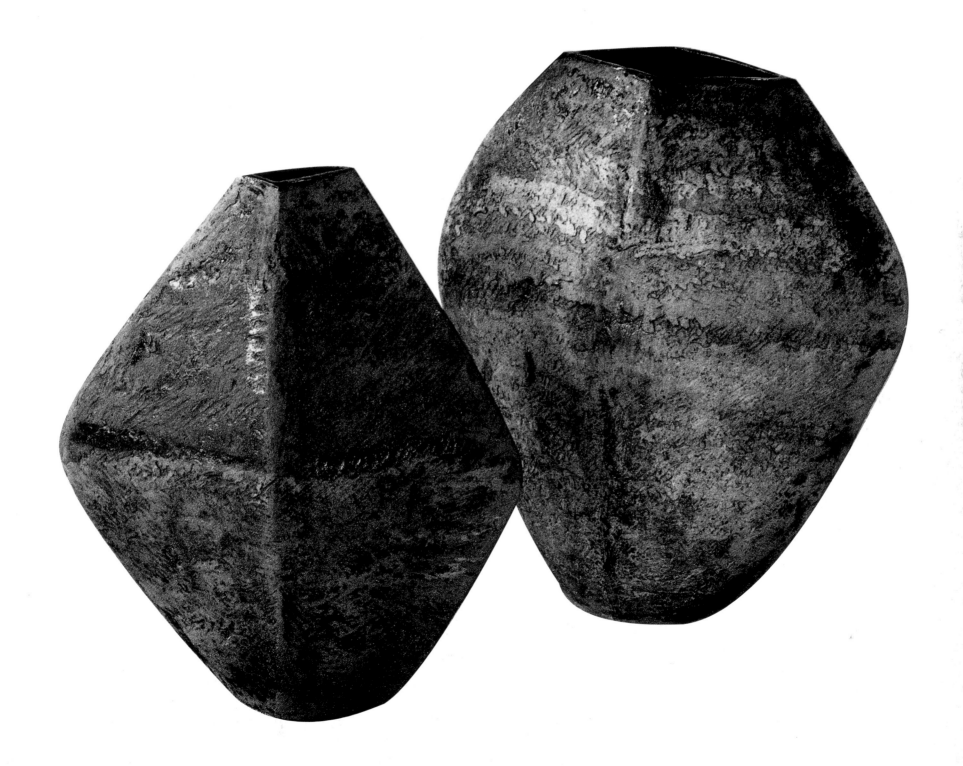

14. TORSOS 1966
earthenware, applied oxides, glazed
interiors, handbuilt
32.0 – 43.9 x 43.6 – 51.3 x 10.5 – 17.2
photograph David Moore

opposite:
15. TOTEMS 1969
stoneware, applied oxides, glazed
interior, handbuilt
51.1 – 64.2 x 38.5 – 56.3 x 10.5 – 27.2
photograph David Moore

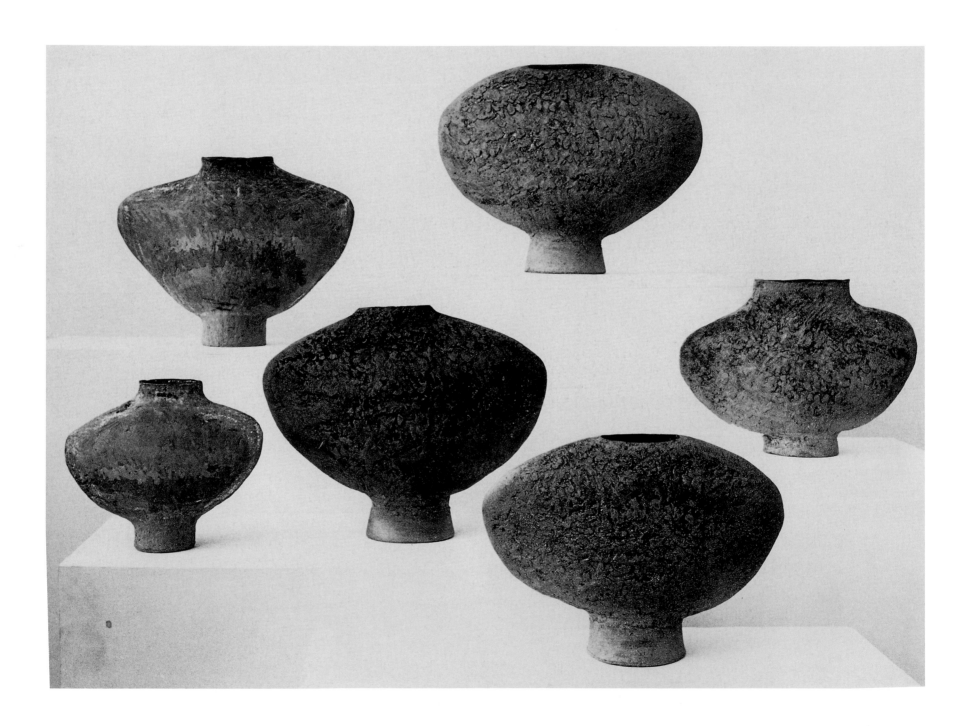

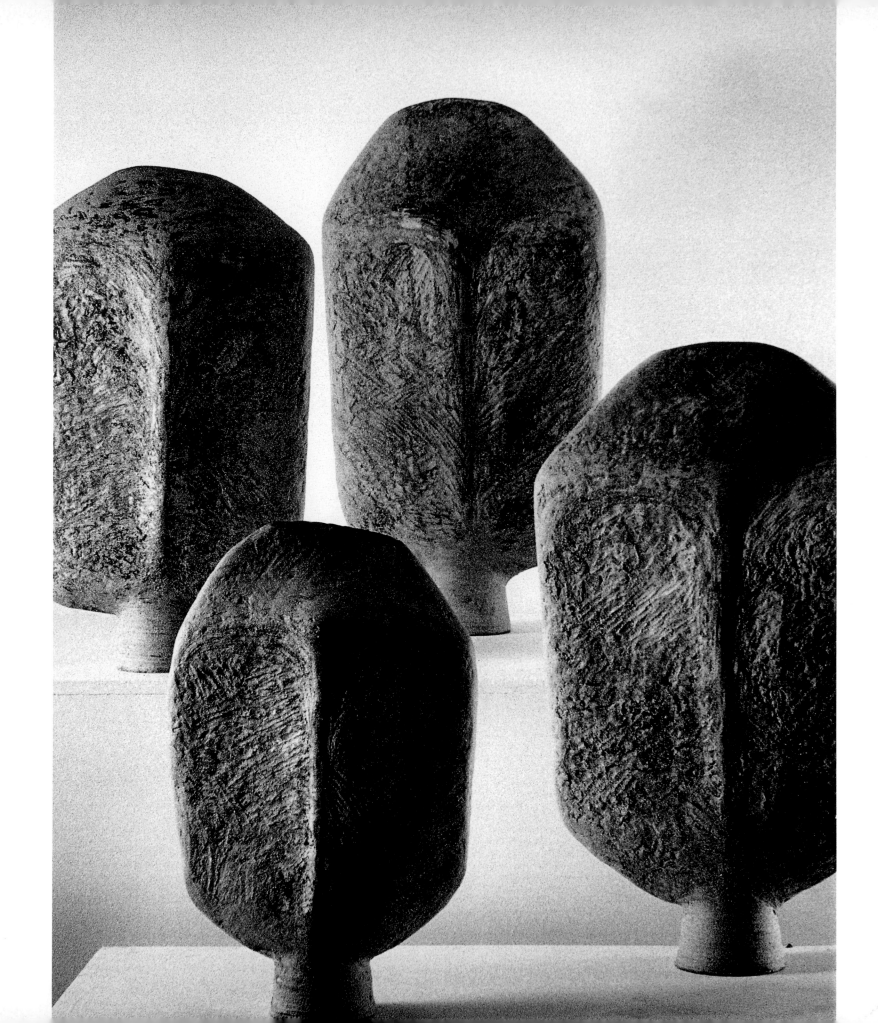

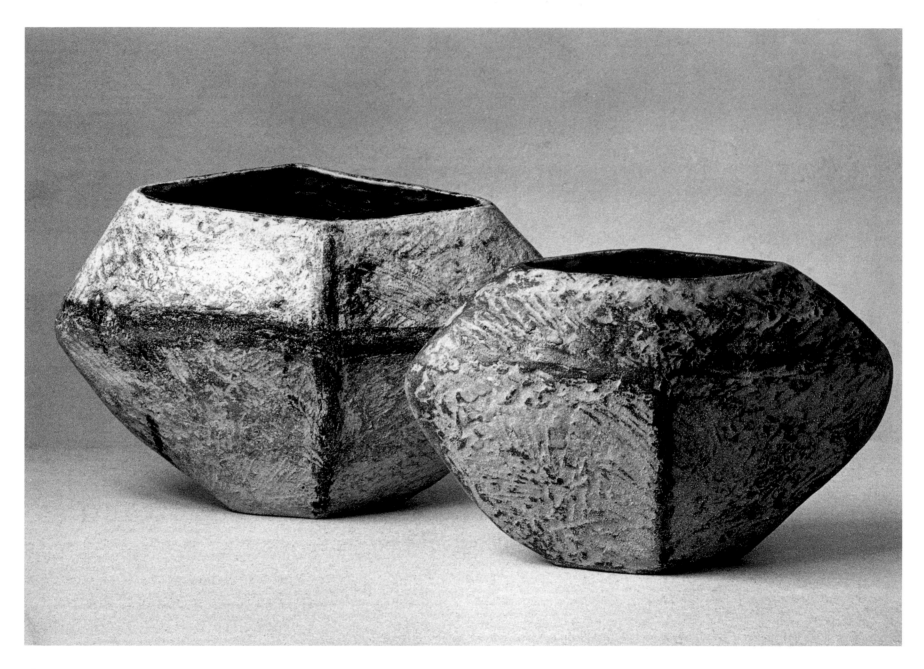

16. WIDE SHIELDS I and II 1970
stoneware, applied oxides, glazed
interiors, handbuilt
31.0 – 38.6 x 23.5 –31.0 x 20.5 – 23.5
photograph David Moore

opposite:
17. DIAL I 1969
stoneware, applied oxides, handbuilt
58.51 x 50.31 x 22.51
photograph courtesy National Gallery
of Australia

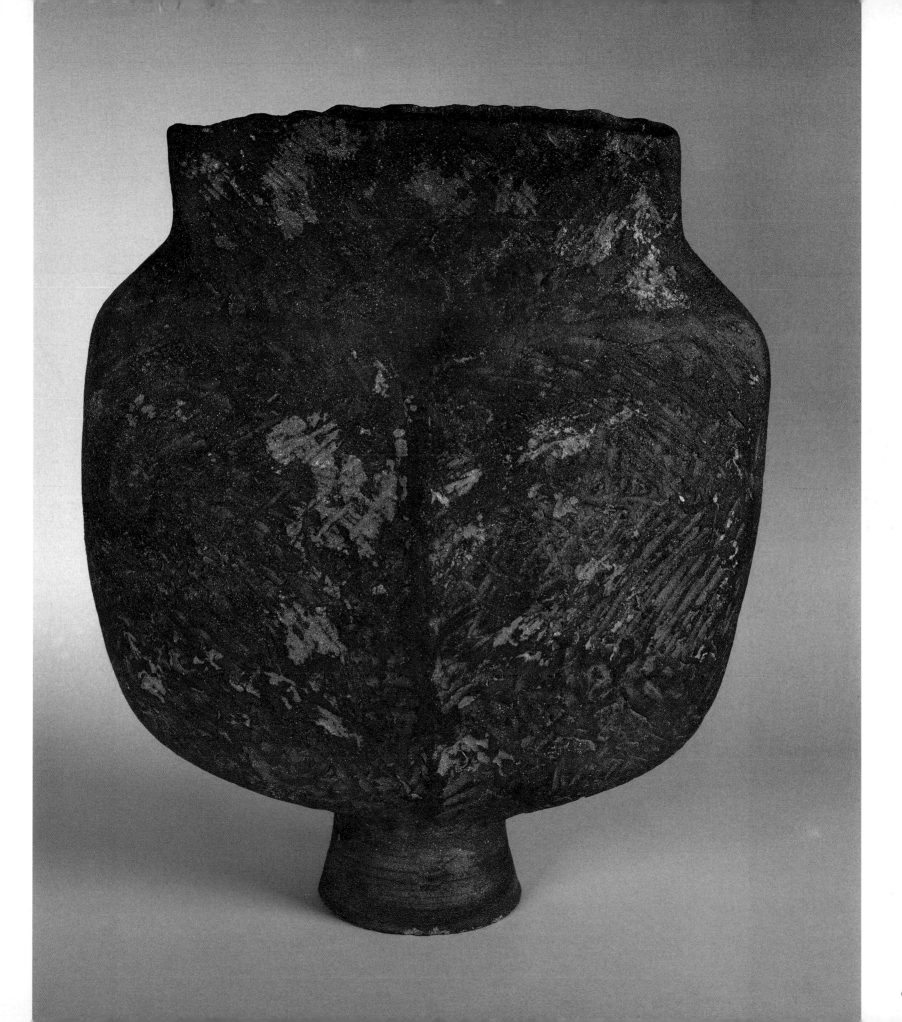

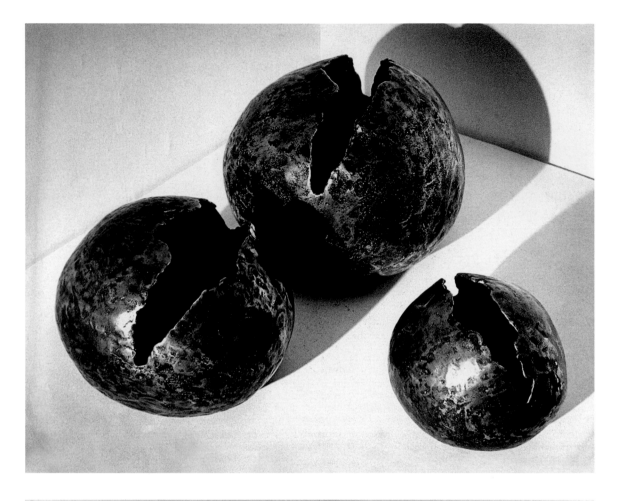

18. SLIT I, II and III 1969
bronze
diameter 22.5; 32.5; 37.5
photograph David Moore

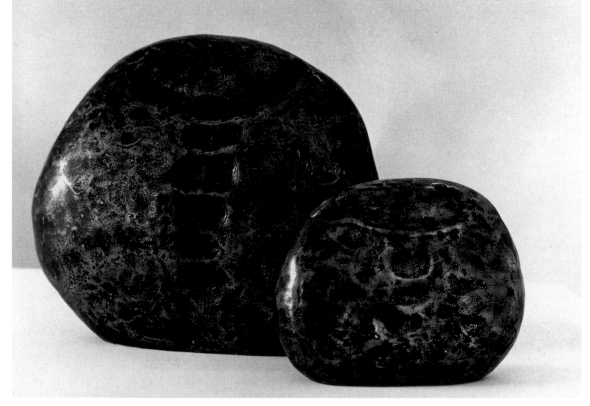

19. PERMIAN I and II 1969
bronze
29.8 x 34.6 x 16.0, 18.3 x 23.0 x 9.9
photograph Marea Gazzard

It is Gazzard's virtuosity of technique which
distinguishes these works. She has a rare ability
to maintain size without coarseness. She can
achieve archaic presence and primitive immediacy
within the thin walls of organic modernism.
In her surfaces, texture and colour emerge as an
intuitive response to form and material. In 1969
she was to win the Richey Ceramic Prize; in 1971
she was made a member of the International
Academy of Ceramics, Geneva; and in 1974 she
was invited to exhibit at the 'Città di Faenza
XXXII Concorso Internazionale della Ceramica
d'Arte Contemporanea'.

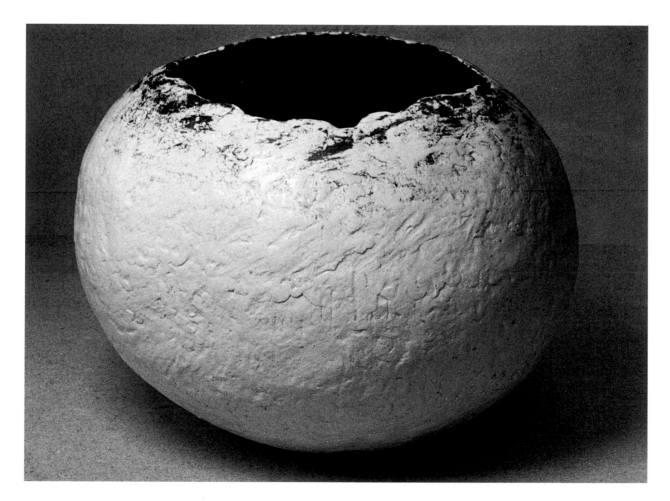

20. BOULDER 1969
stoneware, white glaze with iron
oxides, handbuilt
36.0 x 48.5 x 48.5
photograph David Moore

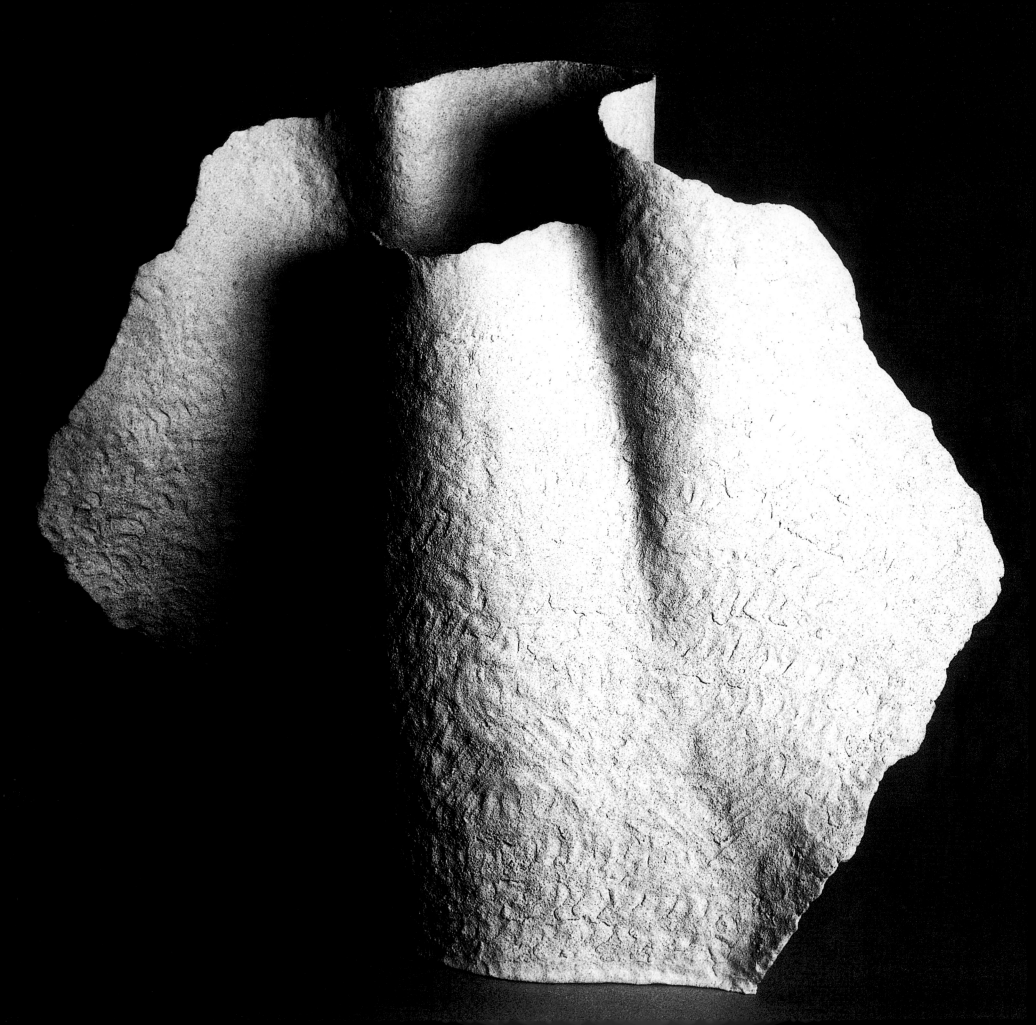

4. Pursuing Excellence

The seventies in Australia were characterised by a questioning of established social and cultural hierarchies and, from 1973 on, unprecedented government interest in the arts, both of which were to affect Gazzard's work.

In the six years since the formation of the Craft Association in 1964, Gazzard's belief in the establishment of a national crafts body that would raise standards and operate on an international level had never faltered. The long hours of meetings and lobbying by dedicated committees had met with some success. An exhibition at the Design Centre in Bridge Street was indicative of improved standards. Australian craft had been seen at an exhibition in Stuttgart, Germany, and at the 'Asia Pacific Exhibition' in New Zealand. The newsletter *Craft News* was established and an overseas exhibition of batik curated by Indonesian Iwan Tirtaamidjaja had been mounted in Sydney. In 1970 an increased effort to involve all States eventually resulted in the formation of a national body and a grant of $12,000 from the Australia Council for the Arts. In 1971 the Crafts Council of Australia was established, with Gazzard as its inaugural president and Jane Burns as executive director.[1]

In the same year craft received recognition from the art world when Marea Gazzard and the weaver Mona Hessing were invited to present a joint exhibition in the temporary exhibition space of the National Gallery of Victoria, hitherto the province of the fine arts. Although the same State gallery had in 1969 mounted Kenneth Hood's major retrospective of the senior potter Harold Hughan, the offer of the large temporary exhibition space to two young women working in contemporary craft was unprecedented and indicative of changing perceptions.

On viewing the exhibition space, which one critic likened to an aircraft hangar,[2] Gazzard and Hessing decided to approach the project as collaborative designers. After studying the space and the lighting, the two artists made a scale model to determine the number, size and position of the works.

This method of working was stimulating. Hessing had previously worked on several large architectural commissions[3] and, like Gazzard, enjoyed producing work in response to a particular space. Visiting each other's studios they would find new ideas constantly occurring as a result of the interaction.

The size of Gazzard's work was limited by kiln dimensions and Hessing, who was working with natural fibres, was restricted to a colour range from sand to brown red. Hessing's free-hanging, off-loom weaving was large and, in response to its earthy tones, Gazzard decided to work in white clay. Both artists were at pains to ensure the integration of their work and materials into an essentially coherent whole. It was a difficult space, and challenged what could be achieved with the most basic of materials and techniques of handbuilt clay and off-loom weaving. Entitling the exhibition 'Clay and Fibre', Gazzard and Hessing hoped to establish a new status for these materials, which lay outside their most commonly perceived functional role.

At this stage of planning for the exhibition Gazzard's interests centred on the earliest expression of form in both nature and art. Her study at the Australian Museum had focused on the forms contained within Cambrian and pre-Cambrian fossils and her attendance at the 1971 World Crafts Council Conference Directors' Meeting in Malta had alerted

21. KAMARES VII 1972
stoneware, unglazed, handbuilt
67.0 x 26.6 x 74.0
photograph Norman Nicholls

following pages:
GATHERING AT VOUNOUS 1972
detail
photograph Donald Gazzard

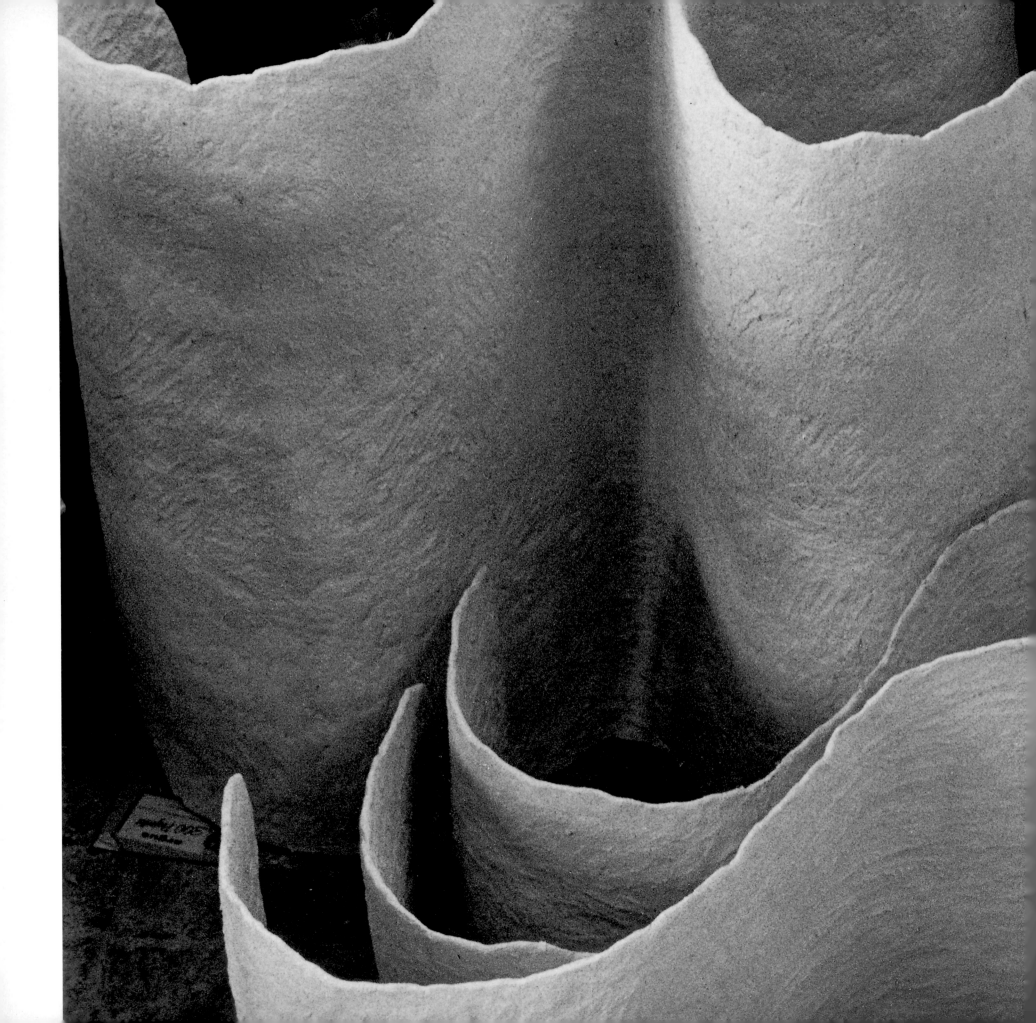

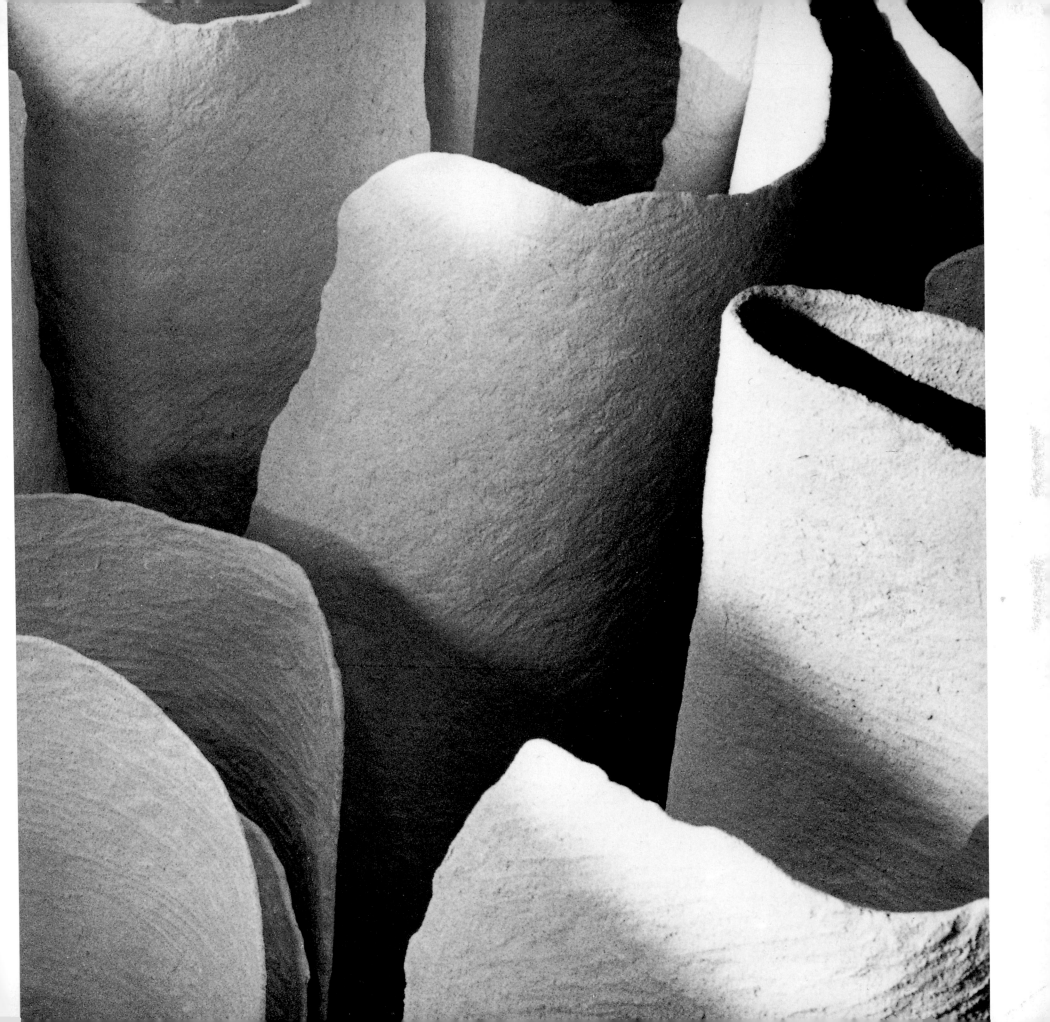

Bernard Boles and Patrick McCaughey, pushed beyond these limitations. McCaughey stated:

Mona Hessing and Marea Gazzard are the superstars of Australian craft. For both women expand, indeed explode the familiar perimeters of the crafts. Where the crafts are still regarded as belonging to the functional and the useful these women declare a new imaginative status for their objects. Marea Gazzard's outsize whitened ceramics have a coldness, a strength of belief in their own object qualities beyond function or purpose which lifts them well clear of the arts and crafts ghetto.[5]

Alan McCulloch suggested that reductivity or minimalism in art had reached a point when the identities of painting and sculpture could be relinquished in favour of a new art form which would include the crafts,[6] while Donald Brook found the exhibition 'deplorable' and made a case for maintaining existing boundaries: 'The works are not craft in the simple and important sense of being useful things well made, and neither are they art in the sense of belonging formally, historically or conceptually to a coherent family.' Such works, he argued, should not be set up in art galleries for people to contemplate as if they were sculpture.[7] Brook chose to ignore issues of intention and the historical role of clay as a sculptural medium. By 1985 his argument had changed and he was to write:

There has been a huge effort in recent years to promote craft to the status of art. Some of the motives for this are soundly based: there is indeed no significant difference between art as it is conventionally so called and craft. But this logic suggests not that craft should be promoted to the status of art (with accompanying mystification) but that art should be demystified into craft as it was for the Greeks and for many other cultures.[8]

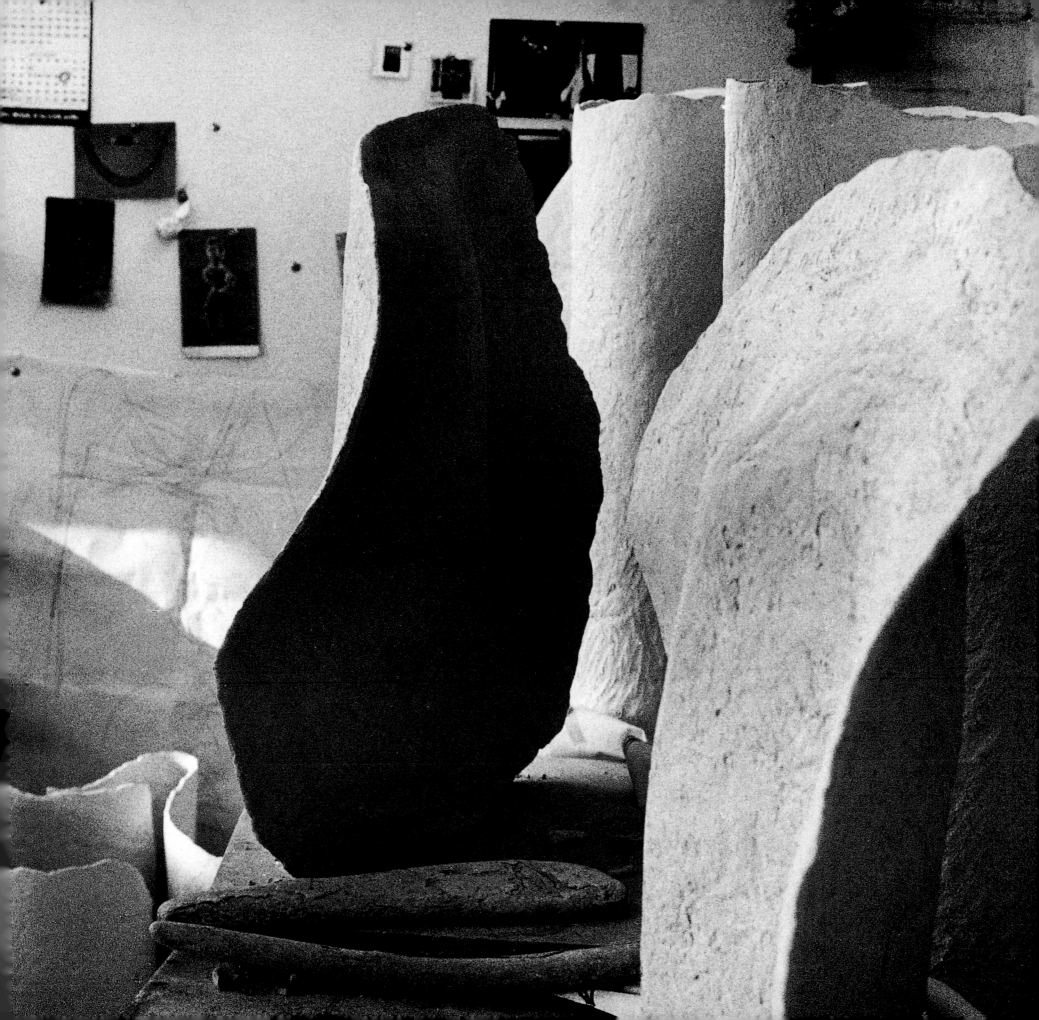

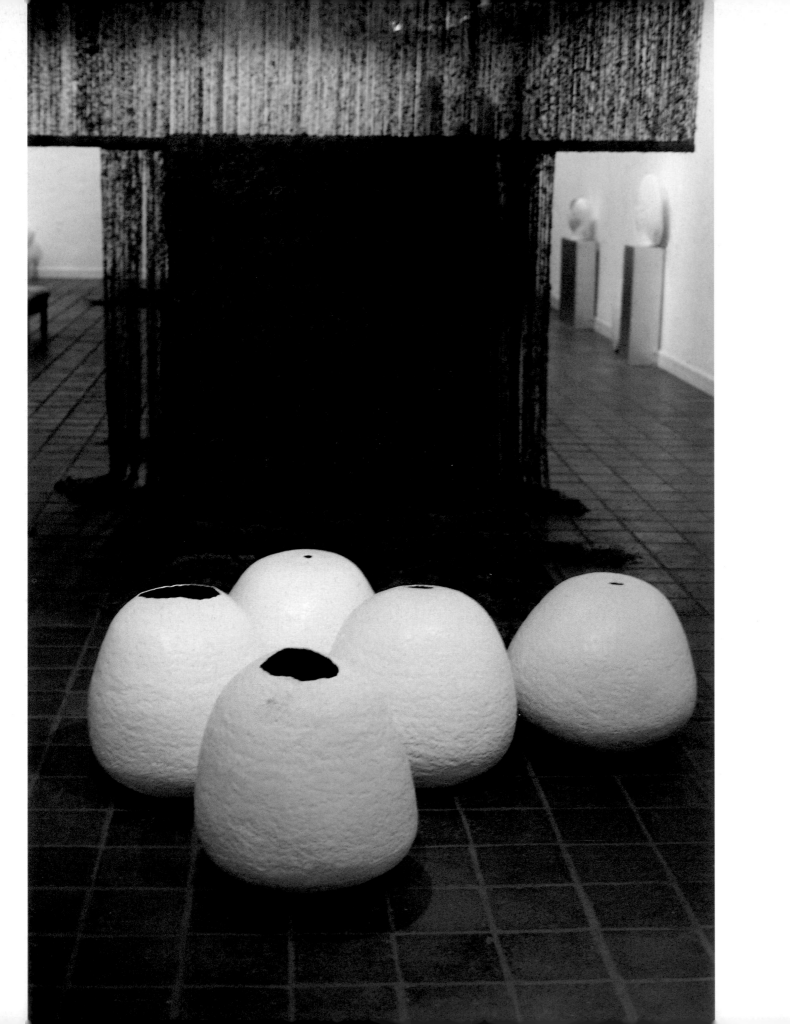

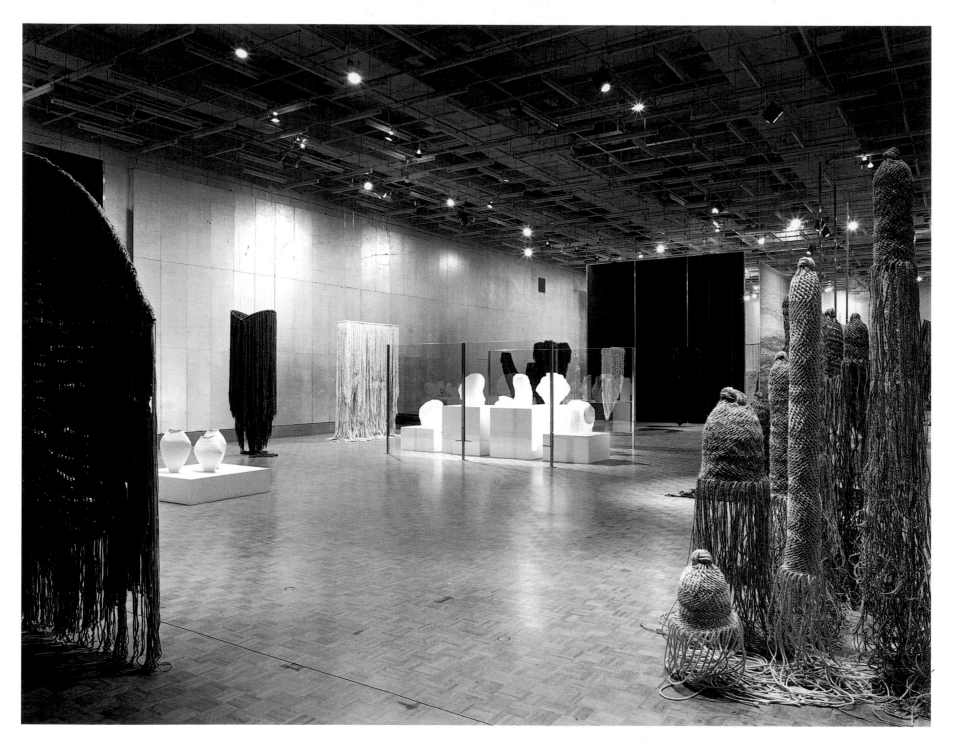

opposite:
23. GAZI I–V 1972
stoneware, white matt glaze exterior,
dark interior glaze, handbuilt
height 50.0 – 54.0, width 48.0 – 57.0
photograph David Moore

View of the Clay and Fibre exhibition
National Gallery of Victoria
Melbourne 1972
photograph David Moore

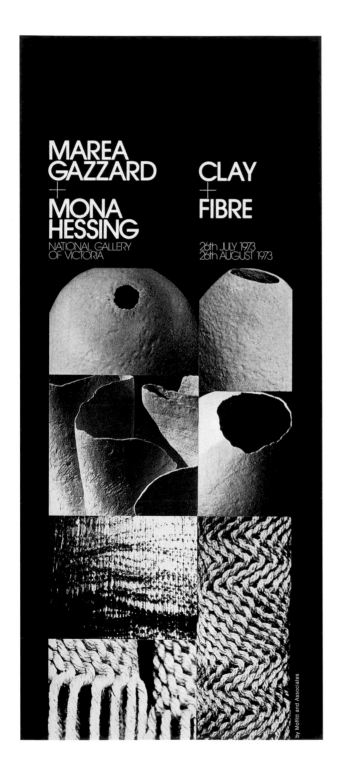

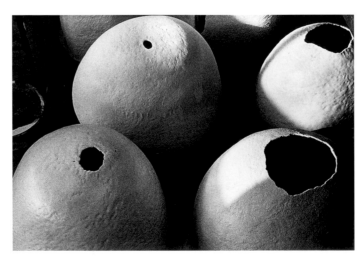

left:
Clay and Fibre catalogue
designed by Valli Moffitt

top:
Marea Gazzard in her studio 1972
photograph Leslie Gerry

bottom:
GAZI I–V 1972
detail
photograph Donald Gazzard

Gazzard did not participate in the debate. By presenting the exhibition she and Hessing had demonstrated a non-functional use for traditional materials. They were concerned with the quality of the objects but not with their classification. Gazzard does not believe in establishing hierarchies based solely on the presence of basic materials and techniques, but rather on the existence of ideas and the success of their execution in whatever medium is adopted.[9]

Because of her high profile in the crafts movement Gazzard's work is constantly subjected to arguments about hierarchical distinctions. In reality, such distinctions are of little concern to her. Gazzard sees no connection between the objects that she makes and her work in promoting the crafts. As she points out, her administrative work centres around issues such as employment, apprenticeship and marketing, which are in no way related to the ideas expressed in the objects she produces.[10]

Increasingly, however, it was craft problems that occupied her time for the next four years. In 1972 she attended the World Crafts Council Conference in Istanbul, Turkey, where she was elected World Crafts Council Vice-President for Asia. In 1973 she was invited by Prime Minister Gough Whitlam to become the first Chair of the Crafts Board of the Australia Council for the Arts, which had been established by the newly elected Labor Government as part of its enlightened arts policy.[11]

Gazzard was conscious of the enormous responsibility of these positions. The Crafts Board was included in the Australia Council for the Arts largely as a result of intensive lobbying by the Crafts Council. It was important that she make a success of the Board in its early years. At this stage there were no staff and no policy, and she had to set aside her own work and concentrate on vital administrative tasks.

Two factors assisted the Board in achieving its objectives. The first was Gazzard's contacts within the World Crafts Council, which enabled her to seek advice and information from more established networks, and the second was the existence of the Committee of Enquiry into the crafts in Australia. Established in 1972 at the instigation of the Crafts Council of Australia, it was not until 1973 that the Crafts Enquiry, under the directorship of Felicity Abraham, became truly effective in supplying information and recommendation to the Crafts Board.[12]

In these early years of the Crafts Board, Gazzard set out to improve education; establish workshops for both local and overseas craftspeople; bring good international exhibitions and lecturers to Australia; establish national exhibitions, traineeship programs and quality publications; and to lobby schools and galleries for greater participation. Through these efforts it was hoped to achieve standards of excellence that would result in an improved status for the crafts. She was also conscious of the need to involve the community and establish an environment in which creativity could take place. By 1975 small crafts industries were being actively promoted and 183 grants had been given to craft organisations as a means of establishing links between craft and daily life.[13]

Gazzard's commitments as World Crafts Council Vice-President for Asia were also demanding. After her election, the Asian Secretariat was moved from India to Sydney. The craft issues of this vast region were varied and challenging.

In 1973 she was invited to Papua New Guinea

to advise on ways in which crafts could be made economically productive.[14] She was then asked to co-ordinate an event representing the crafts of the many countries in the Asian region at the forthcoming Tenth World Crafts Council Conference in Toronto in 1974. She enlisted the help of the choreographer and theatre designer Silver Harris to create an event with a theme of 'Human Adornment'. Harris devised a performance in which fourteen different countries contributed dance and decorations, including the body art of Australian Aborigines, the headdresses of Papua New Guinea and exotic costumes of Thailand. Spectacular kites by Peter Travis flew outside. The success of this production was overwhelming as audiences gave standing ovations and broke into spontaneous dancing. Reporting the event in the American publication *Craft Horizons*, editor Rose Slivka was to write:

If energies can be judged by the quality of the five continental half-days, then we must give our enthusiastic recognition to the sensitive and creative range of Asia, concertized in a stunning performance that showed the contrasts and sympathies that make it, with Australia in its geographical and cultural orbit, a dynamo of craft activity.

… It showed what can be done seriously, imaginatively, poetically to dramatize the many art forms that are alive and well and living in that part of the world.

The original co-ordinating force for the Australian–Asian venture was the indomitable and visionary Marea Gazzard, World Crafts Council Vice-President for Asia.[15]

Australia's contribution to the conference included the film *One Weft Double Cloth*; directed by James Coffey, it examined the work of Mona Hessing, Peter Travis and Marcus Skipper. It also included the publication of a special issue of *Crafts of Australia* edited by Joyce (Joy) Warren.

This publication was made of recycled handmade papers and pictorially presented a range of Australian craft. An introduction by Gazzard voiced a strong commitment to the support of Aboriginal culture and stated that Australia's role as an isolated outpost of Europe was rapidly being replaced by active involvement in Asia, stimulating a two-way exchange through the world of craft.[16]

As part of this exchange Gazzard visited Thailand and Malaysia in 1975 and then organised the week-long Asian Assembly of the World Crafts Council in Sydney. Attended by twenty-one nations, this occasion and the pertinence of its seminars did much to strengthen Asian perception of Australia as a catalyst and organiser within the region.[17]

In 1976 Gazzard retired from her position as Chair of the Crafts Board but it was not until 1978 that she retired as World Crafts Council Vice-President for Asia before becoming World President in 1980. During these years of service Gazzard made twenty overseas working trips. Some were lonely and hard work but more often they were stimulating. These trips enabled her to keep in touch with overseas art and with a number of good friends involved in the crafts. In the United States she would visit Helen and Nicholas Vergette, Rose Slivka, Mrs Vanderbilt Webb and Ruth Duckworth; in India, Patwant Singh and Kamaladevi Chattopadhyay; and in England, James Noel-White and, especially, Lucie Rie.

Travel gave her a grassroots understanding of the complex and varied issues which beset the promotion of craft on an international scale, while the opportunity to study form in many international museums provided stimulation for her own work, which she recommended in 1977.

24. PAROS and TEKE I 1972
stoneware, white matt glaze, handbuilt
68.0 x 73.0 x 18.0, 73.2 x 62.0 x 17.0
photograph Donald Gazzard

below:
25. MELOS and DELOS 1972
stoneware, white matt glaze, handbuilt
67.8 x 70.5 x 21.5, 62.1 x 70.0 x 18.5
photograph Donald Gazzard

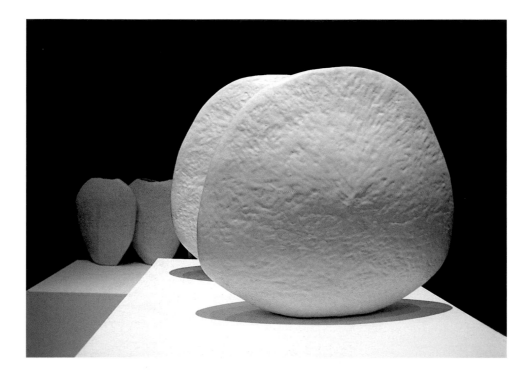

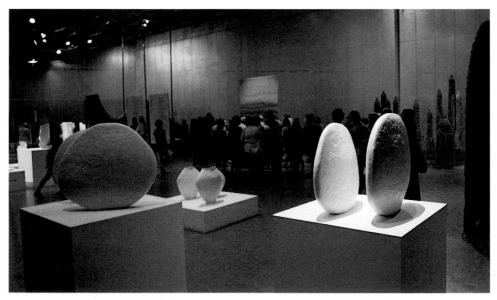

View of the Clay and Fibre exhibition
National Gallery of Victoria
Melbourne 1972
photograph courtesy National Gallery of Victoria

Like many artists seeking a supplementary income, Gazzard became involved with teaching, first at Ascham School, Edgecliff, and then as a visiting lecturer at the University of New South Wales's College of Fine Arts (then the City Art Institute, Sydney). She enjoys teaching and has an easy rapport with students. She is more interested in attitude than talent and believes a teacher's role is to impart specific skills, to encourage a spirit of enquiry and a striving for quality. Ultimately she feels students must develop the ability to criticise their own work and set their own standards. Of her teaching methods she says:

I find it interesting communicating to students the feelings I have about clay and watching their reaction and responses. It's exciting and quite often you can learn – even from a beginner – something you had never thought of before. I find that fascinating …

I try to remove the mystery for them. I suppose in a way I'm trying to teach them to make simple honest things and not be too clever, to start from simple forms and develop their ideas from that …

In teaching I have come to the conclusion that you can teach very simple methods and get very effective ends. Burnishing, coiling and beating do this. The students can become attracted to the clay in this way and then find their own way.[18]

Gazzard's ability to communicate her feeling for clay is well known. Internationally she has lectured at the Smithsonian Institute in Washington DC and at the Central School of Art and Design in London. In 1976 she, along with other artists such as Mexican potter Hugo Velasquez and North American ceramist Peter Voulkos, was invited to participate in a ceramic seminar at the World Crafts Council conference in Mexico City. This was followed by an invitation to be guest artist at the Haystack Mountain School of Crafts and Design

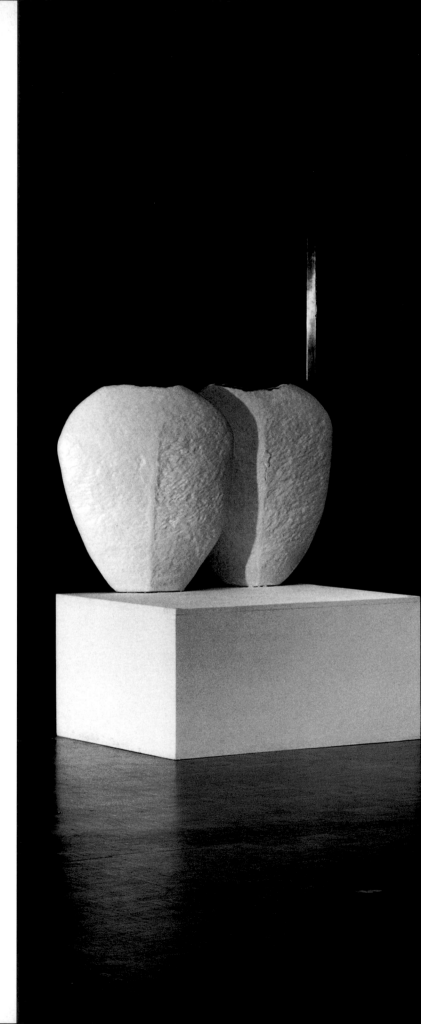

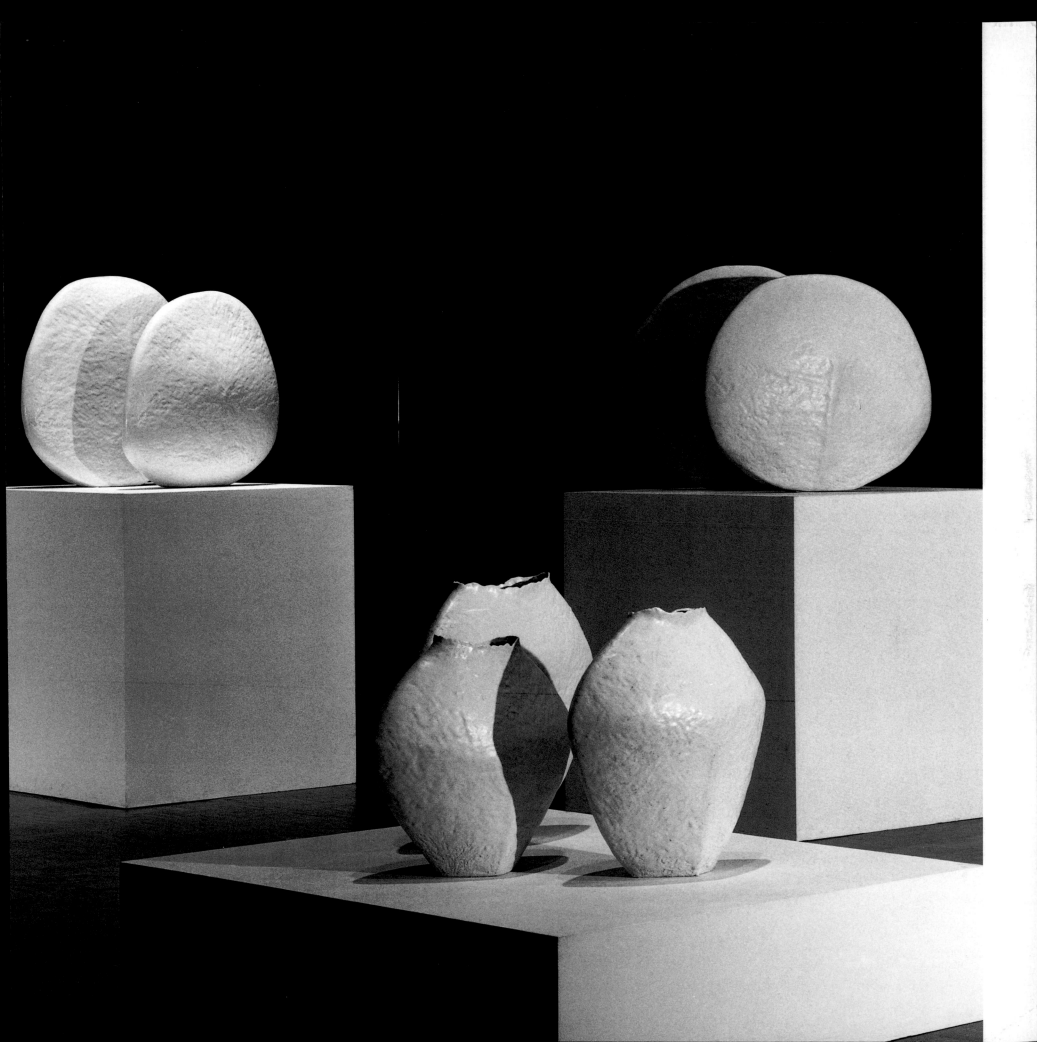

in Maine, USA,[19] where she enjoyed working alongside both visual artists and poets.

In the mid-seventies the Gazzards had moved house. A vacant block of land in Hargrave Street, Paddington, provided Donald with the opportunity to design a contemporary house which provided studio space and more room for their now teenage children. As yet, Gazzard's commitments had left her little time to work in the new studio so it was with much enthusiasm that she began work in 1977.

Looking through her sketchbooks she noted the repetition of form in many of the objects she had drawn. Religious copes at the Victoria and Albert Museum in London, armour in Stockholm, the Buddha in Japan, all reflected an interest in the torso and shoulders of an object. At the Australian Museum she became interested in the whale skeleton and at the Opera House library a book by Howard Blackmore, *Arms and Armour*,[20] revealed similar forms in the illustrations of sixteenth-century armour.

In April 1978 an entry in her diary records:

Fragments have interested me for a long time. The suggestion of an arm, a shoulder or any point of the human body I find interesting. A fragment of an antique Greek or Roman figure is often more interesting than the whole. Also I've been interested in the moulded shape of a garment around the human form. The cope, the cape, the armour – these make me think of the people within … The skeleton of the whale fascinates me.

As she worked, she reflected on the human element sometimes seen in rocks, and she thought she would like to find a means of expressing the ambiguity between images and their associations.

These ideas of rock forms encouraged her to experiment with a dry texture. Using an English clay which was 40 per cent grogged, Gazzard began coiling large works on the kiln shelf. Colour was added later, using a spray gun and contrasting slip before the work was fired (see Appendix). Gazzard works from sketches but as the work progresses, the effects of light and texture influence her perception of the form, as does her intuitive response to the substance of clay. The resulting objects often take the place of sketches as she studies their success, destroying some and developing others. There is often a long period when she lives with and examines her work to determine whether it should be left alone or developed further.

It was during such a period that Wandjuk Marika first observed the works. Marika was then Chair of the Aboriginal Arts Board and, like his predecessor Goobalathaldin (Dick Roughsey), had become friends with the Gazzards through his work at the Australia Council of the Arts. When she first met Goobalathaldin, Gazzard invited him to stay in the family house during his visits to Sydney, and over the years he became very much a part of the family. Later the same hospitality was extended to Marika and his visits were eagerly anticipated. It was on one such occasion that he remarked that her work reminded him of Uluru, the area around Ayers Rock in Central Australia.

At that stage, Gazzard had not visited the area but she was well aware of its significance. She had always felt a spiritual bond with Aboriginal people, and entries in her notebooks often refer to the Aboriginal feeling of a place.[21] Marika's comments now made her think deeply about the region and the Aboriginal mythology of the Kunia people, for whom these great rock monoliths represent events from the Dreamtime.

26. PORTI I 1972
stoneware, white matt glaze, handbuilt
47.9 x 60.0 x 26.0
photograph David Moore

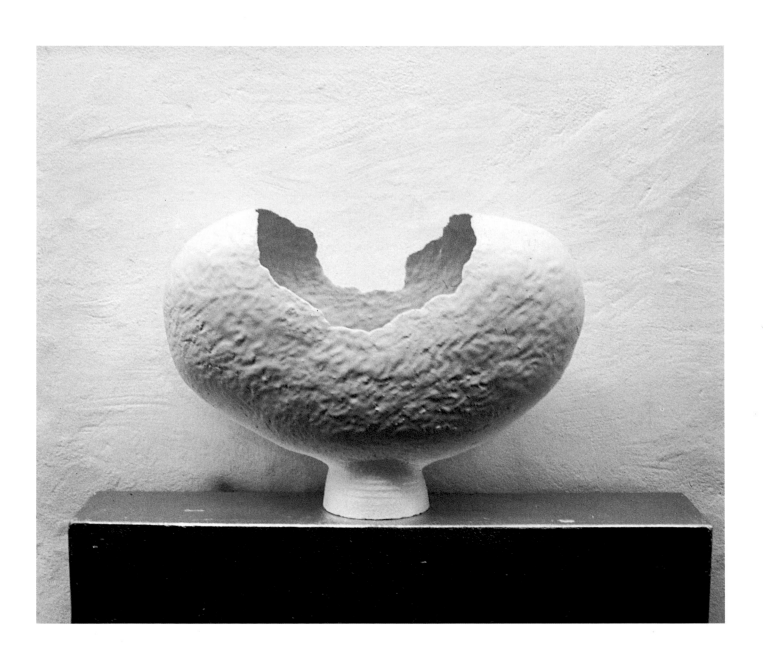

These ideas now began to influence her approach to her work as did the subtle colouration of Lloyd Rees's wash drawings. Walking through the Art Gallery of New South Wales, she had suddenly found herself attracted to Lloyd Rees's *Mount Wellington* 1973. His detailed drawings of rocks are well known and the anthropomorphic quality in some of his landscapes has influenced several Sydney artists.[22] It was his use of colour, a pale blending of fawns, pinks, greys and washed-out ochres to which she responded. This discreet colouration was a means of capturing both the vitality and the timeless quality that she was seeking to express in her own work.

In September 1979 Gazzard had a solo exhibition at Coventry, Sydney, which she named the *Uluru* series. It presented three groups of forms, whose titles paid homage to Aboriginal culture: the *Kunia*, meaning 'the warriors towering above'; the *Bularri* (ill.28), who are the big women of the clan; and the *Mingarri* (ill.29), or mice-totem women. These titles paid homage to Aboriginal culture.

The forms work well in isolation: solitude increases the monumental presence and allows for an intimate contemplation of surface and volume. But when they are grouped together, the viewer becomes aware of the full implication of Gazzard's work. Connecting characteristics and subtle variations of form indicate the intuitive responses and calculated developments by the artist in the exploration of her ideas. Spaces between forms, overlapping planes and the play of light create an intense interaction between the individual work and the group as a whole.

More than Gazzard's previous work, the *Uluru* series has a distinctly anthropomorphic quality. The wide-domed *Kunia* 1979, remote and powerful, affords shifting recognition of flattened faces or strong muscular backs, while the broad and varying forms of *Bularri* 1979 appear anchored to the earth yet interconnect through the open-topped overlay of planes which are formed by the shoulders of the pieces. In contrast, the *Mingarri* 1979 project a tranquil serenity in their more rounded form and softened colour suggestive of the Rees drawing.

In all these works the surface texture is dry, and sometimes etched with sgraffito; colour, although applied to the surface, often appears to emerge from the object like mineral deposits weathered and burnt into the rock substance. Just as the white vitrified surfaces of the 1973 work evoke a Mediterranean feeling, so the texture and colour, ranging from the soft tones of sandstone to the rich reds of the desert, here suggest the Australian character of the work.

In the *Uluru* series Gazzard used the pliable qualities of clay to convey the dense solidarity of rock and its direct relationship to the ground. Although this was a new concept in her work, it is clearly linked to her previous concerns with the ideas of containment and the presence within, expressed through her use of central spines, fragile openings and thin-shelled walls. This language of forms unites the *Uluru* series with her earlier work and points to the continuity existing throughout her œuvre.

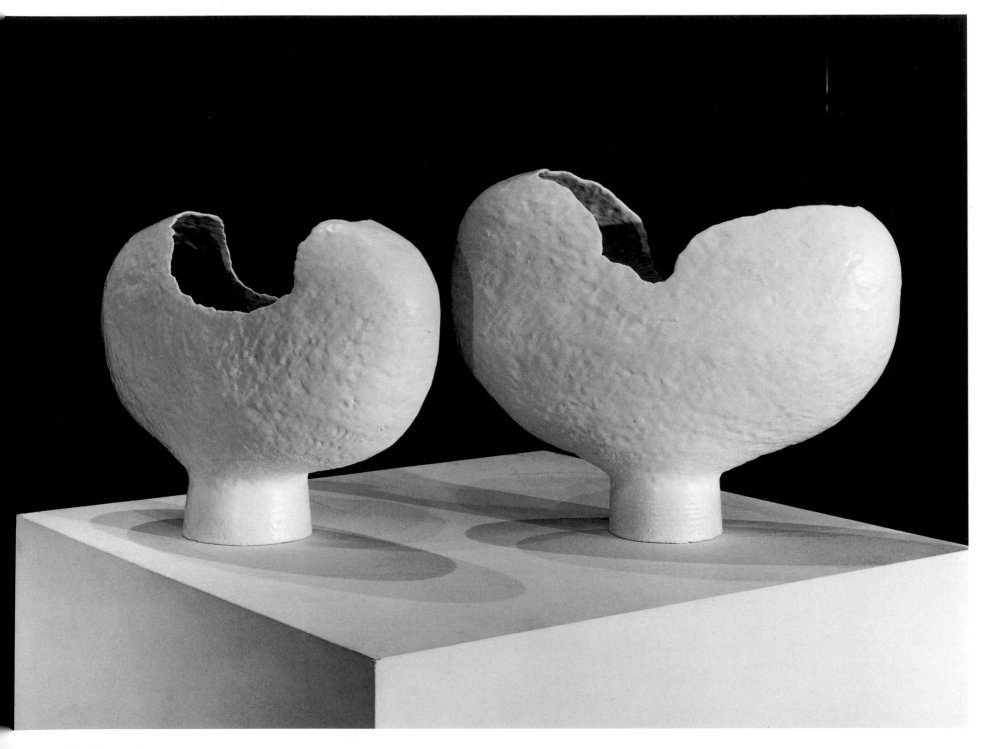

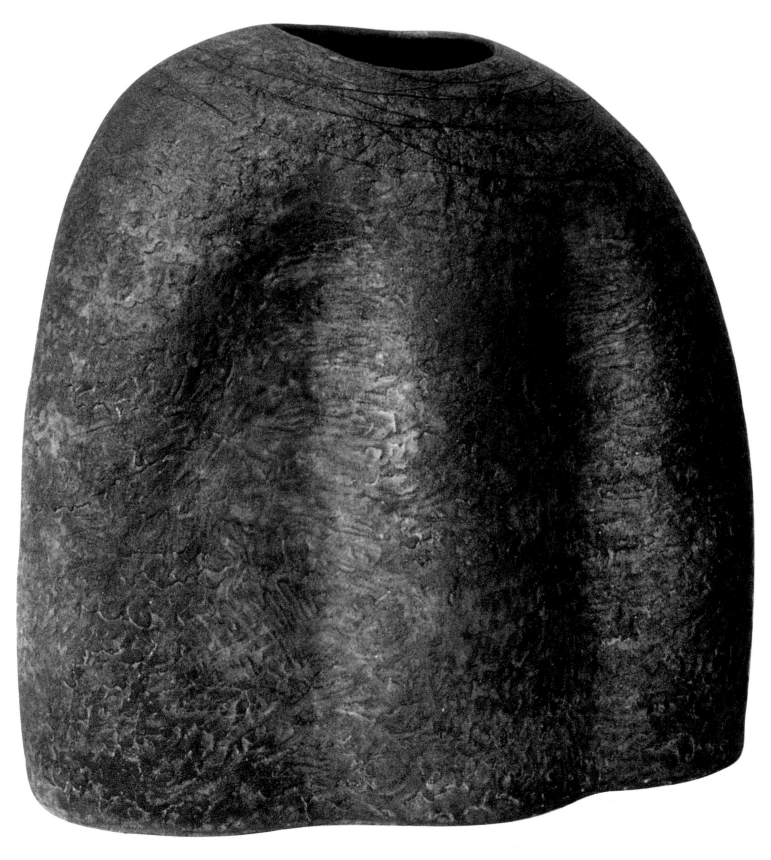

84

5. The World and Mingarri

In the late seventies Gazzard's considerable contribution to the crafts movement was recognised. In 1978, following her resignation as Vice-President for Asia, she was appointed an Honorary Officer of the World Crafts Council, and in 1979 was made a Member of the Order of Australia in appreciation of her services to the crafts.

Her own work was also acknowledged when in 1978 she was awarded a Senior Fellowship by the Australia Council. In 1980 she was invited to exhibit for the second time at the prestigious 'Città di Faenza XXXVIII Concorso Internazionale della Ceramica d'Arte Contemporanea', where she exhibited *Mingarri IV* 1979 from the *Uluru* series.

In July 1980 she became the first elected President of the World Crafts Council. The presidency had been formerly by appointment but at the Ninth General Assembly in Vienna the votes of sixty countries declared Gazzard their fourth World President.[1] Her capabilities were well known from her years as Vice-President for Asia, when she had established a reputation as a hands-on worker. Her support came particularly from Africa and Asia, where she had been found approachable and prepared to work through issues with an understanding of different national perspectives.

The Council was run from a small secretariat in New York, and her presidency would mean more travel and more time away from her own work. Recognising the importance of her presidency for Australia and its international relationships, expenses were co-funded by the Department of Foreign Affairs and the Crafts Board of the Australia Council.

In her election speech Gazzard emphasised that the goals of the World Crafts Council would be achieved not through financial resources but through using the resources of talent, energy and co-operation which existed within the organisation. 'It would succeed', she said, 'through an intelligence of mind as well as hand.'[2] Her policy emphasised regional development with the maintenance of a small headquarters, and a strengthening of ties between the World Crafts Council and UNESCO (the United Nations Educational, Scientific, and Cultural Organisation). She argued that the task of establishing and elevating the status of craftspeople could not be effective until the United Nations system recognised the close interconnection between economic and cultural roles, particularly within third world countries.[3] With the help of Curtis Roosevelt (grandson of Franklin D. Roosevelt) from the United Nations Secretariat, Gazzard worked on strengthening links with UNESCO.

In 1982 she was appointed a member of the Australian National Commission of UNESCO and was one of the Australian delegation at the UNESCO conference on World Cultural Policies held in Mexico in July. Here she was successful in gaining recognition for the crafts, and a unanimous decision resulted in the conference requesting member nations to allocate adequate resources within their cultural programs and national development plans for the identification, preservation and development of crafts. UNESCO agreed to join with the World Crafts Council to undertake a comparative study of the role of crafts within the development process.[4]

Gazzard's presidential duties involved a great deal of travel. They also involved spending time at the New York Secretariat where she worked with the World Crafts Council Executive Director, Ruth Barratt, co-ordinating activities and establishing

28. BULARRI V 1979
stoneware, applied slip, handbuilt
63.5 x 175.0 circumference
photograph John Delacour
courtesy Crafts Council of Australia

85

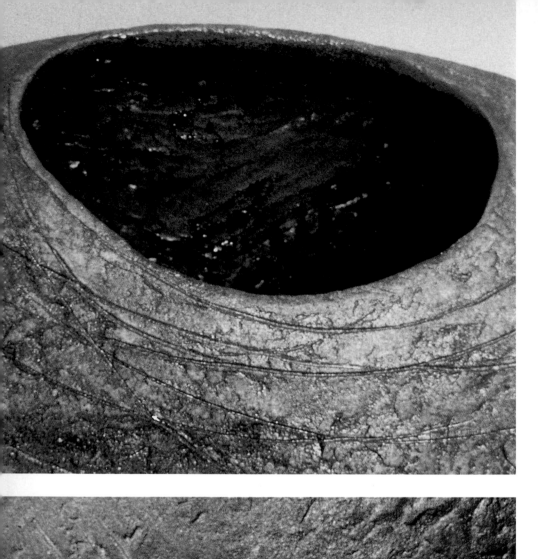

opposite:
Works for Uluru exhibition
details

29. MINGARRI I–V 1979
stoneware, applied slip, handbuilt
55.0 – 68.0 x 137.0 – 143.0
circumference
photograph John Delacour
courtesy Crafts Council of Australia

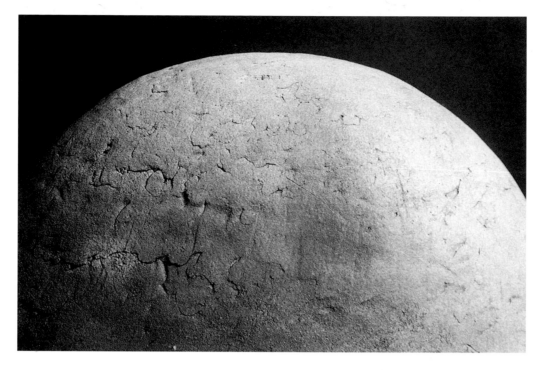

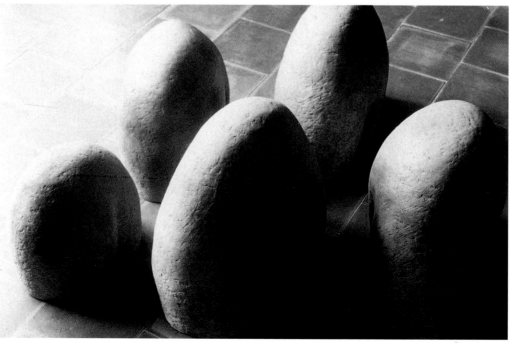

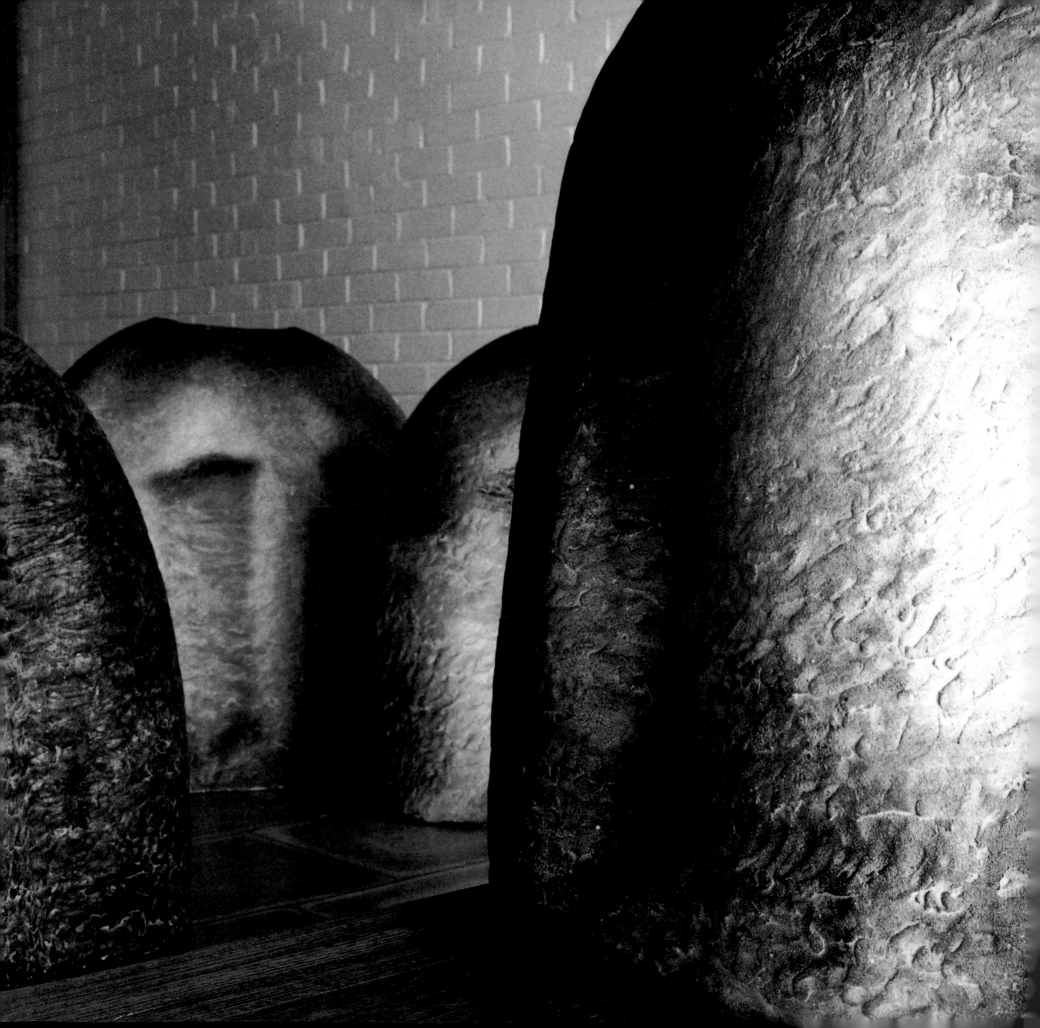

links with other United Nations agencies. One of their prime objectives was to increase awareness of the need to maintain the quality and cultural relevance of craft in developing nations, even when new living patterns brought about changes in the objects produced. This and the need for regional co-ordination were seen as essential to prevent the production of poor quality homogenised craft with no means of maintaining its marketability.[5]

In 1981 her dedication and commitment to the work she had undertaken was sorely tested with the breakdown of her thirty-year marriage. It was a devastating period, but in September she travelled to the centre of Australia with the painter Margaret Wilson, finding solace in the great rock formations which had been important to her recent work. At one point she was moved to tears as she recognised a rock form which seemed to be a summation of all the ideas embedded in the *Uluru* series. The enduring quality of these rocks, compared to the transience of life, gave her the courage to start work again.

Strangely, when she began working it was not the ochres of inland Australia but the colour green which was to inspire her new series.

In the middle of the freezing New York winter of 1982, while working at the World Crafts Council Secretariat, she began to think of the colour green and searched the city for the particular shade she wanted in an underglaze colour for clay. A week later she was in England and visited 'The Great Japan Exhibition: Art of the Edo Period 1660–1868' at the Royal Academy, London, an important, scholarly exhibition which presented a large range of aesthetic objects. Amidst this richness she found that she was repeatedly focusing on the colour green on screens, ceramic jars and paintings. On a screen from the

Momoyama period she noticed a painting of green hills: it was exactly what she had been searching for.[6] It was the incentive to start work.

On her return to Australia she began working on small maquette hill forms between 5 and 10 centimetres high. Gradually these developed into various shapes which became the *Pindarri* series 1982 (ill.30). The forms, handbuilt in terracotta with applied slip and wax, turn away from the anthropomorphic ruggedness of the *Uluru* series and become more smoothly rounded triangular shapes. The surfaces have an ancient feel. Unlike the windswept *Uluru* series, they are not reminiscent of the wilderness but of thousands of years of civilisation. It is the worn green of the orient; like ancient bronze, it is smooth with use.

The simplicity of *Pindarri* 1982 moves away from the specific to the expression of more universal forms. The works were inspired by the 'Great Japan Exhibition', but Gazzard entitled them *Pindarri* – not for regional reference, but as a statement of the forms' relevance to all cultures.[7]

Gazzard's first involvement with public sculpture[8] occurred in July 1982 when she was invited by the then director of the National Gallery of Victoria, Patrick McCaughey, to submit a proposal to the Ian Potter Sculpture Commission for a work to be sited in the moat surrounding the National Gallery of Victoria. This invitation was important in that it provided her with an opportunity to work on a large scale, using hill forms which developed from the *Pindarri* series. Although her proposal was not adopted, the preparation of the submission was beneficial as it taught her much about the complex issues of public sculpture and developed her confidence in working on a large scale.

Early in 1983 Gazzard worked at the World Crafts Council Secretariat in New York and then travelled on to London where she was guest lecturer at the London Central School of Art and Design. On her return to Sydney she was faced with the sale of the family home and the task of finding somewhere to live and to work. It was a period of readjustment which involved a reassessment of emotional relationships and departure from what had been a very special environment.

She quickly found a small apartment in Stanley Street, Darlinghurst, and, unable to find a studio, stored her equipment in a friend's garage. The enforced separation from her work made it essential to find a project to distract her from personal problems. As a child, Gazzard had lived by the sea but was not a proficient swimmer. She decided to learn to swim. The lessons renewed her self-confidence and gave her a sense of achievement as she learned to swim twenty laps. There was also a spiritual bond in going each day to the Domain pool, for on her way she passed by the great Moreton Bay fig trees overlooking Woolloomooloo Bay. The massive roots and limbs of these trees contrast spreading grandeur with encompassing form. They had the same qualities of endurance she had encountered in the art of ancient Greece and in the rocks of inland Australia. Like other Sydney artists, Lloyd Rees and Brett Whiteley, she became fascinated by their form.

In May, a studio became vacant at the Sydney Dance Company premises in Bourke Street, Woolloomooloo. It was an uplifting experience to work for the first time in a large space, and be surrounded by other creative people in the same way that she had enjoyed being guest artist in 1976 at the Haystack Mountain School of Crafts and Design in Maine, USA. The discipline of the dancers was impressive and inspired her to commence work. She began work on a group of low hill forms which she later called *Selini* (a Greek reference to the moon) (ill.33). Her interest in this form had evolved from a study of the top section of her previous *Delos* series 1973. Like *Pindarri*, these low smooth forms have a universal quality.

At a time when the tenets of modernism were under attack, Gazzard's work was becoming increasingly minimal. This simplification was achieved not through a process of elimination but through the synthesis of a wide range of ideas.

She was no stranger to the many issues that had brought about the demise of modernism. Since the sixties, when the art critic Clement Greenberg's formalist theories were at their most fashionable, she had fought on behalf of craft for that which lay outside the mainstream avant-garde, for community-based art, for recognition of women's contribution and for acknowledgment of tradition and regional identity. She was aware, however, that such objectives would only be worthwhile if the resulting objects maintained a standard of excellence. Her own work, which she sees as independent of her involvement in the crafts world, is subject to the same pursuit of excellence. Her persistence in searching for perfection of form was to lead to greater simplification.

In the early eighties Gazzard read Carl Jung's *Man and His Symbols*. A student, Nahum Szumer, had given her a copy of the book after recognising the universal quality of *Pindarri* 1982. Her discovery of Jung and an interest in Tantric art confirmed her belief in the universality of basic forms and increased her interest in forms as a means of communication.

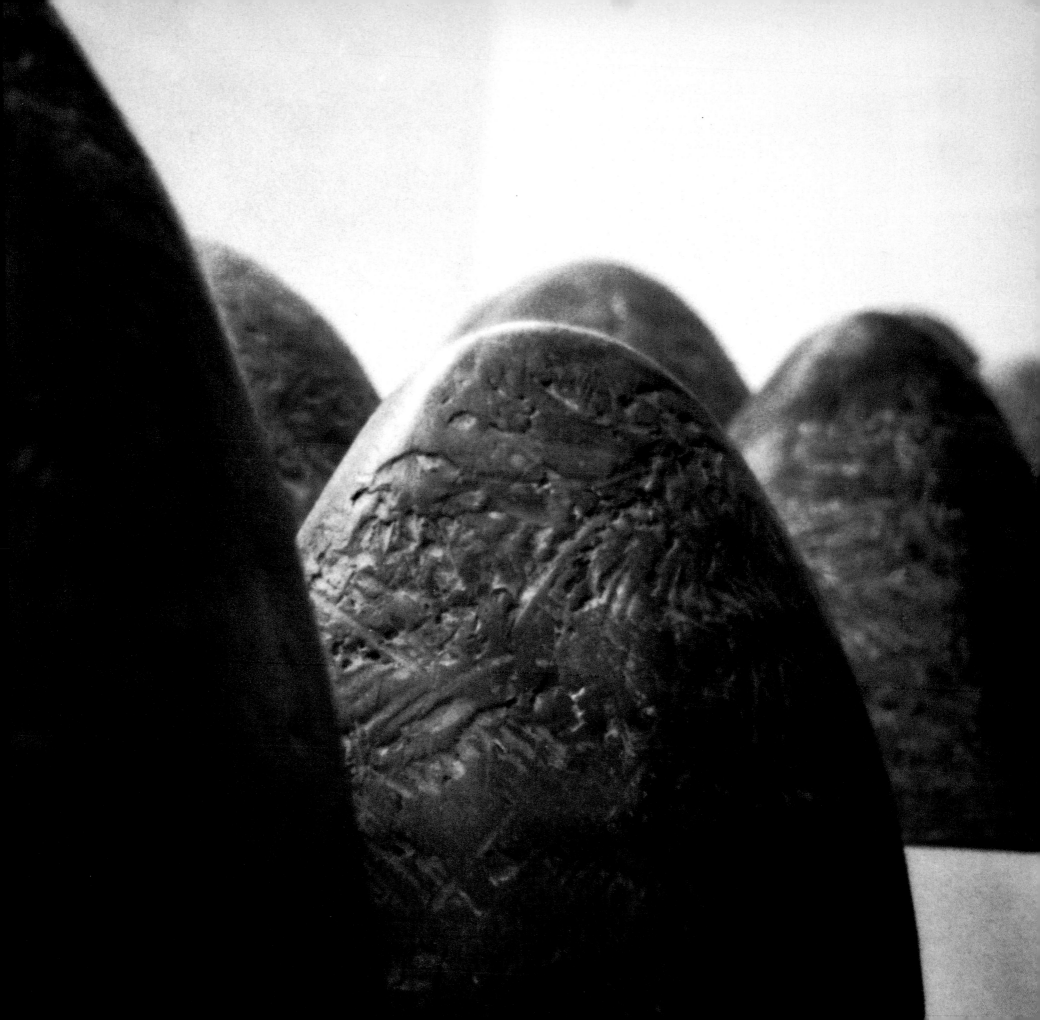

Gazzard's ability to work on a large scale had not gone unnoticed. The dancer and choreographer Graeme Murphy, artistic director of the innovative Sydney Dance Company, had seen her submission for the Ian Potter Sculpture Commission and observed her working on the *Selini* series. He was impressed by the spatial quality of the work and invited her to design sets for a production, *Risks*. Unfortunately, she had to refuse this commission as her World Crafts Council commitments required her presence in Greece for talks with Cultural Minister Melina Mercouri. Mercouri's concern for the crafts was indicative of the World Crafts Council's achievements. Worldwide the status of crafts had improved, resulting in many influential figures, such as Mrs Indira Gandhi and Thailand's royal family, actively supporting the craft movement.

Although Murphy later commissioned her to execute a low-lying, hill form sculpture for his apartment, Gazzard was disappointed not to be involved in the proposed production of *Risks* and became increasingly aware that her presidency of the World Crafts Council left insufficient time for her own work. After her meeting with Mercouri in Athens in 1983 she took a short holiday with her cousin, Anna, on the island Kythera. Among diary entries of her heavy workload her continuing identification with Greece is evident. She records with delight the simple experiences of 'the priest on his motorbike; travelling on the bus beside a proud new father carrying netted blue almonds; the baptism; the pink drink; the honey sweets and the stones of Kythera'.[9]

A visit to Lucie Rie in London and exposure to her concentrated work pattern helped Gazzard realise the need for uninterrupted work. At the Tenth World Crafts Council Conference in Oslo, Norway, in August 1984, she did not stand for re-election.

January 1984 was the last winter spent working at the New York Secretariat. On her return to Sydney she was asked to contact Mitchell, Giurgola and Thorp, architects for the proposed new Parliament House in Canberra. Design of the new Parliament House had been determined as a result of a two-stage international competition held in 1979 and had attracted 329 entries from twenty-eight countries.

Mitchell, Giurgola and Thorp's winning submission for the vast complex[10] was remarkable for its design and for its scheme to integrate major works of art and craft into monumental architectural spaces. These were intended not as decoration but as an integral part of the architectural whole, intensifying the building's content and meaning. It was intended that artists and craftspeople collaborate with architectural teams from the outset.[11]

Two partners of the architectural firm, the art and craft co-ordinator Pamille Berg and its chief architect, Romaldo Giurgola, had visited Gazzard's studio in 1982. In 1984 she was invited to Canberra, where Berg outlined the philosophical approach to the design, showed her a model of the proposed building and asked her to submit ideas for a work for the Executive Court.

The Executive Court, a vital part of the complex, is flanked by the Prime Minister's suite, the ministerial suites and the parliamentary library. It is also an entry point to the building for special guests and members of the executive who arrive by car.

Gazzard gave the project much thought. The court was adjacent to the Prime Minister's suite where decisions of national importance would be made. It was necessary, she determined, to create a space that was quiet and contemplative. As it was also the first point of contact with the building for

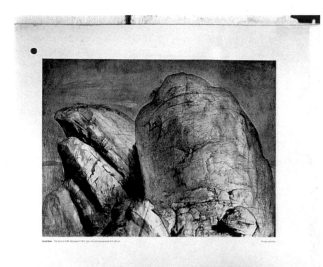

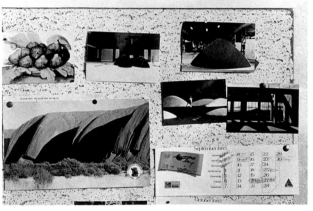

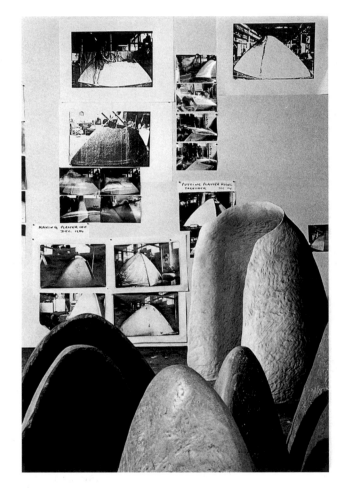

Woolloomooloo studio, 1980

visiting heads of state, she felt her sculpture should reveal a universal form recognisable to most people irrespective of cultural background. It should also incorporate a symbolic aspect relevant to the space and institution and, as the work would be in place for several hundred years, it was important to produce a sculpture which appeared timeless and without signatory overtones.

With these criteria in mind, she worked through a number of solutions before deciding to present a group of five hill-like forms. This would create a quiet contemplative mood, be recognisable as landscape to visiting heads of state and yet make reference to the other centre – the centre of Australia – known for its rock forms and its Aboriginal culture.

Gazzard also felt that as the Executive Court was sited on the only rock formation within Capital Hill it was important for the works to appear to grow from the ground, indicating, like the Easter Island sculptures, that there was more beneath the surface.

The scale, she decided, should be determined by the full vista of the court but should also invite a closer inspection. Therefore the works needed to be comfortable to walk between and look over. In keeping with the contemplative mood she proposed that the works be a soft green colour, in harmony with the architecture, and that the material be cuselmon bronze which is suitable for outdoors, requires little maintenance and would be enhanced with the passing of time.

Artist and architect collaborated from the early design stage. Giurgola had originally envisaged that the sculpture would be sited in the water component of the court [12] but he was attentive to Gazzard's reasons for wanting the works to be earthbound, to be touched and to be walked around. When Gazzard was issued with her brief it incorporated the ideas of both artist and architect. [13]

After costing and establishing scale with paper mock-ups, she built wire sculptures to the actual size of the intended works. These were covered with papier-mâché and coloured. The response was favourable from the architect and the Art Advisory Committee, and she was advised to proceed to Stage I of the commission, which involved producing a 1:20 maquette of the work, a full-size plaster piece and a small bronze.

The Parliament House Construction Authority approved Stage I, and in June 1985 she began making the five clay models. Plaster casts were then taken from the clay models and transported to the Meridian Sculpture Founders in Melbourne where they were cast in bronze using the lost wax method. Photographic and video records of the making of the sculpture reveal the increasing vitality of the forms, from the time she began working in clay. She had to straddle the walls so she could handbuild the large forms from both sides. She works from the inside out and the inside form is just as important as that of the exterior. This direct process of handbuilding resulted in a rounded density, and enriched the surface, which catches light and facilitates the play of shadow.

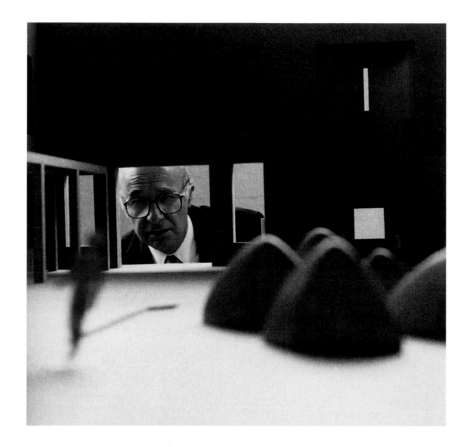

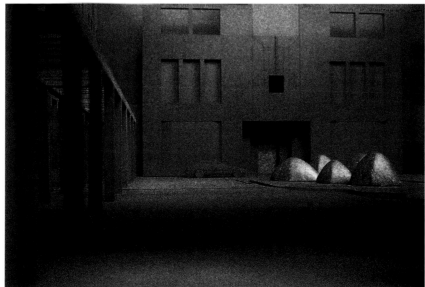

top:
Chief architect Romaldo Giurgola
viewing Gazzard's model of proposed
work, Parliament House, Canberra

right:
1:20 model of proposed work

In the early stages of the work Gazzard had decided
to call the works *Mingarri: The Little Olgas*. In the
Uluru series 1979 she had used 'Mingarri' to refer
to the anthropomorphic quality of the work, which
she associated with the Dreamtime legend of mice-
totem women. In the Parliament House work the
title refers literally to the rocks, and to the way in
which these forms are perceived in the Australian
landscape. From a distance they appear as small
hills and at close range as individual boulders.

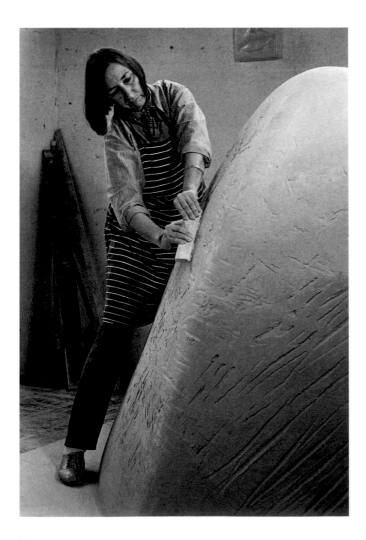

Gazzard working on the clay models
for Mingarri: The Little Olgas
photographs David Moore
courtesy Parliament House
Construction Authority

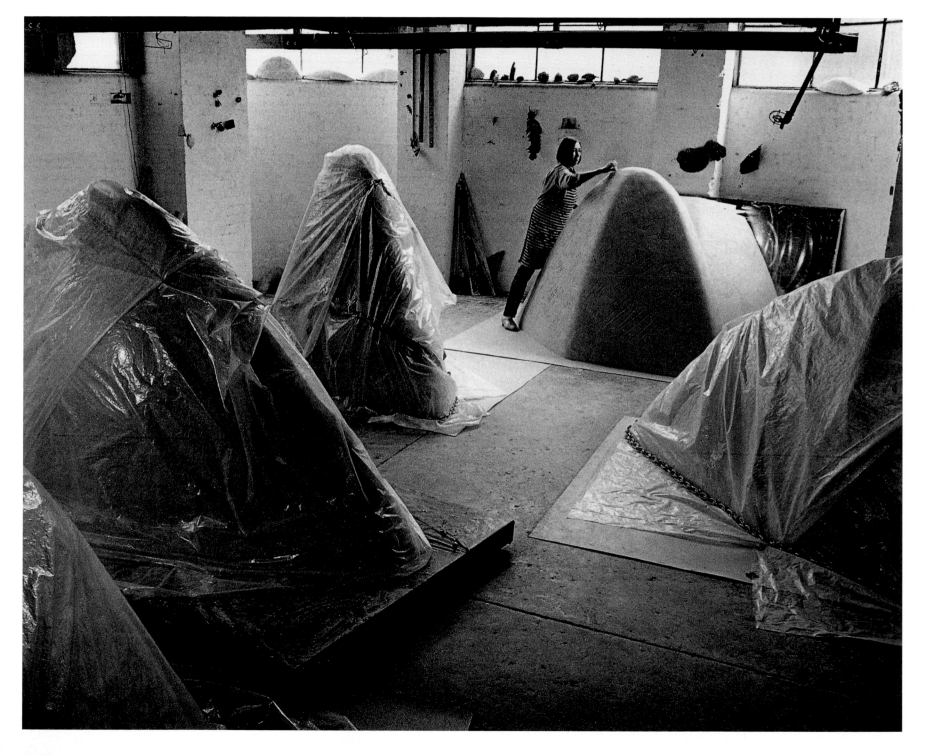

right:
Gazzard working on the clay
detail
photograph David Moore

opposite and following page:
Jan Shaw and Peter Morley taking plaster
casts from clay models
photographs David Moore

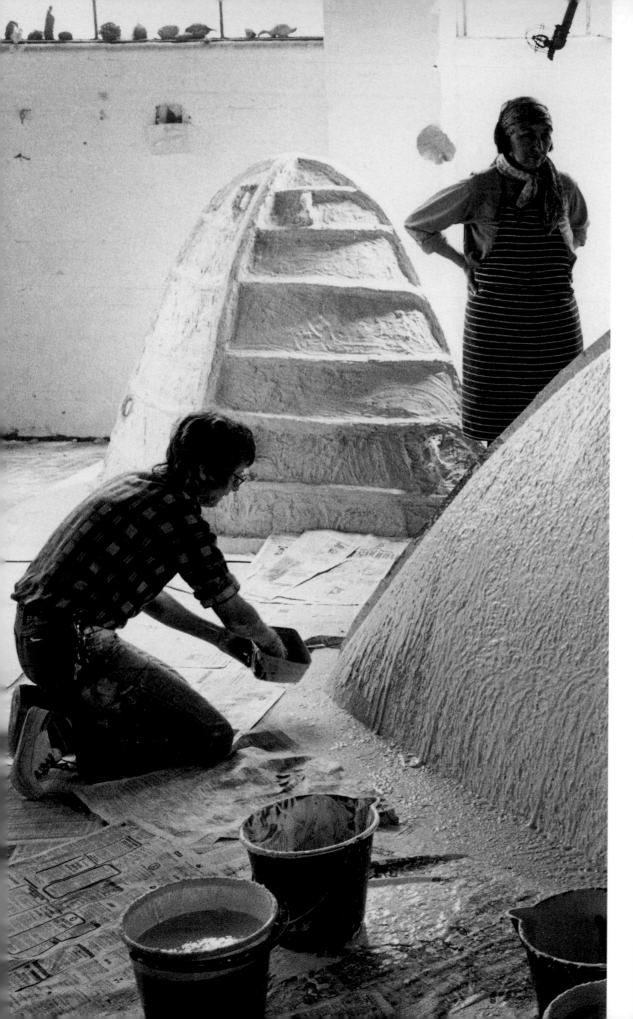
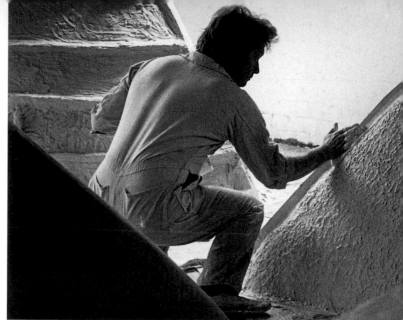
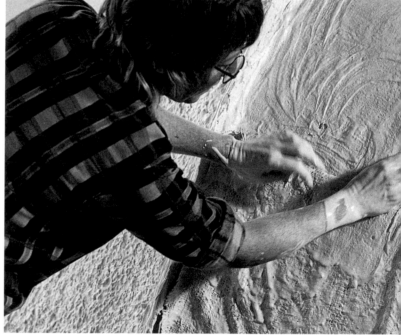
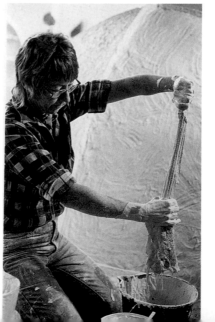
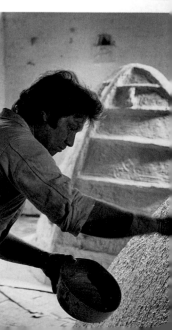

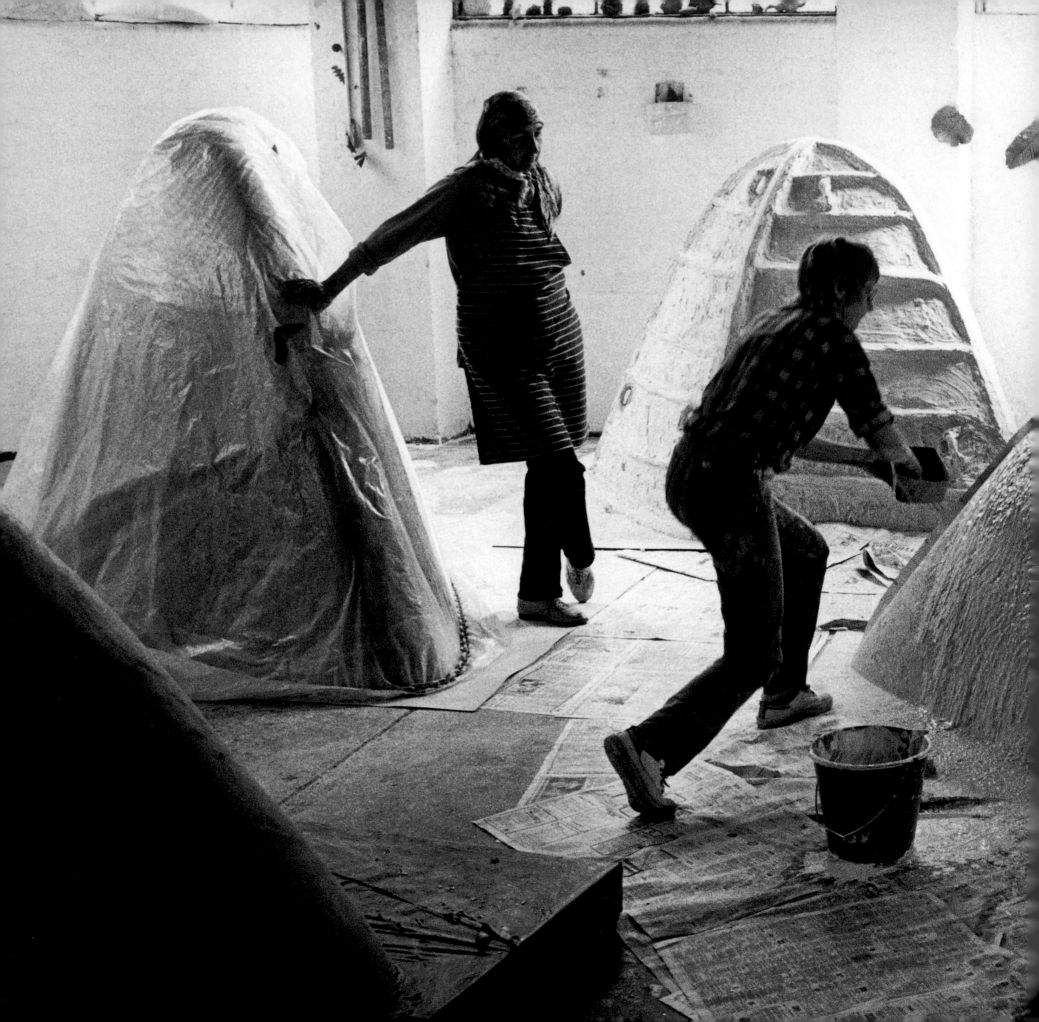

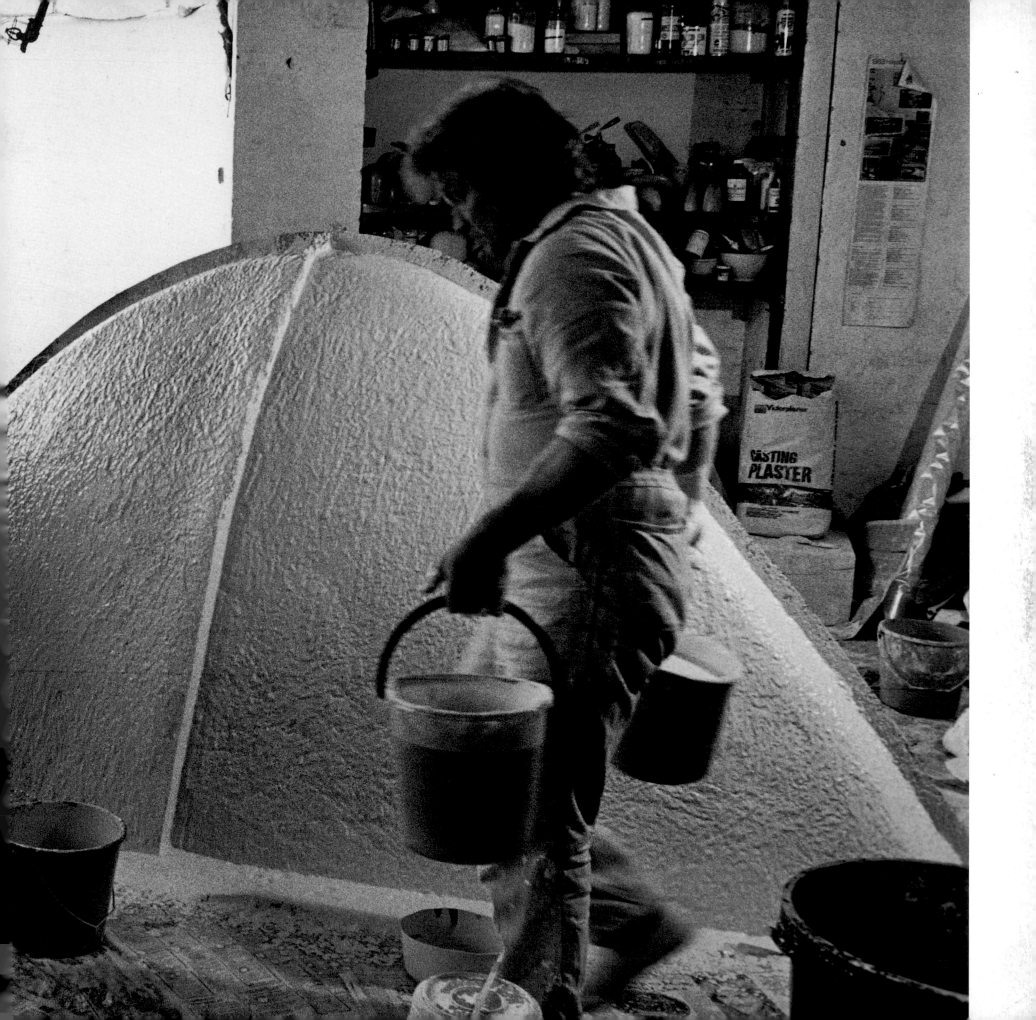

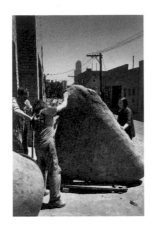

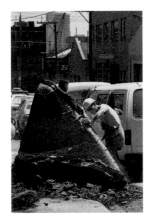

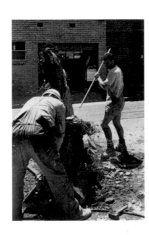

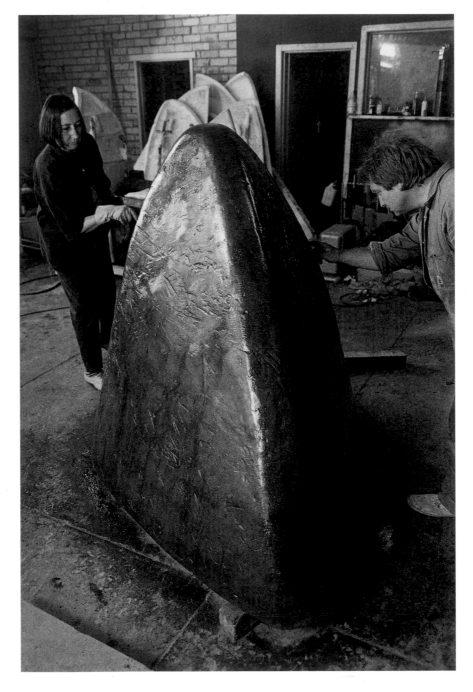

left column:
Revealing the bronze at
Meridian Sculpture Foundry
in Melbourne

right:
Gazzard and Morley applying
patina in foundry (plaster
casts in background)

opposite:
Marea Gazzard on site
with Romaldo Giurgola
and Pamille Berg

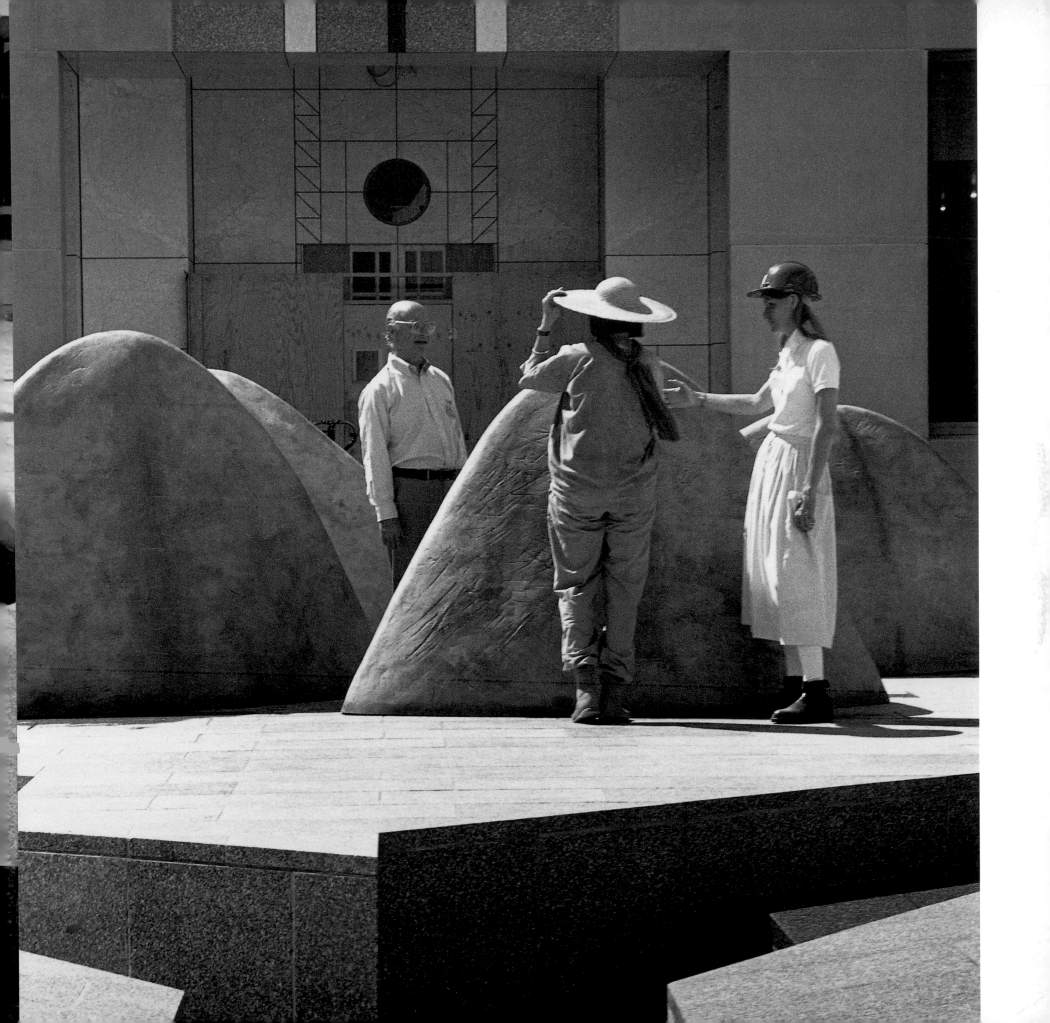

When viewed from the building or from the Prime Minister's office the work has the scale and continuity of hills. As light and shadow pass over the group it expresses the earth's constancy as well as the transience of light. To walk amongst the works is to experience the same qualities of constancy and endurance but on an intimate level. There is a feeling of tactility and of being at one with the work.

The demands of commissioned sculpture for outdoor public areas exceed those of domestic sculpture. To assess costs accurately is complicated and time-consuming; in this, Gazzard's business training was invaluable. The artist must also consider the surrounding architecture, site placement, scale, colour, audience and the question of conservation. Her choice of bronze had addressed the last requirement but the Australian climate was having adverse effects on the patina of the piece tested at the foundry. Each day on her way to the swimming pool she passed the Henry Moore sculpture *Angles* 1979 outside the Art Gallery of New South Wales. She noticed that Moore had obtained the blue–green colour she desired and that the colour had not undergone any atmospheric change.

On 26 April 1986 she wrote to Moore seeking his advice. He generously sent the formula for his own patina with instructions for application. As each bronze was poured Gazzard travelled to Melbourne to apply the patina and finally polished the works with silicone and beeswax.

In March 1988 *Mingarri: The Little Olgas* 1984–88 was installed in the Executive Court of Parliament House, Canberra, after four years' work. On 9 May 1988 the completed building was opened.

Gazzard was successful with Moore's patina, which has maintained the special qualities she was seeking.

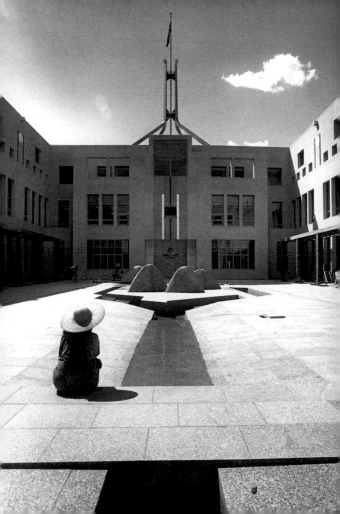

The colour acts quietly with the limestone hue of the adjacent walls and grey granite paving. The subtle liveliness of surface and the interaction of the forms capture light change and actively shape shadows across the southern-lit court. These peaceful patterns of light combine with movement within the waterway to create a soft but perpetual change which contrasts with the stability of the earthbound forms.

Unlike many highly polished bronzes, *Mingarri: The Little Olgas* has the dry green appearance of ancient rock. On closer inspection the pieces appear to absorb light into their almost painterly surface and project their own energy from within.

Respectful of both architectural and human scale, the work achieves monumentality without domination; it conveys strength but does not create a feeling of awe. In designing Parliament House, Romaldo Giurgola had set about imbuing the structure with a sense of place.[14] One way in which he achieved this was by linking the building both physically and conceptually to the land. Gazzard's work acts as the spiritual centre of this link. In referring to the centre of the continent it is symbolic of the ancient rocks and Dreamtime which outlast the transience of the present and of human endeavour.

The Parliament House work was Gazzard's first major public sculpture and, as curator Robert Bell was to perceptively comment, it was a synthesis of her experiences.[15] It is a work which imposes order on a multiplicity of demands and concepts, and presents strong perpetual form with simplicity. The success of the work originates in Gazzard's training as a form potter. It is her attitude to and her handling of clay which push the work beyond purely formalist concerns. From the late fifties it

was the actual earth substance of clay which led her to explore the archaeological, the ancient and the landscape as she sought to discover the intrinsic qualities of the material.

In stating in her original submission to the Parliament House Construction Authority her desire to keep the work free of references to periods or authorship, Gazzard was reiterating a concern which dates from her exhibitions in the early sixties and has resulted in critical comment continually referring to the timeless and anonymous quality of her work. *Mingarri: The Little Olgas* is produced, like most of her work, as a group or series but of all her work it is probably the most potent in revealing her sense of scale, space and placement.

The co-operation between artist and architect in the conception of Parliament House was the realisation of Gazzard's long-held views and constant lobbying for interaction between the arts and the crafts. It achieved not only integration of art and craft within the building but established a model for working relationships and practices between art workers and architects.

When Parliament House opened, it attracted worldwide interest, not only in the architecture but in the collaboration of architects, artists and craftspeople in the early stages of planning. For the architectural critic Philip Drew, the collaboration was not entirely satisfactory in that he perceived the court as 'a granite desert whose saving grace is the marvellous eruption of Marea Gazzard's bronze tors'.[16] In contrast, both *Craft International* and the Finnish publication *Form: Function: Finland* were enthusiastic about the interaction of art and architecture, and nominated Gazzard's work as one of the most important elements in the collaboration.[17]

31. MINGARRI: THE LITTLE OLGAS 1984–88
5 pieces
bronze
126.0 x 200.0 x 110.0
165.0 x 245.0 x 130.0
130.0 x 310.0 x 120.0
146.0 x 340.0 x 140.0
154.0 x 240.0 x 130.0
photograph Gollings Photographs

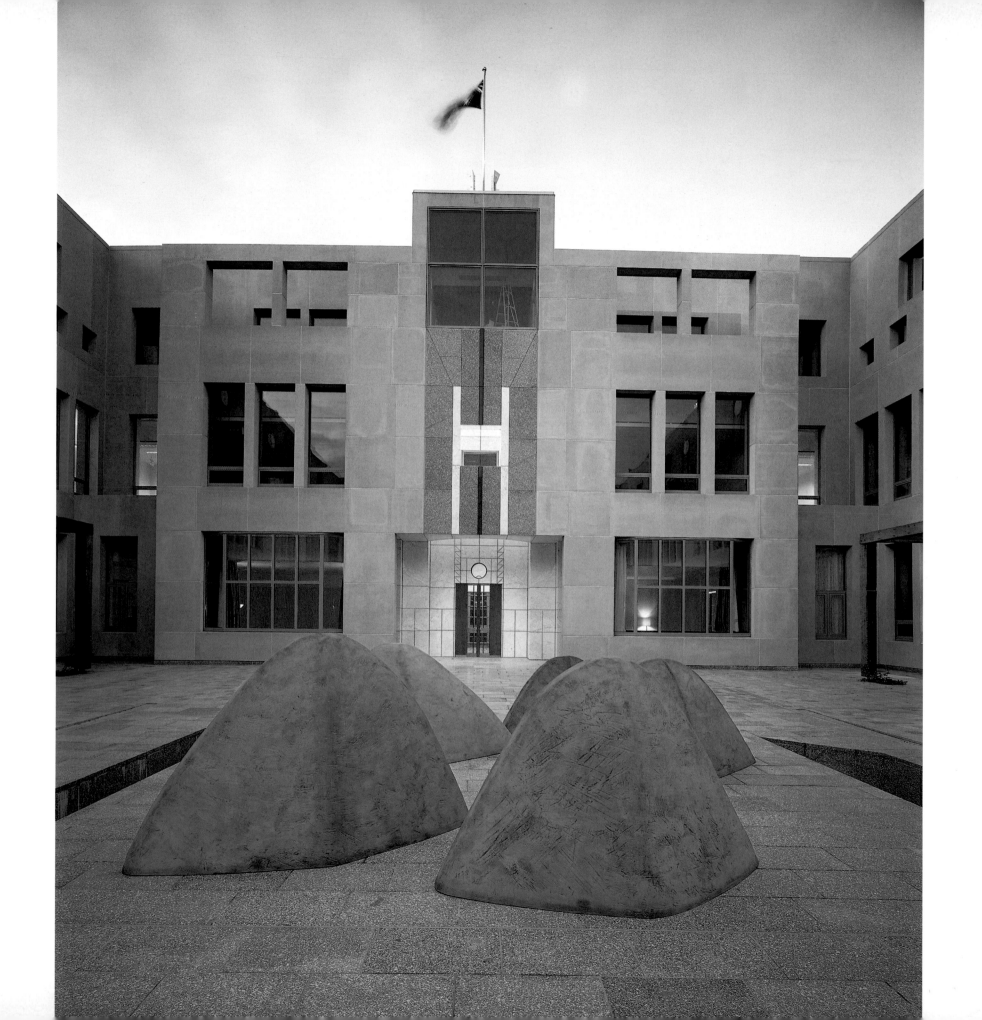

32. CENTRE 1987
charcoal on paper
96.0 x 127.0
photograph Paul Green

110

It is unfortunate that Gazzard's work is seldom viewed by the general public since, for security reasons, access to the court is limited. Thus most people's experience of *Mingarri: The Little Olgas* has been limited to reproductions which convey little of the scale of the work or the intimacy of the surface. For gallery-goers some insights into the works were made possible when in 1987 Gazzard exhibited a photographic diary, drawings, découpage and maquettes of *Mingarri: The Little Olgas* at Coventry in Sydney and at the Westpac Gallery at the Victorian Art Centre in Melbourne.

Included in this exhibition were three other bronze works, *Discs* 1987, *Selini* 1987 and *Aten* 1987, on which Gazzard had been working during the previous five years. In 1984 she had made a number of disc-like clay forms; by the 1987 exhibition these had developed into a set of six bronze discs varying in size from 14.5 centimetres to 48 centimetres in diameter. Like so much of Gazzard's work, they refer to nature and to ancient culture in such a way that the two are inexplicably bound. In *Discs* (ill.35) the size and colour of the works give the appearance of natural stones, yet their proportioned rounded shapes and incised surfaces evoke a feeling of purpose and mystery. Like Stonehenge, they hint at ritual or suggest an arcane language rooted in the sources of nature. They provoke intrigue and wonder, yet at the same time they are secure, stable and recognisable.

Something of the same ambiguity is found in *Selini* (ill.34). Developed from the earlier clay series of 1983 (ill.33), the forms have become lower and sleek. The moon-like shapes are familiar but uncompromising in the tension of their form. In polished bronze they are taut, linear and modernist yet possess an almost poetic luminosity as light passes across them. In *Aten* (ill.37), the shape of

which was inspired by an exhibition of Tutankhamen's tomb, there is symmetry, while the rounded edges and convex surface absorbs light deep inside the work, suggesting solidity and life force from within. As the critic Elwyn Lynn was to comment when reviewing the exhibition at Coventry gallery, 'The work bears the self-sufficiency of Brancusi'.[18]

This exhibition was the first in which Gazzard exhibited drawings and découpage. The drawings, like so much of her work, convey a sense of density and form. Although they exist in their own right and are not sketches for sculptural work, they are indicative of the complexity of thought required to achieve seemingly simple forms. In her *Mingarri* 1987 drawings, Gazzard deals with the overlap of forms. In *Mingarri III* 1987 (ill.36) there is an aura of the unknown reminiscent of Seurat's black drawings where light and density mould the relationship of form, while in the drawing *Centre* 1987 (ill.32) there is an awareness of the sculptor's need to locate the point of gravity and the central force to which form and atmosphere can relate.

In 1979 Gazzard's *Uluru* series had suggested the timeless and the heroic but the forms also suggested a certain vulnerability, a sense of the easily eroded fragile balance between nature and the ancient culture of the Aboriginal people. In the *Mingarri* exhibition the increased self-sufficiency of the work conveys the same timelessness, but the suggestion of fragility is replaced by an emphasis on the eternal and the self-generating energy of the work.

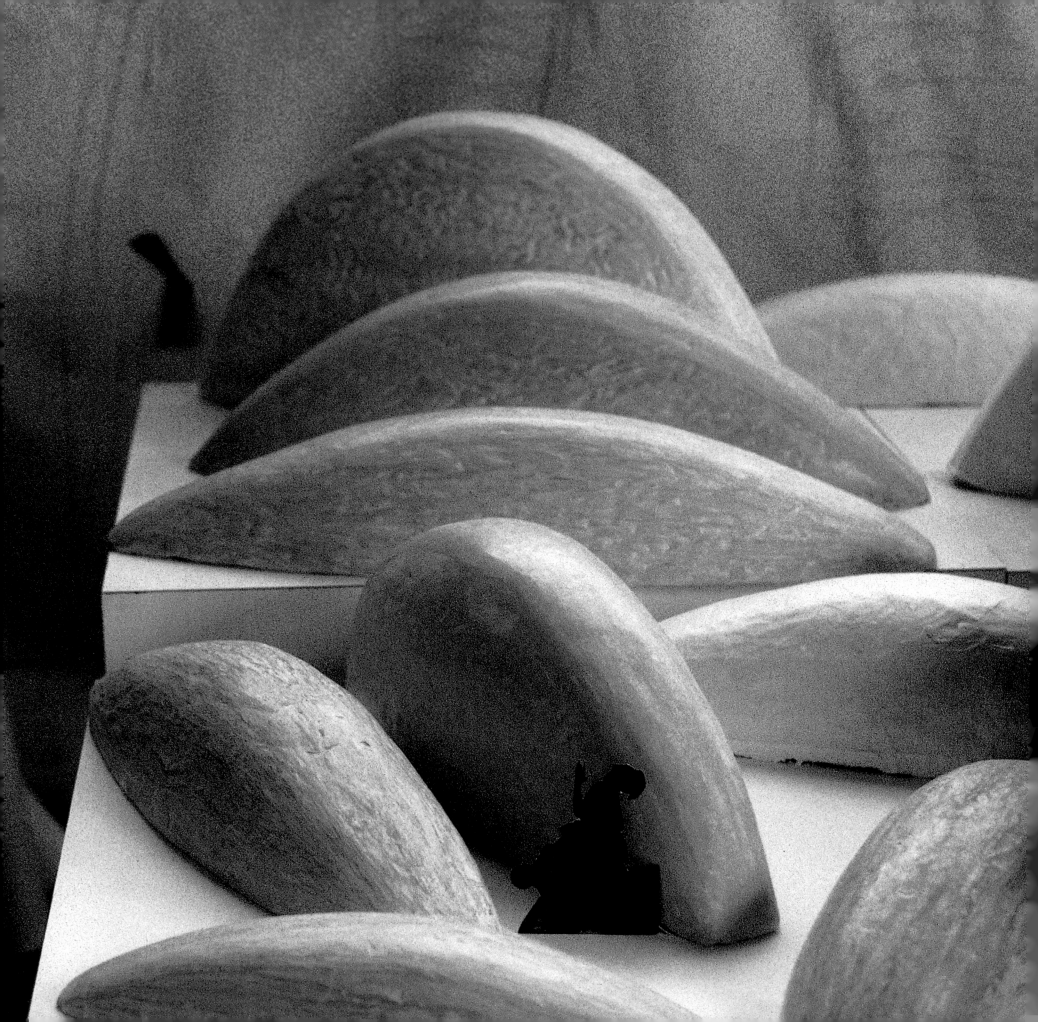

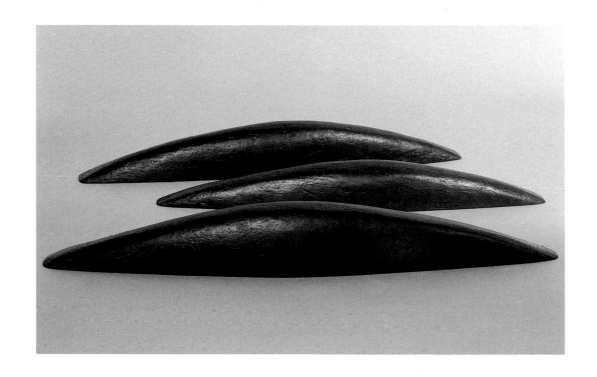

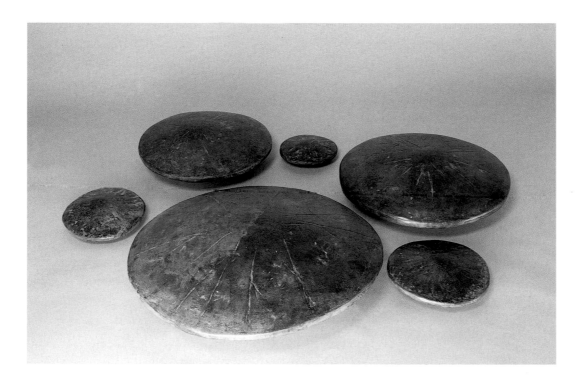

36. MINGARRI III 1987
charcoal on paper
96.0 x 127.0
photograph Paul Green

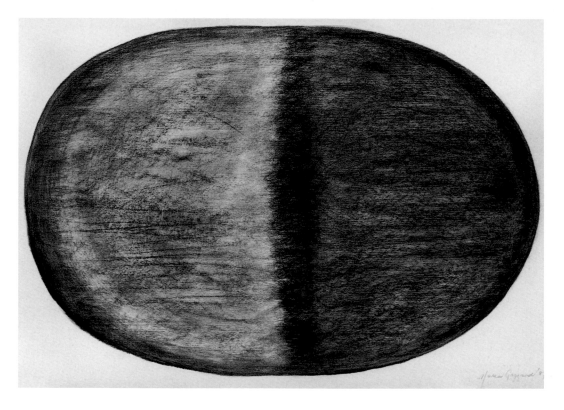

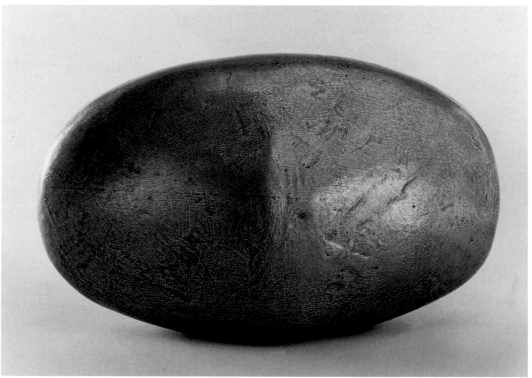

top:
37. DISC II 1987
charcoal and sepia on paper
50.0 x 75.0
photograph Paul Green

38. ATEN 1987
bronze
26.0 x 35.0 x 8.0
photograph Fenn Hinchcliffe
courtesy Coventry, Sydney

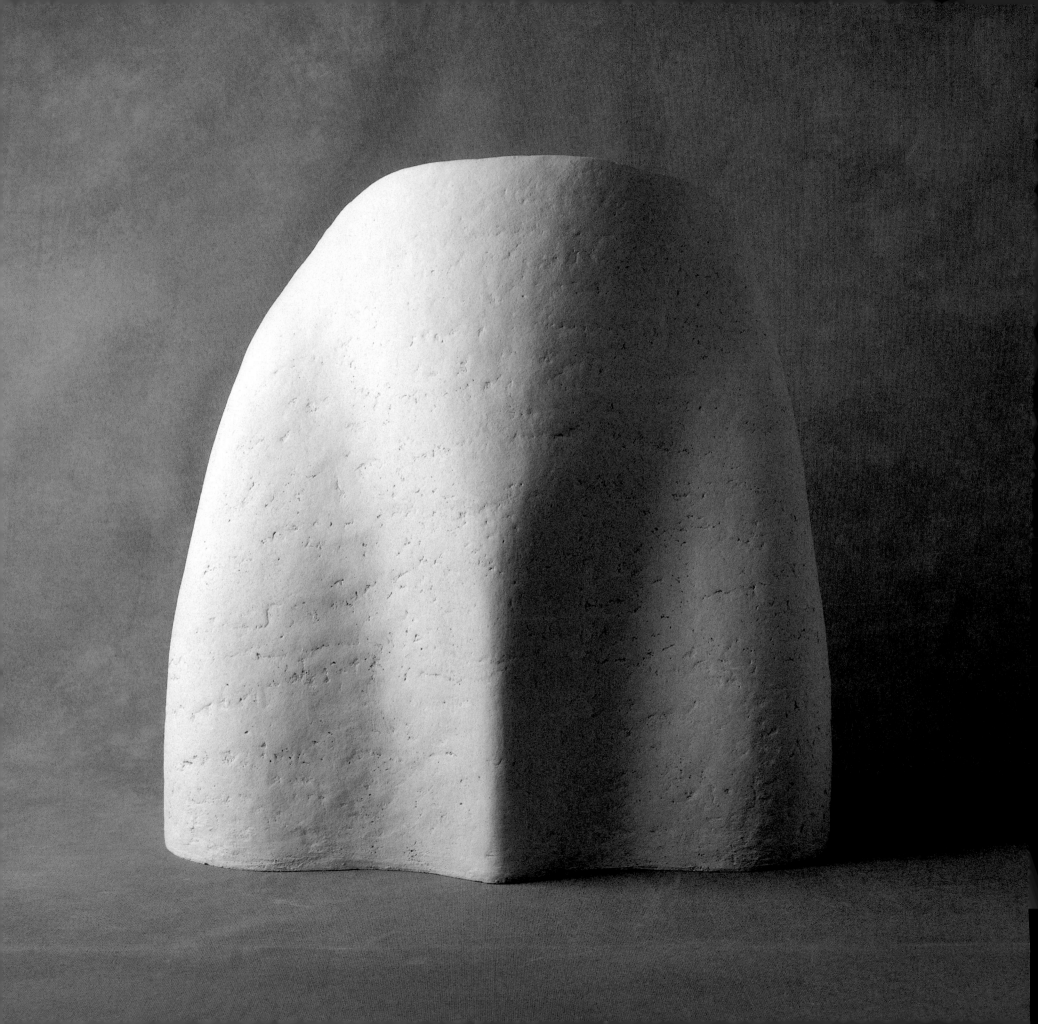

6. Expanding Horizons

In 1986 the Sydney Dance Company moved premises, so Gazzard had to leave her large Woolloomooloo studio and find a new workspace. After purchasing an apartment in the Watertower building close to Redfern Station, Sydney, she moved her kiln and equipment to a car-space in the basement of the building. This was cheap, close to home and separated work from daily living.

The Watertower is an early twentieth-century commercial building which was converted to apartments centred around an internal courtyard reminiscent of Renaissance planning. It houses many interesting people, including several who share Gazzard's concern for Aboriginal issues.

Gazzard's third-floor apartment is on a corner of the building. It is roomy with sufficient space for visits from her children, both of whom are occasionally involved in her work. Clea, a graphic designer, advises on presentation and Nicholas, a stonemason, has made bases for her 1993 series. The apartment has high ceilings, white walls and large windows; light either floods the rooms or is gently filtered through slat blinds. Within this space it is her own work which is the centre of attention.

The 2-metre green *Head* series 1990 is a powerful presence yet engages subtly with a lyrical painting by the octogenarian Aboriginal painter Emily Kngwarreye. Here are the thin edges of the *Milos* series 1990, and the containment of *Personages* 1990 on one wall, a life-size working drawing for a public sculpture. It is a sculptor's room – spacious, reflective, yet filled with vitality.

Arranged along the white window sills, in bleached-out colours, are groups of shells, river stones, a cuttlefish, dried leaves, driftwood and small clay figures, all collected in Gazzard's relentless search for form. The large table and simple chairs are designed by Alvar Aalto, and the sofa by Le Corbusier, but the embroidered cushions were made by Gazzard's maternal grandmother and family on Andikythera.

Gazzard is a warm host who indulges her guests. There is exquisite but 'real' food served on plates by Harry Davis and strong coffee in paper-thin bowls by Gwyn Hanssen Pigott. Like her work, Gazzard's way of life has extreme elegance but does not lose touch with the elemental. Her placement of objects is considered; they have their own breathing space. On a high shelf is a thin-walled bowl by Lucie Rie, along the hall a Helen Eager painting and a vibrant photographic image by Tracey Moffatt.

Gazzard's books are housed in a small study from which a spiral staircase leads to an upstairs bedroom. These are mainly reference books which provide insight into her favourite artists – Georgia O'Keefe, Isamu Noguchi, Kain Tapper, Lucio Fontana, Henry Moore. Books on Aegean art, the Cycladic, the potters Lucie Rie, Hans Coper, Peter Voulkos, and bound editions of the journal *Domus* confirm her interests. Newly arrived is the Finnish journal *Form: Function: Finland*, edited by Barbo Kulvik, the publication which Gazzard finds the most stimulating and relevant to her current work and thinking. From the window an almost limitless view stretches over networks of streets and railways, across the flat terrain of Mascot south to Botany Bay and the hazy horizon where sea meets sky.

Outside the building she enjoys proximity to the markets and encounters with the local Aboriginal

39. MILOS I 1990
stoneware, slip glaze, handbuilt
66.0 x 63.0 x 30.0
photograph courtesy Powerhouse
Museum, Sydney

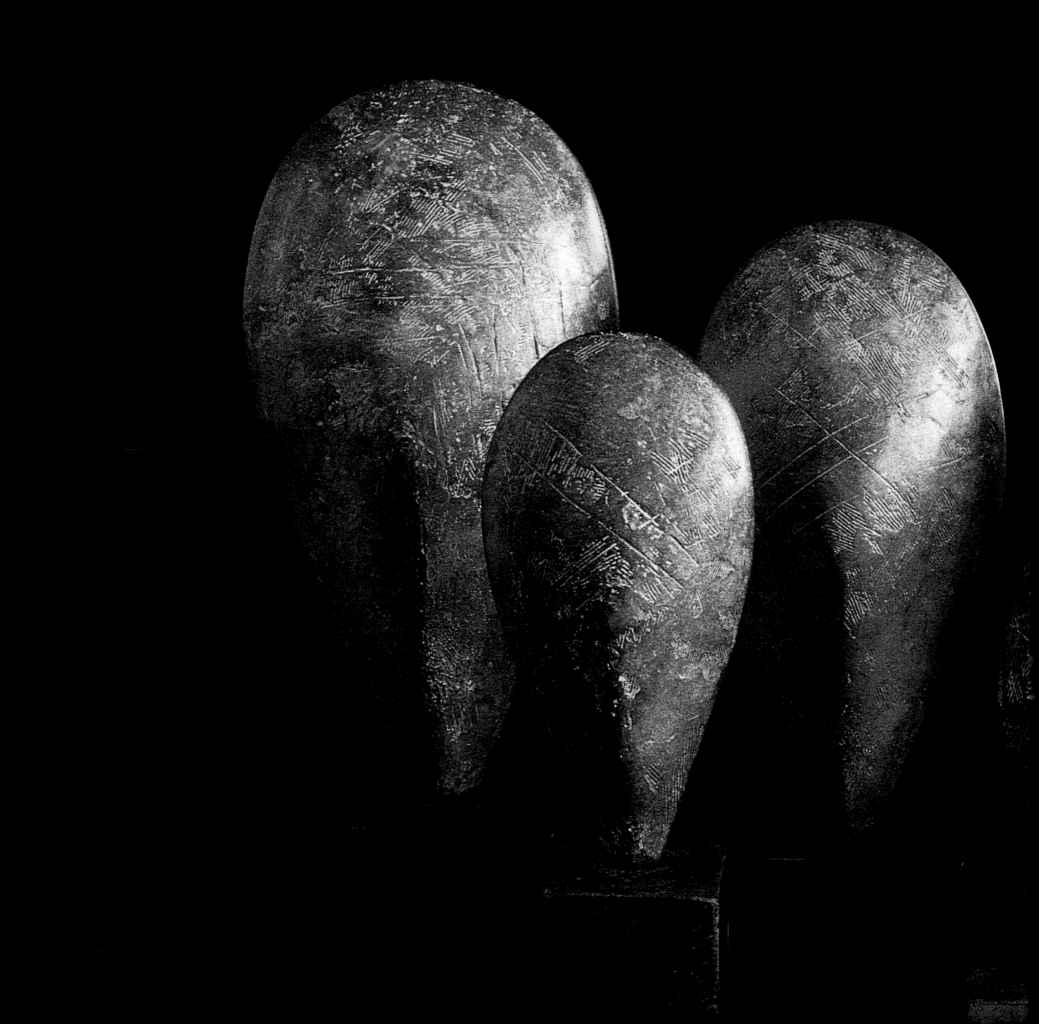

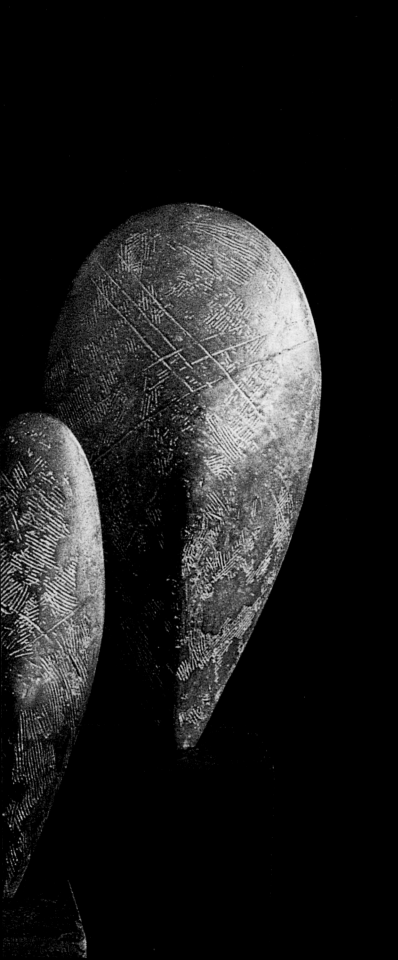

40. PERSONAGE III–VII 1990
bronze and slate
III 30.0 x 13.0 x 4.0
IV 26.0 x 11.0 x 8.0
V 25.0 x 9.0 x 6.0
VI 23.0 x 8.0 x 5.0
VII 14.0 x 4.0 x 5.0
photograph Paul Green
courtesy Coventry, Sydney

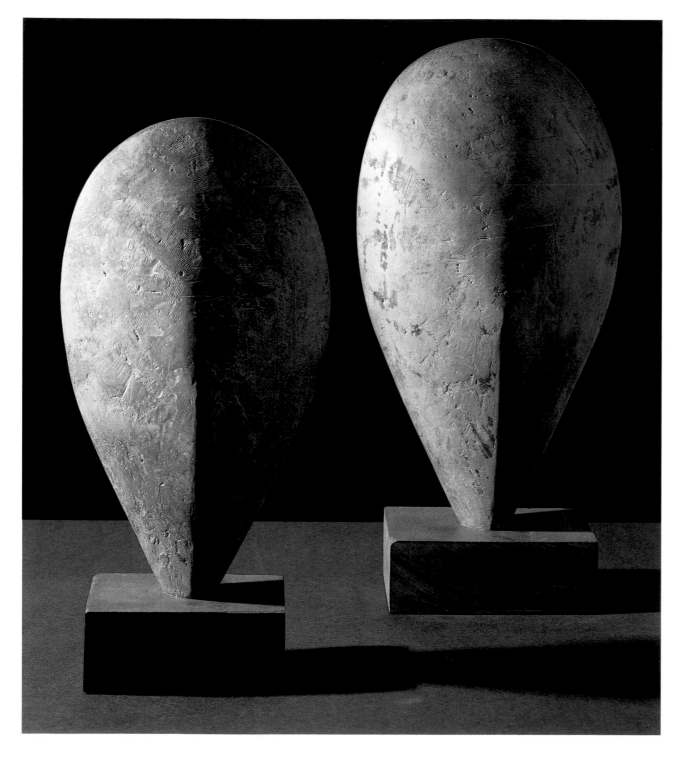

41. PERSONAGE I and II 1990
bronze and slate
I 41.0 x 20.0 x 12.0
II 36.0 x 18.0 x 11.0
photograph Paul Green
courtesy Coventry, Sydney

people. Redfern is free of pretence: it exposes the reality of life but offers an individual freedom with a strong sense of community, qualities to which Gazzard responds.

Something of Gazzard's character is also revealed in the visits to her apartment by the students from Liverpool Girls' High School. In the early eighties Gazzard had taught the girls' teacher Waddy Hazzaz at the Alexander Mackie School of Art. In 1987 Hazzaz died, and the students, knowing of his admiration for Gazzard's work, asked her to design and execute a sculpture in his memory. In 1988 Gazzard was invited to the school for the dedication of her work. Here she was greatly impressed with the genuine interest of the girls and suggested they maintain contact. Since that time various groups of students have visited her studio each year where she helps them with their projects and discusses the process involved in creating her own work.

The girls have made a small video of one such meeting. This shows Gazzard as quiet and interested, communicating with the girls in a way which is highly informative yet positive and uncomplicated.[1]

In contrast to the idealistic values that characterised so much of the seventies, the eighties are generally seen to reflect attitudes of conservatism and pragmatism. Within Australia the visual arts responded to post-modernist strategies, feminist incentives, post-structuralist theories and bicentennial efforts to establish a consensus of national identity. Consumerist values dominated many areas of society and much of the art which was promoted was a response to an increased acquisitiveness. Public projects such as Parliament House, Canberra, with its acknowledgment of craft, women and Aboriginal artists who worked outside mainstream art, sym-

bolised the achievement of some of the objectives that had concerned Gazzard and others during the seventies.

Free of her many administrative duties, she now has more time for her own work. Her commitment to world peace and Aboriginal land rights, two issues which have become increasingly potent in the nineties, remain independent of her own work. She has often made reference to cross-cultural or Aboriginal heritage, but her prime concern is to produce works of quality which strive towards aesthetic excellence.

The bicentennial year of white settlement in Australia in 1988 initiated a number of survey and group exhibitions. Gazzard's work was represented in exhibitions as diverse as 'Australian Decorative Arts 1900–1985' at the Australian National Gallery; 'A Changing Relationship: Aboriginal Themes in Australian Art 1938–1983' at the S. H. Ervin Gallery, Sydney; '20 x 20 Crafts in Society 1970–1990' at the Crafts Council of New South Wales; 'Black and White Drawing' at Coventry, Sydney; and 'The Self Portrait' at the David Jones Gallery, Sydney.

The following year at a seminar Gazzard was asked to comment on the sources of her ideas:

These come from one's own life, from different cultures, museums, nature, walking along the beach or someone asking you to do something.[2]

The history and subsequent ramifications of the work she exhibited at the 1988 'The Self Portrait' exhibition at the David Jones Gallery epitomise her approach. Invited to contribute a piece that examined the concept of self-portraiture, Gazzard spent some months thinking about the project and

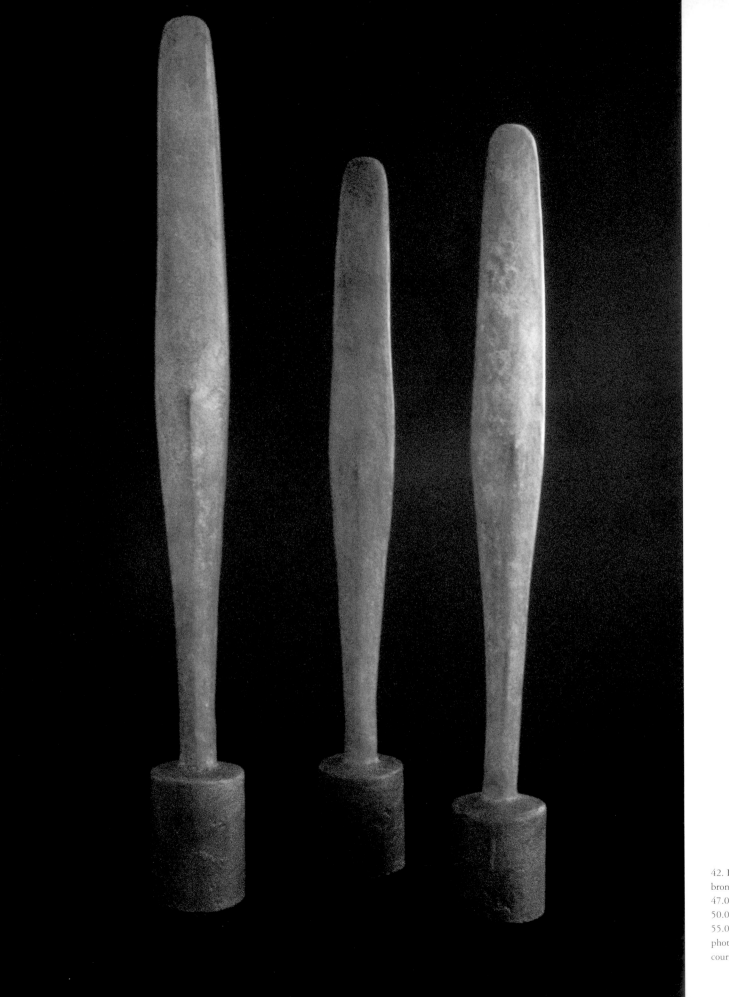

42. PAROS I–III 1990
bronze
47.0 x 5.0 x 4.0
50.0 x 5.0 x 5.0
55.0 x 5.0 x 5.0
photograph Paul Green
courtesy Coventry, Sydney

exhibited a white plaster head *Amorgos*, 1988. Simple and volumetric, it pays homage to both the Cycladic and to Brancusi while conveying its own inner power of tension.

Gazzard had maintained an interest in head-like forms since her early *Dial* series of the sixties. In the eighties an exhibition of German drawing at the Art Gallery of New South Wales where she responded strongly to a drawing of a head by Weiner Knaupp, and the making of *Amorgos*, had again focused her thoughts in this direction.

Late in 1988 she travelled to Paris to take up a residency at the Dr Denise Hickey Studio at the Cité Internationale des Arts and stopped en route in Athens to see the newly opened Nicholas P. Goulandris Foundation Museum of Cycladic and Ancient Greek Art. This museum exhibited not only the ancient art but also referred to more contemporary work which had been influenced by the Cycladic. It had great impact on Gazzard:

I thought my heart would burst with an overwhelming feeling of PRESENCE ... I felt at one with Greece/past/present.[3]

One exhibit which had a profound effect on her was a blown-up photograph of a Cycladic-influenced 40-centimetre bronze head by William Turnbull, her former teacher at the London Central School of Art and Design. This stimulated her to think about expanding the ideas in *Amorgos* to a larger scale in bronze.

Arriving in Paris in October, Gazzard was well pleased with her studio at the Cité Internationale des Arts. It overlooked the gardens, afforded a view of trees, Parisian life and buildings, giving identity to what many artists have described as character-less rooms.

Almost immediately she began studying in the museums. Her sketchbooks reveal wide-ranging interests which more often than not are connected to 'head' forms. From the Pompidou Centre, Musée d'Orsay and Musée Picasso there are sketches of heads by Oldenberg, Giacometti, Daumier, Picasso and Dine. At the Louvre, looking at the Egyptian *Momie de Pachery*, she became fascinated with the

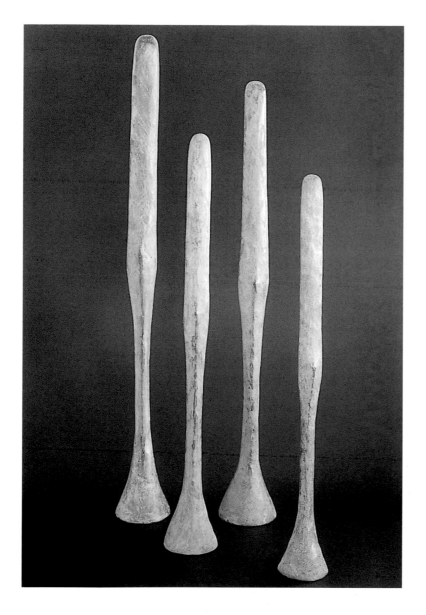

43. ESTE I–IV 1990
bronze
63.0 x 4.0 x 4.0
56.0 x 4.0 x 4.0
73.0 x 6.0 x 5.0
80.0 x 6.0 x 5.0
photograph Paul Green
courtesy Coventry, Sydney

way patterning could be used to define volume, not just surface; the intricate crisscrossing of bandages was a way of building form. The same use of contour line was present at the Musée de l'Homme in cauterised faces of some African tribes and at the Pompidou Centre in the contour drawings of the Swiss artist Zoltan Kemeny. In London, which she visited to see the Henry Moore retrospective,[4] the use of contour appeared in many of Moore's *Shelter* drawings. It was new insight for Gazzard.

In 1990 she became the first woman working in the visual arts to be awarded an Australian Artists Creative Fellowship. This enabled her to continue her work on what had become the *Head* series, which was exhibited at Coventry in September 1990. In this exhibition Gazzard broke away from previous concerns with natural forces and presented forms which were defined by their own autonomy. This concept had already been present in *Aten* 1987 but was now developed with increased authority.

The outstanding achievement in this exhibition was *The Head* 1990 (ill.44), consisting of five bronze works ranging in height from 136 to 176 centimetres. Originally handbuilt in clay, the complex forms are maintained with a seemingly effortless simplicity. The backward-slanting elongated forms clearly refer to the Cycladic but push further to the essence of their form. The proportions of each piece are dictated by the angle measurement from nose to nape of neck, yet there is an ambiguity, partly determined by the human size of the objects, which allows this series to be read as whole figures. As a group they relate formally; edges, volume and light strengthen the works to a unified whole. Yet alone each piece maintains its integrity. In this work there is a tension of forces as the tilting vertical pulls against the horizontal axis and the works slide effortlessly into their bases. Similarly, in the

Personage series 1990 (ill.40, 41) Gazzard has maintained the self-sufficiency of each piece with a clarity of edge and upward thrust which creates their own centrifugal energy indicative of the Paris lesson of using contour to build a volumetric energy. In these works Gazzard's surfaces are subtle, not wind-eroded or excavated but gently worked and patinated to assert the authority of the whole.

This subtlety is also found in the clay works that were exhibited at the same time. In *Milos I* 1990 (ill.39) the white handbuilt surface submits to form. Frontally, these works appear solid but are in fact thin mask-like walls inspired by the funerary masks Gazzard had seen in the Louvre. Their minimal folds and soft shadowing create a powerful stillness. In the same way as the bronze works, they establish a penetrating presence.

Although this exhibition showed many of Gazzard's previous concerns such as the central spine, tension between the horizontal and the vertical, and flattened form, it is also the exhibition in which she most closely identified with modernist principles of synthesis, simplicity and restraint. In her early work, objects often referred to external criteria of ancient civilisations or natural forces; these are now absorbed within the object as the artist increasingly turns her attention to the exploration of its essence.

Given Gazzard's increasing interest in the autonomy of the object it is perhaps not surprising that her next body of work should emerge from a study of the very first man-made objects: tools. Her interest in the archaeological had often led her to sketch early tools and weapons. Since 1967 she has owned a copy of Gyorgy Kepes' *The Man-Made Object* and was aware of Herbert Read's essay which examines primitive tools as the origin of the concept of form in art.[5]

44. THE HEAD 1990
bronze and granite
136.0 x 18.0 x 12.0
145.0 x 20.0 x 17.0
150.0 x 22.0 x 19.0
160.0 x 26.0 x 19.0
172.0 x 30.0 x 20.0
photograph Paul Green
courtesy Coventry, Sydney

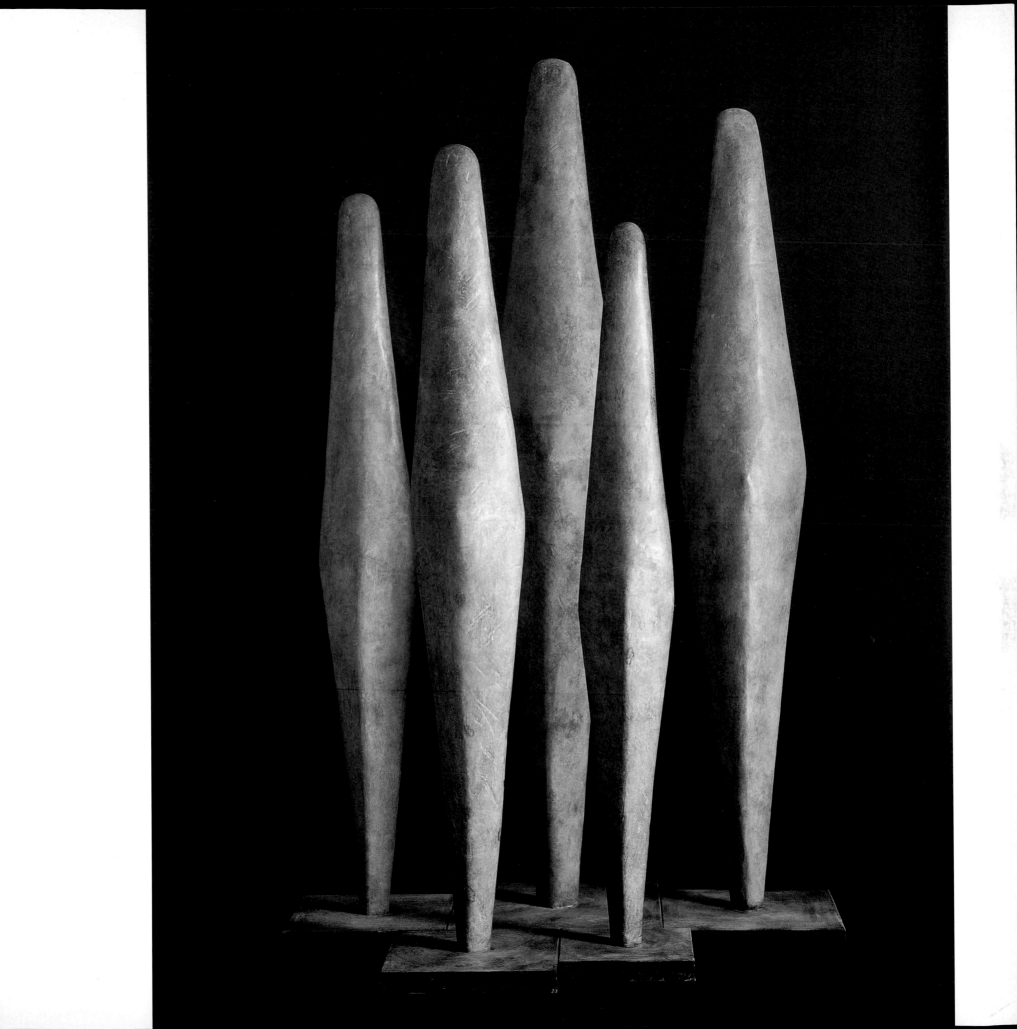

Following the opening of her 1990 exhibition, Gazzard travelled to the United States to study the extensive collections in museums and to see friends such as the Professor of Fine Arts, Arline Fisch, in San Diego, the performance artist Marilyn Wood in Santa Fe, the potter Ruth Duckworth in Chicago and the jeweller Alexandra Solowij-Watkins in Boston. Her museum study was intensive, and sculpture by Oldenberg, Giacometti, Miro and Noguchi was noted. But after visiting the Field Museum in Chicago, drawings of early spearheads, axeheads and knives began to dominate her sketchbooks. Interested in the intuitive and primary response evident in the making of these primitive tools and weapons, Gazzard began to record them and became fascinated with the variety of form present in such simple objects.

On her return to Australia she worked on a series of pastel drawings related to these forms, but it was not until the following year that she was able to develop her original sketches into sculpture. Working first in sketchbooks, she established scale and then built the smaller works in black wax, the larger in plasticine, and commenced work on bases before the works were eventually cast in bronze in 1993. Entitled the *Field* series, they included *Flint*, *Barb*, *Haft* and *Tine* forms.

The *Flint* series 1993 (ill.46), like the *Personage* series of 1990, conveys a self-sufficiency of form. Here the organic is pitched against an exacting geometric precision. The tight linear thrust of the works pushes energy up to the centre of the object, while light falling on the gently rounded surfaces intensifies this effect. As in much of Gazzard's work there is an ambiguity of form and a return to previous concerns of torso and shoulders. The black patination increases density and containment as it sharpens edges and increases awareness of defined

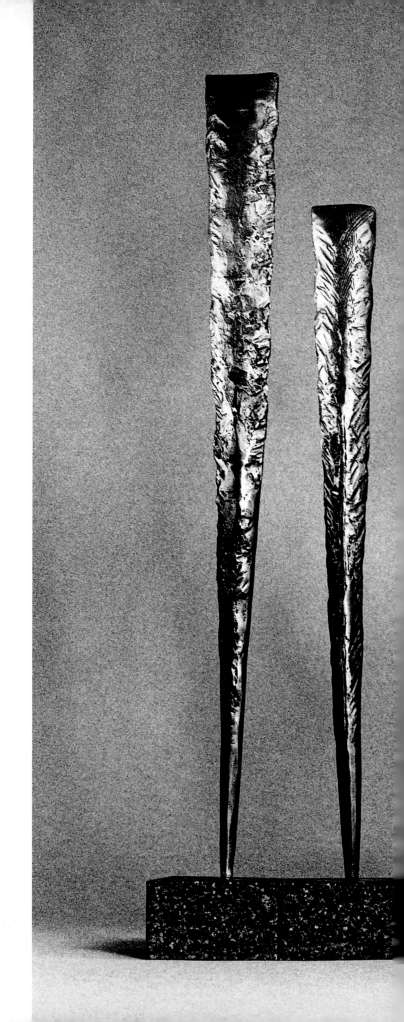

45. TINE I–IX 1993
bronze and granite
56.0 – 80.0 x 7.0 – 8.0 x 2.0
photograph David Moore

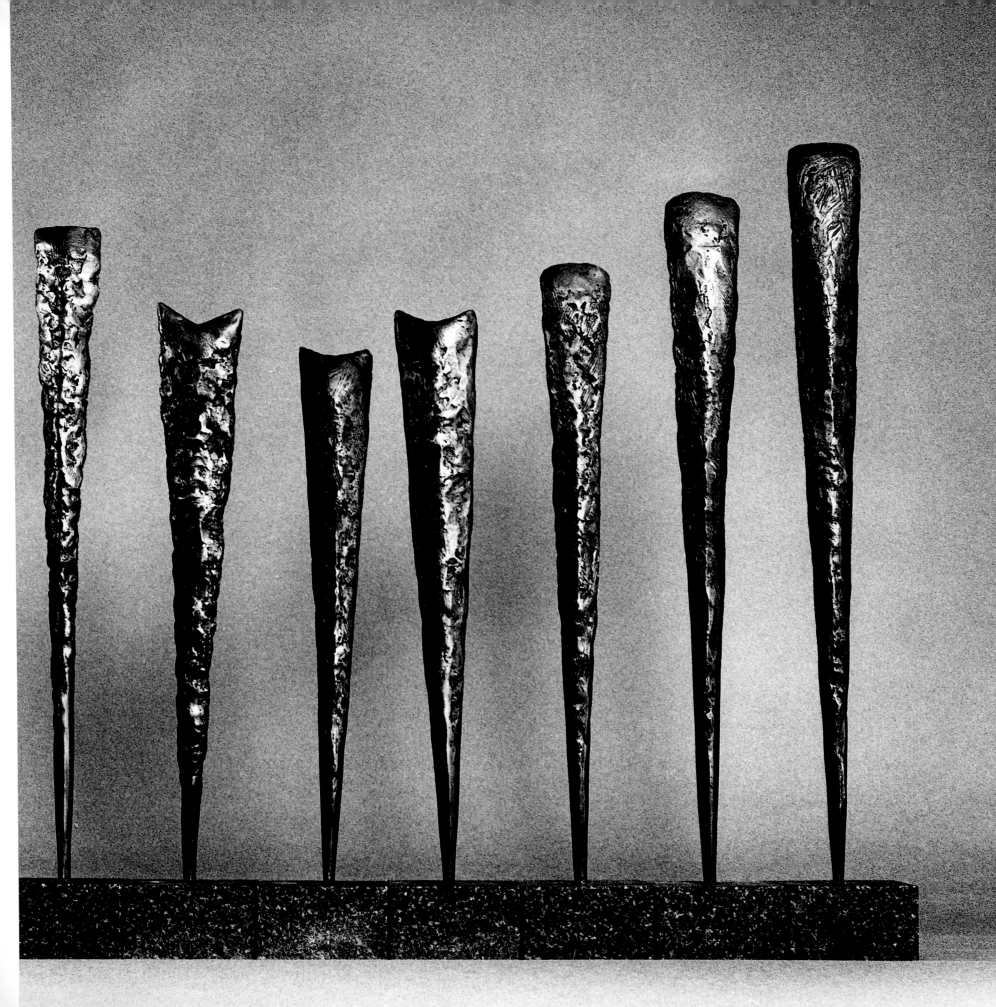

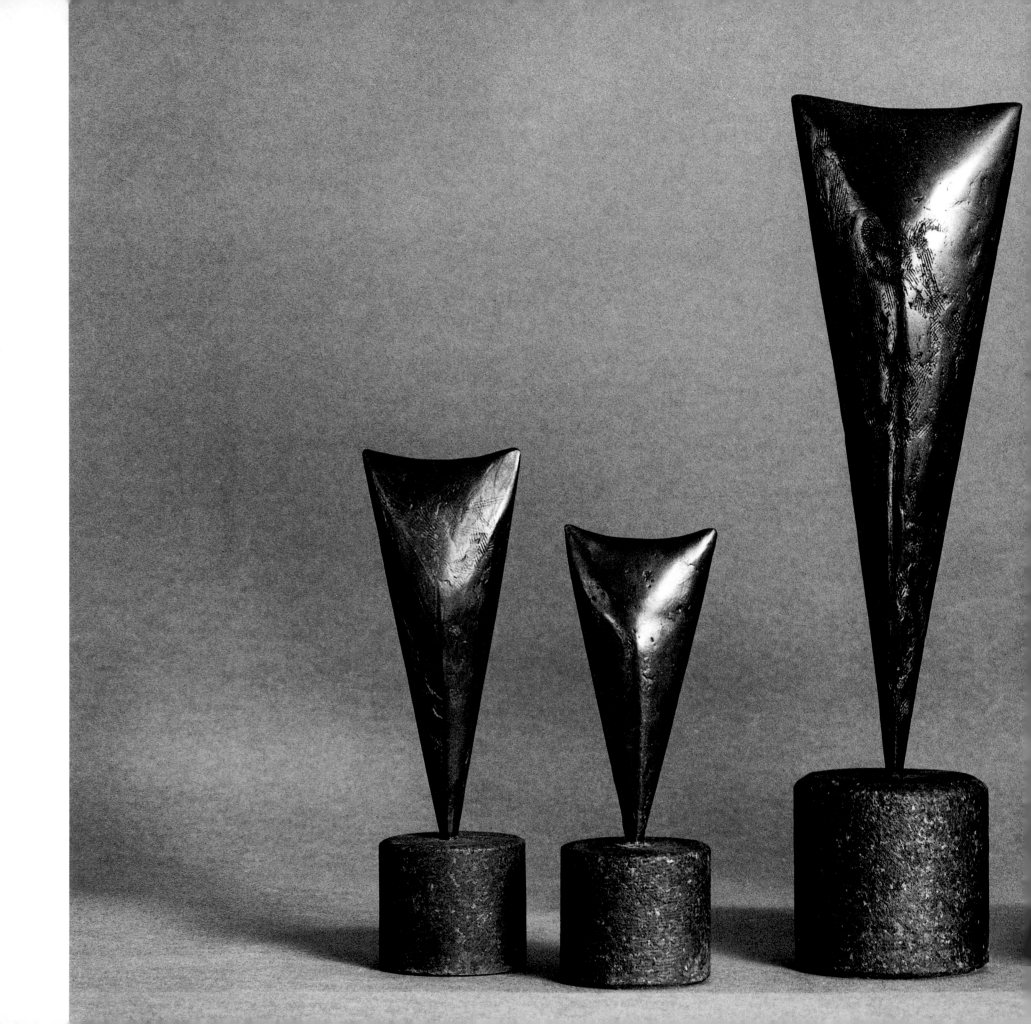

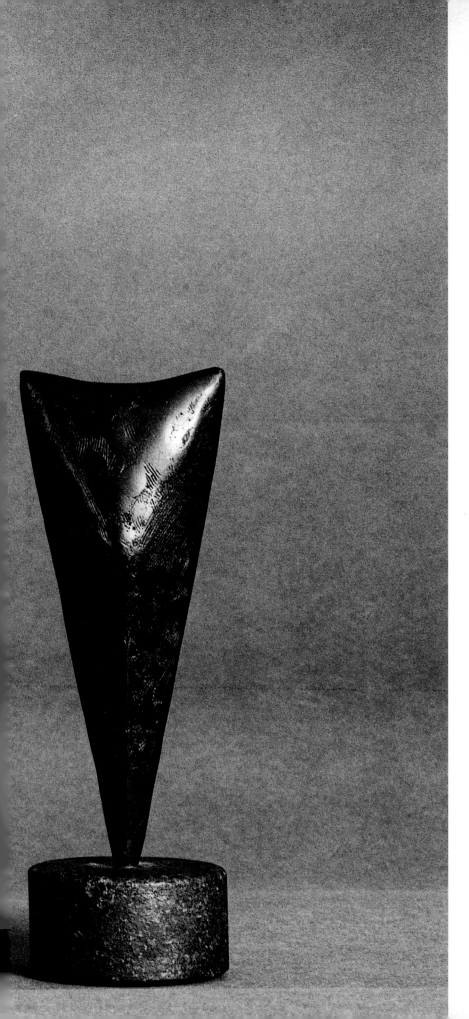

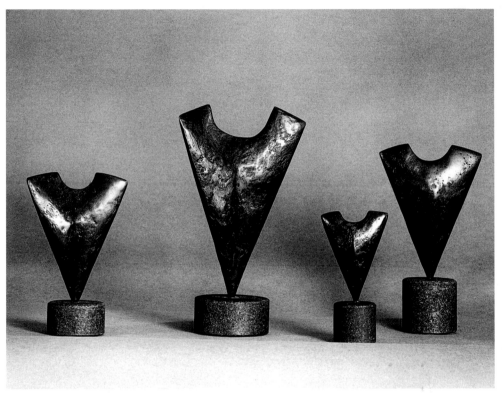

above:
48. BARB I–IV 1993
bronze on granite
17.0 – 30.0 x 8.5 – 17.0 x 3.5 – 5.5
photograph David Moore

left:
49. HAFT I–IV 1993
bronze on granite
16.5 – 32.0 x 5.5 – 8.5 x 2.5 – 4.0
photograph David Moore

song, dance and music. It would also be cast with both black and white dancers and musicians.

For Gazzard it was a privilege to be part of the production. She immediately stopped her own work to begin research on the project.

Blair's life had been complex and embraced highly emotive and political events. Gazzard decided that the sets should show no paraphernalia of society: instead they would indicate Harold's travels through the labyrinth of time – his rites of passage. Simple 'collective memory' shapes would be used to indicate the connection between events in his life. Such an interpretation was indicative of Gazzard's ability to see beyond the superficial. Attentive to costs, she proposed one large circle segment which could be used to signify sunset or sunrise or reversed to form a bridge representing the rites of passage. With simple shapes and material, she created an environment that was symbolically powerful. These sets were free of cultural reference but the costumes she designed were more specific, with women in flowing georgette dresses ranging from yellow to ochre, and men in lycra tights of various red hues. Spotted dresses and suits based on fifties fashion were designed for the performance. After rehearsals at the Wharf Theatre, Sydney, *Harold* opened in Brisbane in February 1992 to critical acclaim.[7]

In March 1992 Gazzard accepted a commission from the ASER Property Trust as part of their contemporary art program. This was co-ordinated by Janice Lally of the Art for Public Places Program of the South Australian Department for Arts and Cultural Heritage, and required a work to be sited in the Adelaide Plaza, on the eastern side of the Hyatt Hotel building designed by John Andrews. This was a position with heavy pedestrian traffic

passing to and from the Adelaide Casino, the railway and the Festival Centre. After viewing the site she decided that the work should not compete with the architecture of the nineteenth-century casino or the new Hyatt Hotel building and that it should adopt a scale which related to the numerous passers-by.

After working through possible forms on scale drawings, Gazzard decided on two large overlapping bronze discs to be mounted on a granite rectangle. These forms refer back to the *Delos* series of 1972 but have a greater tension within the object. In the Adelaide work Gazzard has increased the depth so that the central spine pulls strongly against the circumference. The discs, which measure 1 metre and 1.2 metres in diameter, stand on a 75 centimetre-high rectangular block of granite. It is the overlap of these discs which creates a flow of energy between the two forms. Conscious of the role played by this overlap, Gazzard called the work *The Mandorla* (a place of the spirit).

Gazzard handbuilt *The Mandorla* (ill.50) in clay and it was later cast in bronze at Crawford Casting, Sydney. She used a green patina and worked the surfaces to give them a painterly richness which emphasises the flow of energy from centre to circumference. Unlike the works of the *Field* series 1993, which, in spite of their thrust, convey a powerful stillness and sense of silence, *The Mandorla* has an energising liveliness as the two forms interact and the surface patination suggests depth and power from within the object.

Gazzard's awareness of the power of an object to act on both viewer and maker has provided the unifying force between the two areas of her work as artist and administrator. Although she sees these two areas of her career as quite separate, they are inextricably

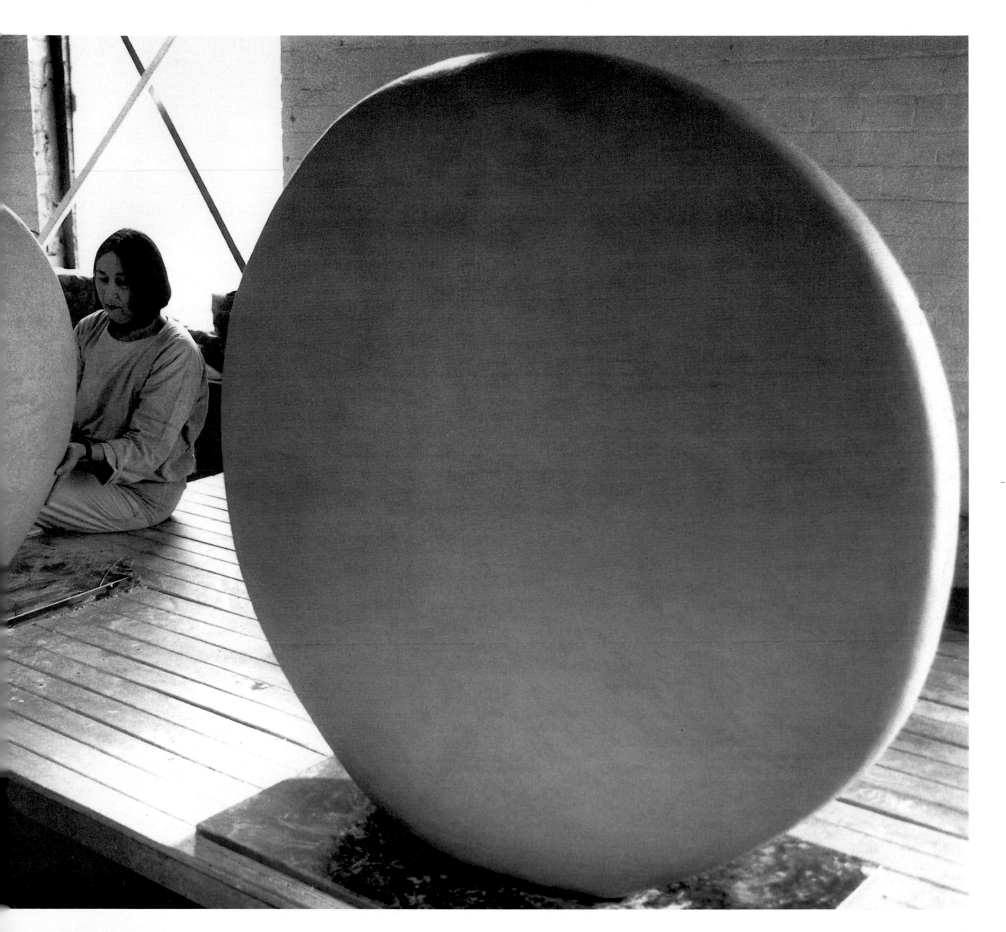

50. MANDORLA 1993
bronze and granite
100.0 and 120.0 circumference on
granite 75.0 height
photograph Michael Kluvanek

bound by a belief in creativity as a means of halting
fragmentation and social dislocation in an indus-
trialised and post-industrialised world. She believes
that the success of such effort can only be maintained
through the pursuit of excellence.

In striving towards excellence in her own work,
Gazzard has been continually conscious of the
effect which the form of an object can have upon
the viewer. Initially attracted to the straightforward
statements and direct strong feeling present in
certain archaeological work, she has increasingly
combined this response with a belief in the
simplicity of modernism as a means of synthesising
complex ideas and feelings while continuing to
make reference to the past.

Gazzard's belief in form has resulted in works of
archetypal presence. Her continual working and
reworking of forms point to both the continuity
and the invention within her œuvre. Her success
has been achieved through a refusal to compromise
and a belief in form not only as an aesthetic
response but as a universal language.

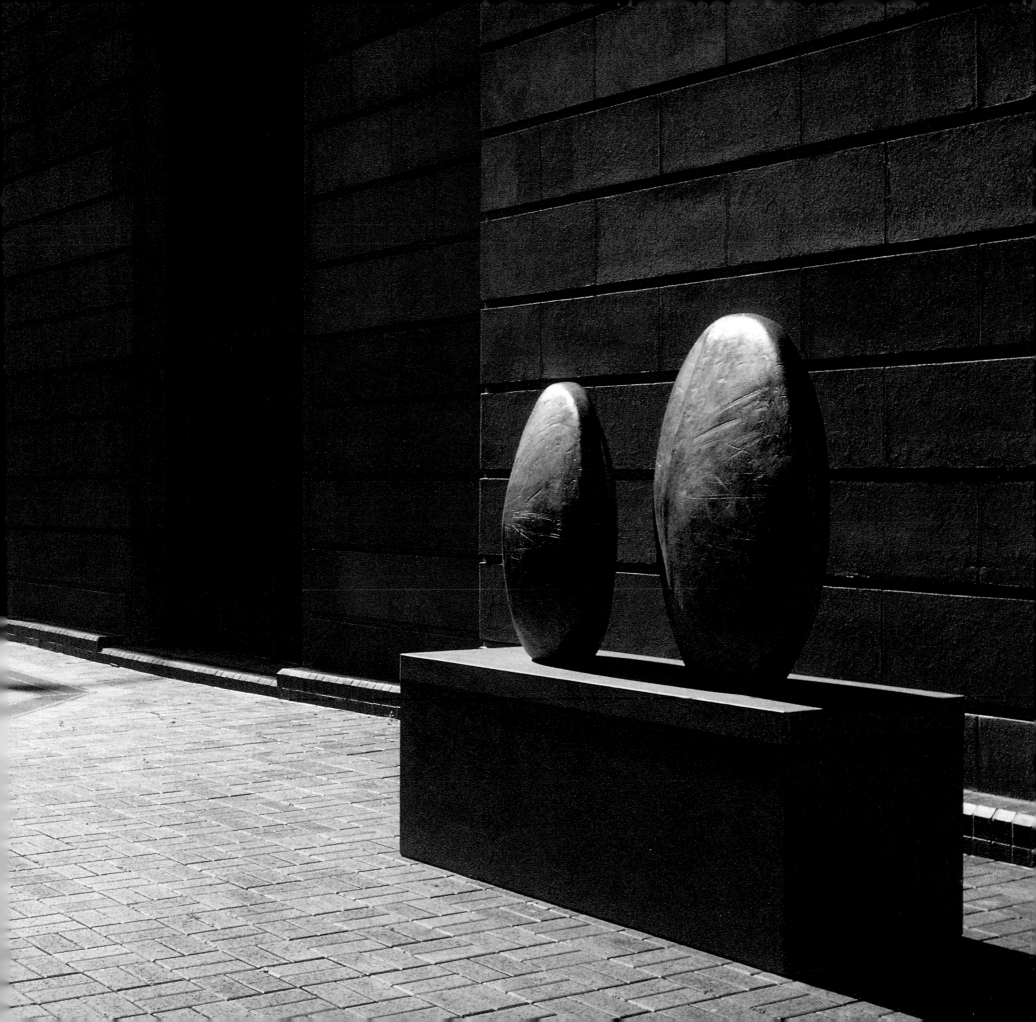

Notes

INTRODUCTION

1 Gazzard, Marea, 'Report on Peru', talk given at the University of New South Wales, unpublished, 1 October 1968.

2 Cochrane, Grace, *The Crafts Movement in Australia*, New South Wales University Press, Sydney, 1992, p. 138, for full discussion.

CHAPTER 1

1 Mary Rudkin née Gilkerson had ten children. Only nine names are known: Bill, Edith, Florence, Nell, Margaret, Herb, Jess, Mary and Christina.

2 Blackman, Barbara, 'Interview Marea Gazzard', National Library Oral History Tape, Canberra, 3 November 1986.

3 Barrowclough, Nikki, 'Parliament House ACT Symbols and Ceremony', *Belle*, Mar/Apr 1986, p. 174.

4 Hobbin, William, reference written for Gazzard, 24 March 1954, in Gazzard's possession.

5 White, Richard, *Inventing Australia. Images and Identity 1688–1980*, Allen & Unwin, Sydney, 1981, p. 158.

6 For further discussion see Strahan, Lynne, *Just City and the Mirrors: Meanjin Quarterly and the Intellectual Front 1940–1965*, Oxford University Press, Melbourne, 1984, p. 134.

7 Strahan, Lynne, *ibid*, p. 135.

8 Interview, Alexia Herbert, Sydney, 6 June 1993.

9 Lange, Eleanor, *Exhibition 1*, David Jones Art Gallery, 1939.

10 Blake, Peter, *Architecture of the New World. The Work of Harry Seidler*, Horowitz, Australia, 1974.

11 *Rose Seidler House,* pamphlet, Historic Houses Trust of New South Wales.

12 O'Callaghan, Judith (ed.) *The Australian Dream Design of the Fifties*, Powerhouse Publishing, Sydney, 1993, p. 162.

13 These journals have continued to be a valuable source for Gazzard who still refers to images from the early editions.

14 Cochrane, Grace, *op. cit*, p. 154.

15 Telephone interview, Peter Rushforth, 4 July 1993.

16 Rose, Muriel, *Artist–Potters in England*, Faber & Faber, London, 1955. Chapters 3 and 5 deal more thoroughly with Leach and Hamada.

17 Melbourne potters such as John Perceval and Arthur Boyd placed a greater emphasis on decoration.

18 Telephone interview, Peter Rushforth, *op. cit.*

19 *Ibid*.

CHAPTER 2

1 Henry Moore, Ben Nicholson, Barbara Hepworth, Walter Gropius, Kasimir Malevich, Herbert Read and Naum Gabo have all at various times lived in Hampstead.

2 Gazzard letter to her mother, 21 January 1956.

3 Interview, Marea Gazzard, Sydney, June 1992.

4 Gazzard, Marea, catalogue foreword, *Hans Coper and Lucie Rie*, Garry Anderson Gallery, Sydney, 1–26 September 1987.

5 Houston, John, *Lucie Rie*, Crafts Council, London, 1981, p. 18.

6 Houston, John, *ibid*, pp. 11–18.

7 Elizabeth Williamson, 'Lucie Rie's austere art of elegance', *Daily Telegraph*, London, 16 February 1982, p. 17.

8 Birks, Tony, *Hans Coper*, Collins, London, 1983, p. 9.

9 Birks, Tony, *ibid*, p. 7.

10 Lucie-Smith, Edward, *Movement in Art Since 1945*, Thames and Hudson, London, 1969, p. 135.

11 Interview, Marea Gazzard, Sydney, May 1992.

12 Birks, Tony, *The Art of the Modern Potter*, Country Life, London, 1947, p. 143. Birks states that Duckworth, more than any other potter who worked in England, is responsible for the explosive change which blew up traditional thinking about pottery at the end of the fifties.

13 Hood, Kenneth and Wanda Garnsey, *Australian Pottery*, Macmillan, Sydney, 1972, p. 65.

14 Interview, Marea Gazzard, Sydney, July 1992.

15 Jackson, Lesley, *The New Look – Design in the Fifties*, Thames and Hudson, London, 1991, p. 10.

16 Gazzard diary, recollection of living at 10 Water Street, Camperdown, Sydney; written on 9 June 1991.

17 Interview, Marea Gazzard, Sydney, May 1992.

18 Gazzard letter to her mother, 4 June 1958.

19 Entry in diary, Easter 1971.

20 Interview, Marea Gazzard, Sydney, May 1992.

21 Gazzard letter to her father, 10 July 1958.

22 Receipt from Heal & Son, Tottenham Court Road, 10 April 1958, lists: one large green bowl, one small green bowl, one green vase, one small green and brown vase, one white vase, one ashtray round, one ashtray oblong, one set three plant pots.

23 Mitchell, Beverley, 'Cups, saucers fine for others, ceramicist prefers the unusual', *Gazette*, Montreal, Quebec, 21 July 1960.

24 Gazzard letter to her mother, 25 May 1959.

CHAPTER 3

1 This resulted in the formation of the Antipodean group with the artists Charles Blackman, Arthur Boyd, David Boyd, John Brack, Bob Dickerson, John Perceval, Clifton Pugh and the art-historian Bernard Smith.

2 Telephone interview, Peter Rushforth, 4 July 1993.

3 The Sturt Workshop was established in Mittagong in 1941 by Winifred West, headmistress of Frensham School. It aimed to develop imaginative thinking and to relate the individual to the community. During the sixties Les Blakebrough was manager of the pottery. As well as attending workshops, Gazzard would sometimes work at Sturt, which had a large kiln that enabled her to execute some of her bigger pieces. Later Donald designed the guest-house for Sturt and the family would occasionally holiday there.

4 Edwards, Deborah, *Lyndon Dadswell 1908–1986*, Wild & Woolley, Sydney, 1992, p. 133.

5 Thompson, Patricia, *Accidental Chords*, Penguin, Australia, 1988, p. 88.

6 Garnsey, Wanda, *Pottery in Australia*, Vol. 1, No. 1, May 1962; editorial committee: Marea Gazzard, Ivan Englund, Ivan McMeekin, Peter Rushforth; 2nd issue, Vol. 1, No. 2, layout by Gazzard.

7 Thomas, Daniel, 'Pottery – it's come to life in Sydney', *Sunday Telegraph*, 24 November 1963, p. 91.

8 Telephone interview, David Jackson, 14 August 1993.

9 Richards, Michaela, *The Best Style*, Art & Australia Books, Sydney, 1993, p. 82.

10 As well as the local avant-garde, the Hungry Horse in 1963 exhibited the Spanish texture painter, Jose Guevara, and contemporary Italian painters, including Alberto Burri.

11 Forman, W. and B., and J. Poulik, *Prehistoric Art*, Spring Books, London, no date. This book was also influential for the Sydney potter Margaret Tuckson, who purchased a copy after borrowing Gazzard's.

12 Thomas, Daniel, 'The week in art', *Sunday Telegraph*, 1 December 1963. Thornton, Wallace, 'Hungry Horse', *Sydney Morning Herald*, 27 November 1963, referred to her striking individuality and flair for a decisive generous shape. The quality, he said, 'comes from the strong off beat turn of form, from the beautiful external texture of the terracotta allied to the harmonious near white internal glaze'. Gleeson, James, 'Art', *Sun*, 27 November 1963, stated: 'much of their appeal arises from the subtle incongruity of their primitive surfaces and the extreme elegance and sophistication of the asymmetrical forms'. Lynn, Elwyn, 'Space shapes and ancient artefacts set potter's pattern', *Sunday Mirror*, 1 December 1963.

13 Jackson, Lesley, *The New Look – Design in the Fifties*, op. cit, p. 12, states that certain avant-garde developments in the fine arts, such as abstract expressionism, became more rapidly accepted by the general public during the fifties because of their widespread adoption within the applied arts. The reason for this intimacy appears to be the particular appropriateness of abstraction for the applied arts. For as long as the fine arts remained rooted in the principle of realism and representation, there would always be a divide between painting, sculpture and the decorative arts. A mutual reliance on abstraction brought them closer together.

14 Gazzard, Marea, lecture 'Clay' at Contemporary Art Society, September 1965, unpublished; referred to in *CAS Broadsheet*, September 1965.

15 *Craft Horizons*, an American publication, began as a pamphlet in 1943 and in 1959 became part of the American Craftsmen's Council under the editor Rose Slivka; by the sixties it had become the most influential crafts magazine.

16 Mrs Aileen Vanderbilt Webb (1892–1979) began her interest in craft during the Depression when she helped farmers' wives to sell handmade objects. This alerted her to the marketing and educational needs of craft. In 1939 she established the Handcraft League of America and in 1943 the Craftsmen's Educational Council as a means of improving standards and promoting public awareness of the crafts. By 1958 the Handcraft League was replaced by the American Craftsmen's Council. The Museum of Contemporary Crafts and School for American Craftsmen had also been established.

17 Hersey, April, *Women in Australian Crafts*, Craft Australia, 1975 (no pagination).

18 This meeting was attended by Moira Kerr, Mary White, Marea Gazzard, Les Blakebrough, Ivan McMeekin, Helge Larsen, Col Levy, Joyce (Joy) Warren, Axel von Rappe, Elizabeth Nagel and the architects Tom Heath and Neville Gruzman. Heather Dorrough was later involved.

19 Mrs Vanderbilt Webb believed in a working reality of the ideal of the brotherhood of man. She saw the World Crafts Council as being like the United Nations, a means of increasing understanding and a desire among men to live at peace with one another; *Craft Horizons*, Jan–Feb 1963, p. 11.

20 Hersey, April, *op. cit.*

21 White had a strong interest in Aboriginal culture. In 1971 she was appointed craft advisor to the Australian Council of the Arts to explore the potential of developing the crafts in Aboriginal communities drawing on traditional skills and beliefs, see Grace Cochrane, *op. cit*, p. 240.

22 The Hungry Horse exhibition, 1 December 1964, included Les Blakebrough, Alex Leckie, Col Levy, Milton Moon, Bernard Sahm, Robin Welch and Marea Gazzard.

23 McGregor, Craig, *In the Making*, Thomas Nelson, Melbourne, 1969, p. 182.

24 Hughes, Robert, 'Made in Japan', *Nation*, 22 February 1964, p. 21.

25 Brook, Donald, 'Two vigorous exhibitions', *Canberra Times*, 4 May 1967.

26 Lynn, Elwyn, 'Robustness and suavity', *Bulletin*, 29 October 1966.

27 Thornton, Wallace, 'Art from Italy and Japan', *Sydney Morning Herald*, 19 October 1966.

28 Lansell, G. R., 'Grape and laurels', *Nation*, 6 May 1967, p. 20.

29 Interview, Marea Gazzard, Sydney, June 1992.

30 Hazel de Berg tape No. 564, National Library, Canberra. Gazzard comments on Australia's need to be involved in Asia.

31 *Proceedings*, *Dublin 1970 World Crafts Council*, p. 26.

32 Interview, Robert Bell, Perth, 21 April 1993.

33 Gazzard had been particularly impressed by the sculpture collection of Dr Kurt Stavenhagen in Mexico, also works in the Museo Anthropological which have this flattened headdress.

CHAPTER 4

1 Cochrane, Grace, *op. cit*, p. 114.

2 Shannon, Michael, 'Props from Wagnerian rites', *Australian*, 11 August 1973, p. 21.

3 Hessing had worked on the dorsal curtain for Clarke and Gazzard's Wentworth Memorial Chapel, a wall-hanging for the University of New South Wales's Sir John Clancey Auditorium foyer, and a wall-hanging for the architects Stephenson & Turner.

4 Adams, Bruce, 'Needlework with Guts', *Sunday Telegraph*, 11 February 1973. McGrath, Sandra, 'Art is craft is art', *Australian*, 10 February 1973, p. 16. Gleeson, James, 'An exhibition with a difference', *Sun*, 7 February 1973, p. 52. Borlase, Nancy, 'The closest thing to a Bedouin encampment', *Bulletin*, 12 February 1973. Boles, Bernard, 'Bye crafts, hello aesthetics', *Nation Review*, 13 August 1973.

5 McCaughey, Patrick, 'Two superwomen explode perimeters of craft', *Age*, 13 August 1973.

6 McCulloch, Alan, 'Point of no return', *Herald*, 1 August 1973.

7 Brook, Donald, 'Wasteful essays in freewheeling sensibility', *Nation Review*, 11 February 1973.

8 Brook, Donald, '(Real) art is not craft', *Craft Australia*, Autumn, 1985/1.

9 Interview, Marea Gazzard, Sydney, July 1992.

10 *Ibid.*

country house, Greystone, at Riverdale outside New York. Visited the Calder Exhibition at the Whitney Museum of Contemporary Art, New York, the Museum of Modern Art and the Egyptian Rooms at the Metropolitan Museum. On her return to Sydney she recommenced own work, and studied at the Australian Museum. In June she visited Japan and Manila to organise the 1978 World Crafts Council Conference. In August she started teaching at the University of New South Wales, College of Fine Arts (then the City Art Institute), Sydney. She continued her own work with increased interest in form suggested by torsos and armour. In December she and Donald travelled privately to India, France and USA.

1978
In January went to New York for World Crafts Council meetings. February: death of mother, Christina Medis. She exhibited in 'Australian Pottery', Festival of Perth, Fremantle Arts Centre, Western Australia; 'Australia Clay' exhibition touring Pacific and North America, and in 'Australian Crafts', Crafts Board touring exhibition. In September she attended the World Crafts Council Conference in Kyoto, Japan. She retired as Vice-President, Asian Region World Crafts Council and was made an Honorary Officer of the World Crafts Council.

1979
Worked on *Uluru* series, which she began firing in February. Taught at the City Art Institute. Solo exhibition at Coventry, Sydney. Made Member of the Order of Australia.

1980
Awarded Senior Fellowship by Crafts Board, Australia Council. Began working on *Mingarri IV*, to be exhibited at XXXVIII Concorso 'Internazionale della Ceramica d'Arte', Faenza. Worked on Crafts Council film on handbuilding. In June she visited Italy and travelled to Vienna for the World Crafts Council Conference where she was elected President. Began work in this capacity preparing for meeting of Secretariat in New York. Exhibited in 'Recent Ceramics', touring Europe, organised by the Crafts Board and Department of Foreign Affairs.

1981
January: worked at World Crafts Council Secretariat in New York then visited Amsterdam, London, Paris and Bangkok. Exhibited in 'Ceramics Exhibition', Ivan Dougherty Gallery, Sydney. In May–June she travelled to Malaysia, New York, San Francisco. In New York she worked with Rose Slivka and Nathalia Tabak and met Bill and Elaine de Kooning. On her return to Sydney there was a breakdown of her marriage. Trip with painter Margaret Wilson to Central Australia.

1982
Worked in the New York Secretariat for the World Crafts Council. Met Curtis Roosevelt from the United Nations Secretariat who helped Gazzard strengthen link between the World Crafts Council and United Nations. Travelled to London where she saw the 'Great Japan' exhibition, which inspired a new series of work. She then visited Thailand and returned to Sydney, where she taught at the City Art Institute. In June she visited Sri Lanka for the World Crafts Council Asia Region meeting and then travelled to Greece to organise World Crafts Council conference. In July she was made a member of the Australian delegation to the UNESCO Conference on World Cultural Policies held in Mexico City. Here she was successful in gaining recognition for the role of crafts by over 200 countries. She was also appointed a member of the Australian National Commission of UNESCO and her work was selected to exhibit with Sir Sidney Nolan's at the UNESCO Conference, Mexico City. On her return to Sydney began work on the

Pindarri series. She exhibited in the '1982 Mayfair Ceramic Award Exhibition', Crafts Council Centre Gallery, Sydney; the 'Women in Arts Festival' with Bridget Riley and Inge King at Coventry, Sydney; and 'Australian Women Artists', Blaxland Gallery, Sydney. She was appointed a member of the Trust of the Museum of Applied Arts and Science, Powerhouse Museum. She was also invited to submit a proposal for the Ian Potter Foundation Sculpture Commission, Victoria; this encouraged her to work on a larger scale.

1983
Worked at the World Crafts Council Secretariat, New York, then travelled to London to be guest lecturer at the Central School of Art and Design, London. She returned to Sydney for the sale of Hargrave Street house and moved to an apartment in Darlinghurst. In May she moved her studio to the Sydney Dance Company building, Woolloomooloo. She attended the World Crafts Council International Meeting on Apprenticeship in Craft, Sydney, and began her own work concentrating on disc-like shapes. Became interested in Jung's universal form. In August she travelled to Greece and London for World Crafts Council. She exhibited in 'Contemporary Australian Ceramics', National Gallery of Victoria touring exhibition.

1984
Worked at the World Crafts Council Secretariat, New York, and was guest lecturer at the Renwick Gallery, Smithsonian Institute, Washington, DC. She then travelled to London, Paris and Malaysia. On her return she attended the UNESCO meeting in Canberra, ACT, and held discussion about work for proposed sculpture in Parliament House, Canberra. In July she visited Malaysia for a special crafts exhibition. She also visited Sweden and Norway. At twentieth World Crafts Council Conference in Oslo she resigned as President of World Crafts Council. On her return to Sydney she began work on the Parliament House project.

1985
Taught at City Art Institute, Sydney. Worked on Parliament House project. Guest speaker at International Meeting of World Crafts Council in Jakarta, Indonesia. Exhibited in 'Impulse and Form', Art Gallery of Western Australia. Exhibited at Australian Pavilion Expo '85, Tsukuba, Japan.

1986
Moved to the Watertower building, Redfern, NSW. Vacated Woolloomooloo studio. Worked on patina for Parliament House works. Travelled to New Zealand with Jane Burns.

1987
Finished Parliament House bronzes. Worked on drawings for exhibition. Finalist in the 'Royal Blind Society Sculpture Award'. Awarded Special Grant by Crafts Board, Australia Council, to prepare exhibition. Solo exhibition of Parliament House and other work at Coventry, Sydney, and at Westpac Gallery, Victorian Arts Centre, Melbourne.

1988
Awarded residency at Dr Denise Hickey Studio in the Cité Internationale des Arts, Paris. Installed bronzes in the Executive Court of Parliament House, Canberra. Graeme Murphy commissions sculptural work. Executed work for Liverpool Girls' High School. Exhibited in 'A Changing Relationship: Aboriginal Themes in Australian Art 1938–1983', S. H. Ervin Gallery, Sydney; 'Australian Decorative Arts 1900–1985', Australian National Gallery, Canberra, ACT; '20 x 20 Crafts in Society 1970–1990', Crafts Council of New South Wales; 'Black and White Drawing', Coventry, Sydney; 'The Self Portrait', David Jones Gallery, Sydney. Travelled to Greece: visited Athens,

Piraeus, Poros, Crete; and Paris. Took up residency at the Cité Internationale des Arts and studied in the Louvre, where she became interested in forms suggested by funerary masks and mummies. Visited London for Henry Moore retrospective.

1989

Finished Graeme Murphy commission and began work on *The Head* series. Gave lecture, 'Shaping history, 50 years of Australian Pottery', Powerhouse Museum, Sydney. Became the first woman in the visual arts to be awarded an Australian Artists Creative Fellowship.

1990

Worked in wax on *Este* and *Paros* series. In March, worked in clay on the *Milos* series. Worked on large-scale drawings. In September solo exhibition at Coventry, Sydney. In October she travelled to USA visiting Santa Fe, Los Angeles, San Diego, Chicago, Boston, New York and Washington, where she studied in the museums of these places. Became intrigued with early tools particularly those in the Field Museum in Chicago. On her return to Sydney she began work on designs for sets of Kim Walker's production, *Harold*.

1991

Did research work for *Harold* and worked on drawings for the *Field* series. Designed sets and costumes for *Harold* and began working in wax for small *Field* series. She exhibited in the 'Asia Pacific Crafts Exhibition', Kyoto Museum, Japan; 'A Tribute to Ronaldo Cameron', Lake Macquarie City Art Gallery, NSW; and 'Brown 1970s Ceramics', Shepparton Art Gallery, Shepparton, Victoria.

1992

January: worked on *Harold*, which opened in Brisbane on 19 February. She judged the National Craft Award at the National Gallery of Victoria. She was invited to submit scheme for ASER Property Trust sculpture to be sited in the Adelaide Plaza, Adelaide. She travelled to Adelaide to inspect the site before working on various designs and finally developing the piece *Mandorla*. Attended the Henry Moore exhibition at the Art Gallery of New South Wales.

1993

Completed *Mandorla*, which was installed in the Adelaide Plaza. Completed work for exhibition at Coventry, Sydney.

Index

Numbers in italics refer to illustrations